PORTRAITS

MICHAEL KIMMELMAN

PORTRAITS

TALKING WITH ARTISTS AT THE MET,

THE MODERN, THE LOUVRE

AND ELSEWHERE

RANDOM HOUSE

NEW YORK

Most of the material in this work was originally published,
in different form, in *The New York Times.*

Front cover art: detail from sculpture, *Pauline Borghese,* by
Antonio Canova (1757–1822), courtesy of Erich Lessing/Art
Resource, N.Y. Back cover art: sculpture, *Lilith,* 1994, by
Kiki Smith. The Metropolitan Museum of Art, Purchase,
Roy R. and Marie S. Neuberger Gift, 1996 (1996.27).
Photograph by PaceWildenstein.

Library of Congress Cataloging-in-Publication Data
Kimmelman, Michael.
Portraits: talking with artists at the Met, the Modern, the Louvre
and elsewhere/Michael Kimmelman.-1st ed.
p. cm.
Published simultaneously in Canada by Random House
of Canada Limited, Toronto.
Includes index.
ISBN 0-679-45219-2
1. Artists—Interviews. 2. Artists—Psychology. 3. Artists
and museums. 4. Art appreciation.
I. Title.
N71.K56 1998 701´.15—dc21 98-9589

Website address: www.randomhouse.com
Printed in the United States of America on acid-free paper
24689753
First Edition

Book design by J. K. Lambert

To the memory of my father,
to my mother and
to Maria

CONTENTS

INTRODUCTION

This book records not only what eighteen artists said about the art they chose to look at in various museums but also what they revealed about themselves in the process. The chapters are, indirectly, portraits of the artists, whose tastes suggest the range of the present eclectic art scene.

It has its origins in a series of interviews I did with the artists, recently published in *The New York Times.* I thought they contained the seeds of something worth developing and decided to rework them, adding a substantial amount of new material and generally trying to change them from newspaper articles into a book of idiosyncratic biographies.

Mostly, the interviews occurred at the Metropolitan Museum of Art in New York, the idea at first having been to see the same place through many eyes, *Rashomon*-like, and so to prove there is no single, right way to look at art. However, when the sculptor Richard Serra wanted specifically to talk about Jackson Pollock it was natural to include the Pollocks at the Museum of Modern Art, and after that Jacob Lawrence decided to visit both museums. A few interviews were conducted in Europe: with Henri Cartier-Bresson in the Louvre and in the Pompidou Center in Paris; with Lucian Freud in the National Gallery, London, in the middle of the night, because that is when he likes to go there, and he can; and with Balthus in his chalet

in Rossiniere, Switzerland, where, too frail to travel to Paris, he spoke with a book of paintings from the Louvre on his lap. An interview with Francis Bacon from some years ago is also included because it involved a visit to the Victoria and Albert Museum in London to see the Constables he loved there.

Among other things, the book aims to show that good artists, of different sorts, can talk straight about art. The cliché is that artists aren't articulate, but this isn't true. Some are, some aren't, like the rest of us. The ones here, I think, are eloquent in different ways. They all try to describe what's relevant to the present in the past, though naturally what they consider relevant varies with their interests. So when the sculptor Kiki Smith described how the slight tremble of some pre-Columbian gold jewelry in the Met suddenly put her in mind of "those survival-research laboratories that take dead animals, like cats, and reanimate them by motorizing their limbs . . . like Frankenstein or Jesus or Osiris," she formed a personal connection outside traditional art history, needless to say, but meaningful to her art. Art is something actually alive to her, which is why, for instance, she inspected her own *Lilith,* in the Met, of a crouching naked woman, empathetically.

These talks were not the first ever done with artists in museums, not even the first to be published in the *Times.* Only after Richard Goode, the pianist and a reader about art and everything else, lent me a copy of Pierre Schneider's *Louvre Dialogues,* from 1971, did I decide to invite Brice Marden to the Met, because we happened to meet one evening. My hesitation involved the distance, for better and worse, that a critic tries to keep between himself and the people he writes about. The interviews turned out to be a good way to speak about art with a variety of artists I respect.

Schneider began his introduction by quoting Cézanne: "One can only speak properly about painting in front of paintings." Cézanne recalled having wanted to burn down the Louvre, adding "poor jerk that I was," and eventually

decided it was "the book from which we learn to read." Every artist has a slightly different view of museums, naturally. Schneider went on to point out how Matisse, for example, unsure about a portrait, visited the Louvre for inspiration and found a Veronese with a similar pose, then returned to his studio to change his picture to resemble Veronese's. Lucian Freud's relationship to the National Gallery, as he describes it in the interview here, sounds similar: "As if it were a doctor," he says. "I come for ideas and help—to look at situations within paintings, rather than whole paintings. Often these situations have to do with arms and legs, so the medical analogy is actually right." Richard Serra said he goes to museums to look at only one or two works per visit, and focused on Pollock's *Autumn Rhythm* at the Met for a couple of hours. At the other extreme, Cindy Sherman acted as if she hadn't ever been to the museum before, while Hans Haacke expressed an attitude that stemmed, like his art, from the counterculture politics of the sixties and early seventies. For him the museum was an institution of power, though he appeared to be having fun there. Most artists did: they seemed to think of the museum, in the end, as their clubhouse.

It was amusing to hear from people who read the *Times* interviews and praised as perceptive the remarks by artists whose works they admired, while finding the other interviews strangely unsatisfying. The idea of the series was to cover a range that would probably please no one. The range could have been wider and included more young artists, though everyone's list would be different—and it seemed to me irresponsible not to talk to Cartier-Bresson or Balthus or Jacob Lawrence while there was the chance to do so. Cartier-Bresson likes to tell his numerous interviewers that he refuses all interviews. The day I arrived in Paris to meet him, one ran in *Le Monde*. Balthus didn't grant interviews for years, but he has done a couple lately—he gave one to David Bowie—perhaps at the urging of his wife, Setsuko Ideta, partly, I think, to help sell his drawings and paintings to support themselves in their

enormous château. Maria-Gaetana Matisse, the widow of Balthus's former dealer, Pierre Matisse, kindly wrote my letter of introduction, after which it took more letters and telephone calls to secure a date, or so it seemed. His health unpredictable, Balthus is reluctant to plan in advance. Traveling through Europe, I called from Vienna to confirm our meeting and got the equivalent of a blank stare from Setsuko. I ended up in a hotel only a few miles from Rossiniere, still not sure whether Balthus would keep the appointment that same day. He didn't, but he saw me the next and, with Setsuko, plied me with tea cakes and whisky, though I was not certain that he ever knew my name. He called me Kellman as I left.

Freud guards his privacy so jealously that only his lawyer and children are said to have his phone number. Close friends call the lawyer. John Richardson, Picasso's biographer and an old pal of Freud's, made the introduction this time. My review of Freud's Met show in 1993 apparently disposed him to think charitably of me, so through his lawyer we fixed a date and I flew to London. He was unavailable. We made another date a month later, I flew to London again and he changed the appointment to the following Saturday at midnight. Knowing he had special access to the gallery at odd hours, I presumed this to be his plan. But he wanted to have drinks at a club. We rendezvoused at his studio, where he paints at night. Boxes and magazines everywhere. Freud has no patience for small talk and greeted me with questions about art. The next day we would meet, he promised, which we did, over lunch, while he explained his reluctance to choose among the pictures in the gallery's collection. He didn't want to be misinterpreted. Might I choose for him? I was evidently being auditioned. A few days later, on short notice, around midnight, he finally swung past my hotel and drove us to Trafalgar Square, where he parked his Bentley on the street and we walked to the gallery. The lights had been left on for him. We stayed past three in the morning.

Freud, it turned out, was cited by several artists during

the interviews, along with Giacometti, Velázquez and Guston: not an altogether odd list, really, considering how much art of the 1990s deals with the human body, surrealism, sex, cartooning. A topic of many of the conversations was what might be called the in-built tension between figuration and abstraction, obviously a central issue throughout this century. Different artists talked about it in different ways. I was struck by how often the figurative artists stressed the abstract, formal side of their work. It seemed a reminder that art is a craft first—involving arrangements of shapes, colors—and then, perhaps, it becomes something more than that.

All the artists were told beforehand that they could talk about whatever they wanted, a single work or dozens, for an hour or days. I held a small tape recorder, which, besides providing a full record, allowed us to speak without the awkwardness of my having to take notes. Most artists came to the interview prepared. The hope was that their different interests would lead them to different parts of the Met. On one level the goal was to solicit opinionated guides to the museum. Brice Marden went to the Southeast Asian galleries; Bruce Nauman to arms and armor and musical instruments; Chuck Close to African and Native American art; and Nancy Spero to see the sculptures of goddesses in the Egyptian rooms, while among European paintings she singled out a generally little noticed self-portrait from the 1780s by Adélaïde Labille-Guiard because it showed a female artist with two female students. Several artists picked out the same pictures or sculptures: Pollock's *Autumn Rhythm,* Guston's *Street,* Ingres's grisaille *Odalisque* (which is sometimes attributed to Ingres's workshop), the Velázquez portrait of Juan de Pareja, Vermeer's *Young Woman with a Water Jug,* Degas's dancers. A few others. These works recur in the book. I regard them as variations on themes. Mostly, I let the artist lead the way, which often meant Velázquez, Vermeer and so on, but sometimes, when it seemed right or when they left it up to me, I did gently point them in one direction or another, and after a while, occasionally, toward

one of these works specifically to see how their reactions compared with the reactions of other artists. Cindy Sherman was somebody who asked for suggestions, so we looked at Ingres, Degas, Rodin. Kiki Smith had an elaborate plan that crisscrossed the museum, and stuck pretty much to it.

Around the time that *Louvre Dialogues* was published, Nelson Rockefeller, then the governor of New York and a member of the board of the Museum of Modern Art, which his mother had helped to found, was accosted at an American Association of Museums convention by a group of artists calling themselves the New York Art Strike Against Racism, Sexism, Repression and War. They demanded that Rockefeller resign from the Modern because of what they said were his links to the manufacture of matériel for the war in Vietnam. He squinted at them, baffled, and asked, "What is sexism? And what does it have to do with art?"

Among other things, this incident suggests the divisive atmosphere that Schneider described in his introduction. He explained the purpose of his interviews by asking "Has the art of our time, which rejects all its predecessors, broken forever with the past? Can this abyss still be bridged by some sort of dialogue? And if a continuity still exists, what is its nature?" He hoped that the confrontation between living artists and the art in museums would provide answers and also throw light on the works of the artists themselves, more so than the usual starchy statements prepared by artists' galleries.

The situation has obviously changed since 1971, but the questions remain relevant. Museum attendance is at record levels but popular enthusiasm for the latest art seems to have dimmed in the last decade. Partly, I think, this is because too many artists failed to live up to their eighties hype, and partly because without the same money and glamour, art can no longer compete with, say, film for the public's attention. (Is it any surprise that eighties art stars like Julian Schnabel, Sherman and David Salle have begun to direct movies?)

Then there is the quality of much nineties art: often preachifying and rebarbative, it seemed at first penitential, as if apologizing for the excesses of the eighties. The art community was becoming more racially and sexually diverse, but improved demographics did not justify lecturing audiences in the rarefied spaces of the Whitney Biennial about the virtues of freedom of speech. New art seemed condescending, self-righteous and solipsistic. The stultifying influence on artists, and critics, of academics besotted by Post-Structuralism also caused too much of the work in galleries in SoHo or Los Angeles or wherever to take on a dry, hermetic, even smug tone. More recently young artists have begun to turn from mandarin and political fashions to make art that aims at a kind of sensational public spectacle; it is sometimes more congenial and civic-minded (there's lots of so-called site-specific sculpture and installation art) but is also often consciously unbeautiful and preoccupied with private stories and obsessions that can be mystifying. Matthew Barney's art is a good example. Robert Gober's is another. The scarifying and cheerfully ghoulish quality of the newly fashionable art from London is yet another. The art scene, increasingly varied, is now less, not more, comprehensible to outsiders. This book is a modest attempt to help bridge the gap between artists and the public.

Some people might be surprised by how few responses writers at the *Times* generally get to articles. The series provoked more than the usual reaction, perhaps simply because readers were grateful for opinions about art from someone besides me. I'm only half kidding. One of the purposes of the series was to get more voices about art into the paper. Another was to avoid the standard journalistic formats. Walter Lippmann once observed that journalism reports only the news that conforms to formulae, which have to do with shifts in government and other institutions, with celebrity, crime, money and so on. Most of what actually happens in the world remains invisible in the media—a situation astronomers might consider analogous

to dark matter in the cosmos. With newspaper art criticism, the endless round of exhibitions dictates coverage that can become reactive and piecemeal, event-driven.

Newspaper editors, who like to deal in facts, tend to be uncomfortable with cultural coverage because it is often not quantifiable, the way the stock market is quantifiable—unless, of course, it can be made to resemble the stock market, which, as everyone knows, is roughly what happened during the eighties, when art as a journalistic subject became nearly synonymous with the money that poured into it. This money justified art's significance as news, and the art world lent itself to the equation—with unfortunate consequences, because too much of the public came to see art's value in terms of money and celebrity and blockbuster exhibitions, which were also about money and celebrity. Then when the art market collapsed, people came to feel the way investors did about junk bonds—betrayed and mistrustful. As an alternative to the standard celebrity profiles and auction house stories, therefore, these interviews are meant to prove that living artists have things to say about the art on view every day in the permanent collections of some of our oldest and most august museums.

A built-in deception in these interviews, as in much journalism, is that although the talks were conversations, in print I have mostly absented myself to let the reader, in essence, take my place as the person to whom the artist is speaking. Inevitably lost is the give-and-take of a normal exchange, which was one reason for interviewing couples like Nancy Spero and Leon Golub, and Bruce Nauman and Susan Rothenberg: to recount the chatter between them. With Golub and Spero, a couple of gentle old Lefties, long married, their shared values made them easygoing together. Nauman and Rothenberg, dissimilar artists of dissimilar temperaments, happily married since 1989, seemed bound by affection where their tastes might have split them apart, meaning that each one looked at art that

the other one might not have, provoking a different sort of dynamic.

Most of what was said obviously had to be cut for the interviews to fit into the *Times,* and many excised remarks are restored here. Articles long for a newspaper and published over months look different together in a book, another motive for the often extensive revisions, though at heart the interviews are still what they were, for better and worse. I hope, collected, they say something not just about what art of the past contemporary artists like to look at but also about how to look at that art. Art historians, friends of mine, sometimes reacted to the artists' remarks with condescension. Since the artists didn't tell them much that they didn't already know about history, they didn't see why they, or anyone, should care. The reason is that the artists weren't talking about history, or at least not academic art history. They were talking about the present, and about how to fit themselves into a historical continuum that goes from cave paintings through Picasso to now. In the interviews a few artists tried to link themselves with traditions, as Chuck Close did with Netherlandish portraiture; others denied the obvious connections. As Roy Lichtenstein puts it at the end of his interview: "All abstract artists try to tell you that what they do comes from nature, and I'm always trying to tell you that what I do is completely abstract. We're both saying something we want to be true."

And they are often telling us something useful to know. For example, Cindy Sherman's seeming disregard for history, as such, belied a more practical relationship on her part to the art of the past. For her it is a creative source of images, as are the medical supply catalogues from which she buys props for her photographs. It is neither more nor less important, a viewpoint akin to the deadpan way Warhol appropriated pop culture images. Perhaps Sherman's attitude can be said to reflect a broader ambivalence in modern culture toward the past. I leave this to others to

decide. But during her interview, in front of a Courbet, Elizabeth Murray raised an interesting point along this line: "You look at this Courbet and you can relate to it even though his world is so distant from ours. . . . What this Courbet or that Cézanne does is invite you into their worlds, and when you pop out again you've got something in your life that you didn't have before."

Like Murray, the other artists here restore to past art, I think, a sense of immediacy that historians often seem to fear or neglect, but that anyone can relate to who doesn't succumb to the intimidations of History. There is a difference between historical value and taste, which people forget. Rembrandt is a great figure but we don't have to like his work. Artists know this instinctively.

In 1824, Eugène Delacroix, who thought all artists should go to museums to steep themselves "from time to time in great and beautiful works of art," wrote in his journal that what moves great artists, "or rather, what inspires their work, is not new ideas, but their obsession with the idea that what has already been said is still not enough." It's what Milton called the obsession with "things unattempted yet in prose or rhyme." That's one of the messages of these interviews. The artists are like critics in the old Bloomsbury sense: people who treat Old Masters with the same urgency or disdain that they feel toward new art, because old art is also alive to them. The interviews prove Delacroix's implicit point that new art is always, in some basic way, a commentary on the past.

PORTRAITS

BALTHUS

was born in this century, but I belong much more to
the nineteenth century," says Balthasar Klossowski,
known to the world as the painter Balthus. As it hap-
pens, Balthus was born on February 29, 1908, a quirk of
fate, he likes to joke, that makes him twenty-two. The poet
Rainer Maria Rilke once told him that being born on leap
day was like slipping through a crack in time; it gave
Balthus access, Rilke said, to a "kingdom independent of
all the changes we undergo." For years he has contrived to
live in that kingdom, in life as in his archaizing art, di-
vorced from his time in a realm of his own devising.

Balthus has been described as a realist painter, but he is
a realist of a singular and imaginary sort. His portraits and
figure studies, painstakingly and thickly painted, have a
calculated naïveté and a predilection for precisely drawn
yet somehow mysterious imagery, full of oddities of scale
and gesture. His landscapes are dreamy, almost fairy-tale
scenes bathed in a granular light, images of time in
abeyance. There's a geometry and flatness to the art that
can be described as modernist, but in every way Balthus
has tried to put distance between himself and the principal
goings-on in art of the twentieth century.

I have come on a spring day in 1996 to visit him in his
sprawling eighteenth-century chalet in Rossiniere, a tiny

Swiss mountain village, between Montreux and Gstaad. He and his wife, Setsuko Ideta, also a painter, have lived here for more than twenty years. They tell me that they came once when it was an hôtel garni, found it to be for sale and bought it. The steep rising hills and, on this day, the soft spring colors can bring to mind some of Balthus's gauzy landscapes from a time before he moved here, as if this were a fulfillment of a vision he had had years ago. Before Rossiniere, Balthus lived in grand and often conspicuously remote houses in France and Italy. During the 1950s he painted the view from his dilapidated château de Chassy in the mountainous region of the Morval in central France. Those pictures come to mind here, where Balthus enjoys a kind of isolation. Almost proudly he makes a point of the fact that he has never been to the United States, not even for his own retrospectives over the years at the Museum of Modern Art and the Metropolitan Museum in New York.

Balthus has agreed to meet for a few hours. Today he is dressed in a seaweed-green Japanese abbot's robe, short black boots over bright red socks, a gold chain around his neck. Thick glasses perch on his nose. His gray hair is brushed straight back. You can see that he was handsome when he was younger. Though he speaks slowly, in a gravelly voice, he has lost none of his mischievousness or preening finesse. A chain-smoker, he keeps a lighted cigarette bouncing in the corner of his mouth when he talks. "You don't smoke?" he asks me at one point, then, with a dismissive arch of his eyebrows, answers himself: "No, of course not. You're an American." Setsuko, an alert, piquant woman in her early fifties, wears a blue kimono with red sash, her lips bright red, her face white. Filipino servants flutter about the room. I feel vaguely that I have stumbled into a Sax Rohmer novel.

Knowing his famous reluctance to say much about himself, I have brought along a book of paintings from the Louvre to talk about because many of the works that have influenced him, the ones he has echoed most often in his

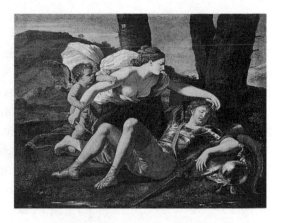

Nicolas Poussin / *Rinaldo and Armida*, 1629
Oil on canvas, 32⅜ x 43 in.
Dulwich Picture Gallery, London

Balthus / *Thérèse Dreaming*, 1938
Oil on canvas, 59 x 51 in.
The Metropolitan Museum of Art, New York

art, come from the Louvre. He went there countless times as a young man teaching himself to paint.

"The Louvre was the most instructive place for me," he says, "and chiefly because I looked at Poussin." At seventeen, Balthus copied Poussin's *Echo and Narcissus* there, and later he adapted the figure of the reclining Narcissus in several paintings, as he has adapted other figures from other Poussins, like the sleeping Rinaldo from *Rinaldo and Armida* in *Thérèse Dreaming,* a languid image, mildly erotic, of a child rapturously dozing.

"I taught myself to paint, and I went to the Louvre to find how the great painters did it. There I understood that if you do not have the means of telling something, you have nothing. Poussin came out of a time when art was a craft. To make an art like the art of the seventeenth century, when Poussin was alive, is impossible today because artists no longer know how it's done."

Balthus has got on to a favorite subject, the decline of civilization. "You know, the human being was quite different in Poussin's period," he says, a theory he has put forward before. "And the human being has completely changed, especially since the war. Before the war there was another kind of humanity, but I'm convinced that something has happened to mankind, something terrible, that Mr. Hitler let something diabolic into the atmosphere. There's no longer any culture, if you've noticed."

Balthus is scythelike, a wraith. These days he needs help to cross a room. He hears with difficulty, and his eyes are too weak to allow him to draw. Setsuko says she assists him in his studio, calling herself his "studio boy." Just how much assistance she has given him lately is a matter of some art-world gossip. Always slow to finish a painting, he has exhibited only one new painting in the last few years, though he says he paints every day.

A friend, the writer Claude Roy, once likened him to a cat: "brilliant, but in that very brilliance, reserved, skittishly secret, courteously open yet hermetically closed." And it is true, Balthus is evasive, and one can get the im-

pression that his remarks—everything about his extravagant persona, in fact—are a little fantastical and to be taken with a grain of salt. For instance, years ago, to the bafflement of friends, he let it be known that he was of noble birth and that his rightful name was the Count de Rola, and moreover he declared, despite his German, Russian and Polish ancestry, a family connection between himself and Byron (in whose onetime home, the Villa Diodati, near Geneva, Balthus happened to live for a time). "We come from a very bloody clan," Balthus claims, and I think I detect fleeting amusement on Setsuko's part. Other people have not been so amused by his reluctance to acknowledge his Jewish ancestry, which includes a maternal grandmother and a grandfather who was a cantor in Breslau, nor by the lengths to which he has sometimes gone to attack those who have pointed out his heritage.

Until lately, Balthus had a horror of interviewers and photographers, which is not to say he wasn't sociable. It is, of course, possible to be both socially ambitious and reclusive when it comes to public scrutiny, and this was Balthus's situation. His most repeated remark for the last thirty years is that "Balthus is a painter about whom nothing is known." The statement implied that whatever people thought they knew about him or his work was wrong. And even now, as he accepts with his wife's encouragement a degree of the attention he once shunned, he is impatient and dismissive with questions about his art. Partly he believes it should speak for itself.

But partly he has a dread, not unfounded, that people will ask him about his infatuation with adolescent girls, for although he has done hundreds of works, he is inevitably linked in the public's mind with his paintings of young women in enigmatic and sometimes suggestive poses. Skeptical and censorious Americans, in particular, tend to regard him as the Humbert Humbert of the art world.

"I really don't understand why people see the paintings of girls as Lolitas," he volunteers, to get the issue out of the way. "You know why I paint little girls? Because women,

even my own daughter, already belong to this present world, to fashion. Little girls are the only creatures today who can be little Poussins." Poussin seems to be a play on words: in French it means a little chick, and can be a term of endearment, but it also implies a figure from the works of Poussin, pure and timeless.

"My little model is absolutely untouchable to me," he insists. "Some American journalist said he found my work pornographic. What does he mean? Advertising is pornographic. You see a young woman putting on some beauty product who looks like she's having an orgasm. I've never made anything pornographic, except perhaps *The Guitar Lesson*." An image from 1934 of a girl naked below the waist and draped over the knees of a bare-breasted woman, *The Guitar Lesson* is a painting Balthus said was contrived to attract attention when he was virtually unknown. Courbet, whose paintings of lesbian lovers, among other works, alarmed nineteenth-century viewers, was clearly a big influence on Balthus's work. "For the people of his time he was probably very irritating. He did what he could to shock. And he was a peasant." But there is a more direct source than Courbet. The figure of the girl, it has been pointed out, mimics the dead Christ in the fifteenth-century Avignon Pietà in the Louvre; it's a link that, by its blasphemy, heightens the shock.

And implausibly Balthus therefore denies the connection. "I absolutely never thought of that, never," he protests. "I'm Catholic. I'm a member of the Order of St. Maurice and St. Lazare!" I decide to change the subject slightly. What, by the way, does he think of *Lolita,* whose author, after all, was almost a neighbor of his when he lived in Montreux? "It's very Russian," he says of the Nabokov novel, dryly and after a moment. "But the subject doesn't interest me."

Balthus was born in Paris. His father was an art historian who wrote about Daumier. His mother, Elisabeth Dorothea Spiro, known as Baladine, was a painter so close in style to Bonnard that, so the story goes, Bonnard once saw a work

by her and asked, "When did I do that?" Balthus recalls
Bonnard as "a great friend of my family, and as far back as
my memory goes, I see Bonnard. Americans don't under-
stand Bonnard, which is very sad for America because he's
probably the greatest painter of the century, and such a
wonderful man. The letters between him and Matisse dur-
ing the war gave me a new view of Matisse, I must say.
They are just two old survivors writing to one another.
Certainly Bonnard's work was important to me in that it
gave me a sense of what painting ought to be. It's difficult
to say whether it had a direct influence on my work but it
had an influence on my way of looking at things. Vuillard,
too. One can say that painting was still alive when those
two were alive."

Balthus was thirteen when *Mitsou* was published: it was
his story of a stray tomcat, for which he also drew pen-
and-ink illustrations. Despite his claims to abhor all popu-
lar culture, since *Mitsou* he has always had a surreptitious
romance with old advertisements and illustrations, from
which he sometimes cribs. "But not modern ones," he
says. "When you look at older popular art, you find a sim-
ilarity to Courbet, but in modern illustrations you find
nothing at all. What I like are the illustrations that artists
call kitsch, from children's books, in which they are keep
ing the tradition that goes back to great painting. I don't
think they're kitsch." I ask if he also admires Delacroix's il-
lustrations of Shakespeare, because they, in particular, have
something of Balthus's intentional expressive awkward-
ness. "They have been very important for me," he says.

Already there were characteristics in *Mitsou* that would
define Balthus's later art: an imponderable sense of narra-
tive, a strange otherworldliness and a desire for pictorial
order. As a boy, Balthus moved to Switzerland and Berlin
with his mother and brother, Pierre. His mother, who had
separated from his father, had become close to Rilke, who
wrote the preface to *Mitsou* and later dedicated "Narcisse"
to Balthus. He also found patrons to help pay for Balthus's
travels. From Switzerland it was possible for Balthus to go

to Arezzo and Florence to see the great frescoes by Piero della Francesca, Masaccio and Masolino. Works like Balthus's *The Street,* of 1933, make oblique references to them, and in general in Balthus's art, the combination of stillness, symmetry and powdery, bleached color, like the color of ancient stone, can be linked to those frescoes. I show him a Piero portrait in the Louvre book. "It's true, there is a strong connection," he says. "But with Masaccio, I feel even more related. Piero I admire enormously. He taught me many things, but I feel nearer to Masaccio and Masolino. I can't really tell you why, except that Piero is too near perfection, so near that he's squashing. However, who can say for certain about such things? For instance, I made a nude and only afterward did I realize that it had been inspired by a work by Simone Martini. A friend of mine pointed it out to me, although I really wasn't thinking of Simone when I painted it."

Balthus / Copy after Piero della Francesa's
The Invention and Recognition of the True Cross, 1926
Oil on cardboard, 17½ x 26¼ in. Galerie Jan Krugier, Geneva

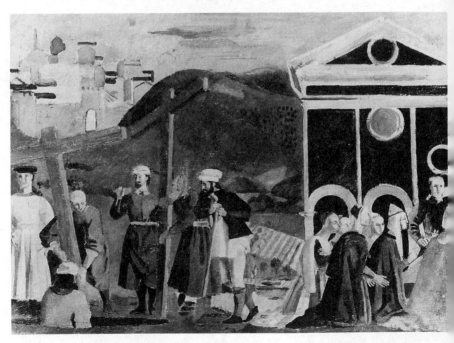

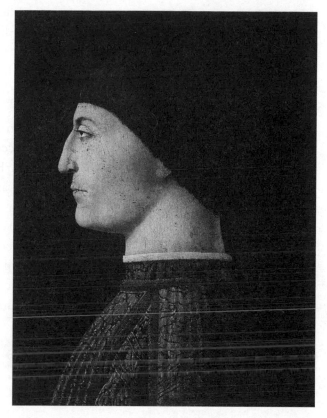

Piero della Francesca / *Portrait of Sigismondo Malatesta,* c. 1450
Oil and tempera on panel, 17½ x 13½ in. The Louvre, Paris

Beginning in the 1930s, Balthus started to earn a repu-
tation among the leading poets, writers and artists in Paris,
where he was living. He met Gide, Camus, Paul Éluard,
Antonin Artaud (to whom Balthus became so close that
his portrait of Artaud, gaunt and arresting, is nearly a self-
portrait). He also met Picasso. "Dear old Pablo. Personally
I loved him very much," Balthus reminisces. "You know
he bought one of my paintings when I was young. He said
he was intrigued because everyone else was making Picas-
sos except me. He covered me with such compliments that
I can't repeat them. As for his work, I liked it in the twen-
ties, after Cubism." He is talking about the Neoclassical
works. "But I looked again at the Rose Period recently,
and really you can't find anything in it to nourish you."

Dora Maar / *Untitled,* c. 1935
Gelatin-silver print, 11⅜ x 9¼ in.
The Museum of Modern Art, New York

This is interesting, considering that there is an affinity be-
tween Balthus's art and the Rose Period, a certain dreamy
silence, which Balthus claims not to see. "I knew everyone
around Picasso, you know. Jacqueline I didn't like."
Jacqueline Roque was Picasso's second and last wife. "But
I liked Dora Maar very much." Maar, Picasso's lover in the
1930s and early 1940s, was a gifted, often witty photogra-
pher and later a painter, now sadly little remembered ex-
cept for her part in his life. If we would recall her even less
well had she never met him, we might also recall her more
for what she did in her own right. In later years she be-
came an intensely private and deeply religious woman, an
oblate. Picasso had made her into his *Weeping Woman.*
"Women are suffering machines" was his notorious re-
mark. She told the writer James Lord: "All his portraits of

me are lies. They're all Picassos. Not one is Dora Maar."
Balthus remembers her warmly: "A very interesting per-
son, very dignified."

Balthus got to know Derain and Miró, too. His portraits
of them show the one as rock-solid, the other as tender as
a sparrow. "Derain was one of the most extraordinary men
I've ever met because he was like a cloud," he says, though
this is not quite the image that his stony portrait conjures
up. "He'd change every day. He was tremendously amus-
ing. Miró was quite different. He never said a word, and
you never knew what he thought. I don't know whether

Balthus / *Joan Miró and His Daughter Dolores,* 1937–38
Oil on canvas, 51¼ x 35 in.
The Museum of Modern Art, New York

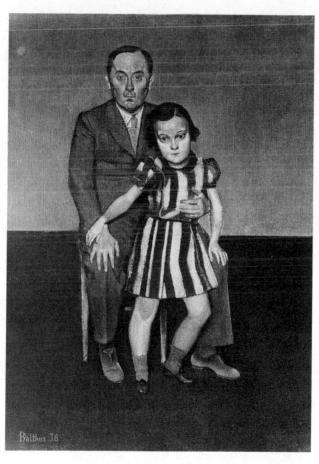

he was intelligent. He was really like a little child, with the astonished expression of a six-year-old. His earlier works I admire, the self-portrait that was like a Spanish primitive, for instance. But then I didn't like what he did very much. Picasso said to him, 'Look here, Miró, at your age, making paintings like this!' "

Like Miró, Balthus was courted by the Surrealists, but the courtship didn't last long. He wasn't the type to join a group, least of all one headed by André Breton. "I couldn't stand him," Balthus sniffs. "Did you know he was the son of a gendarme? My first break with the Surrealists came when they talked of Novalis, and I said, 'None of you know German well enough to understand Novalis and I consider you all uncultured.' And of course that was the end."

Someone else briefly in the Surrealists' orbit, but someone Balthus admired enormously, was Giacometti. The two of them, despite their dissimilar personalities, became joined by their love for the art of the past, their self-critical reluctance to regard a work as finished and their passion to represent reality in art, albeit a reality that each one conceived differently. I notice that Balthus owns a bust by Giacometti. "A woman once went to see him, and he was completely bored by her so he said, 'Sit down, madame, and I will make your portrait.' When I saw it in the studio,

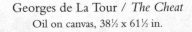

Georges de La Tour / *The Cheat*
Oil on canvas, 38½ x 61½ in.

Balthus / *The Game of Cards,* 1948–50
Oil on canvas, 55⅛ x 76¾ in. Collection Thyssen-Bornemisza, Madrid

I said, 'How beautiful,' and he said I was the first person to
think so, so he gave it to me.

"I remember we went to visit him in Stampa once,
when his mother was there." Stampa was Giacometti's
childhood home in Switzerland, to which he regularly re-
turned. "What was funny was that my parents knew the
Giacomettis, so his mother had met me as a child. But this
time I came with my wife, and Giacometti's mother asked
me if I was also Japanese."

We flip through the Louvre book, past Lorenzetti and
Sassetta, Giorgione and Mantegna, all of whom he says,
without further comment, that he admires, and I stop on
Georges de La Tour's picture of cardplayers, because it is a
subject to which Balthus, in his own paintings of cardplay-
ers, has given an especially weird, malevolent spin. He
gazes at the La Tour, admiring what he calls its abstraction.
It is true that the revival of La Tour's reputation, like Ver-
meer's, came in the modern era, after hundreds of years of
neglect, and had to do with the way his cylindric bodies

and geometric forms appealed to tastes attuned to abstraction. But what, I ask, does Balthus mean by abstraction, considering how little regard he always says he has for abstract art? He simply shrugs, so to prod him I mention that the photographer Henri Cartier-Bresson, one of Balthus's oldest friends, once told me that he could see a link between La Tour and Léger.

This causes Balthus suddenly to perk up. "Oh, my God! Léger, whom I knew very well, could never have painted this. He was very stupid. You know Gide once said nothing was more stupid than Léger. Most of the people who did abstraction were stupid. Art is a métier," Balthus declares, having worked himself into a lather again. "I don't consider myself an artist. I consider myself a worker. Unfortunately now this idea seems useless, because if you look at modern art you see that now everybody can do everything." He shakes his head in disgust. "And in fact nobody does anything."

ELIZABETH MURRAY

ontained within the curves and angled planes of Elizabeth Murray's oddly shaped, sometimes ballooning, canvases are figures and objects: hands, babies, tables, coffee cups, palettes, brushes. It can take a while to decode them. They are nominally abstracted forms in flux, props in mostly domestic dramas of a psychological intensity and tenderness sometimes belied by the jazzy, throbbing colors that Murray prefers. Her works suggest motion, fluidity. They are animated and visceral, and full of demotic shapes drawn from the comics (she thought of becoming a commercial artist when she was young). But they're also indebted to painters like Cézanne, Miró, Klee, Johns and de Kooning.

Murray is a lanky woman with frizzled white hair and a soft voice. She is solicitous but also intense in a quiet, nononsense way. At the Met, her eye arrested by one unexpected thing or another, she becomes rapt, moving back and forth while looking, so the act of seeing is physical and shifting. She talks reverently about the craft of painting and about the transformative and tactile quality of pigment on canvas.

She was born in 1940 and brought up in the Midwest. She studied art in Chicago and California, taught in Buffalo for a while and moved to New York City in 1967. At

a time when Minimalism and Conceptualism were ascendant and not many other ambitious young artists did much else, Murray rejected fashion and began to develop her own way of painting. At first it derived from Minimalism, but increasingly it gained action and narrative. By the early eighties, the art world had come around to Murray. A traveling retrospective that stopped at the Whitney Museum of American Art in 1988 was a sign that she had come to be regarded as a leading figure of her generation. Her work was used to bolster the growing fascination among younger artists with popular imagery. She was hailed as a feminist painter. But she resists easy categorization.

When she goes to the museum these days it's often with her daughters, she says, and they want to visit the decora-

Elizabeth Murray / *Stirring Still,* 1997
Oil on canvas on wood, 92 x 115 x 7 in.
Collection of the artist, courtesy of PaceWildenstein

tive arts and arms and armor sections, so this time she wants to concentrate instead on paintings that interest her, beginning with Cézanne, who inspired her work in the early 1970s, when she just was beginning to get her bearings.

"Cézanne was the first painter I saw when I was a young art student: it was like knocking on a door and hearing an answer." She is standing in a room of Cézannes in the Met's galleries of nineteenth-century European art. "I went to art school in Chicago and took your basic art history courses and I was shocked at how boring it was. There wasn't any emotion or heart or a sense of where these things came from, why people did these paintings. You're changing at that point in your life, there's all that teenage angst, and I was looking for some reason to be an artist. And then I saw a little still life by Cézanne and it was like a voice saying hello to me. There was something incredibly sensual and human in Cézanne's work. I was shocked a couple of years later when I really started to get involved with painting and took some courses with teachers in the late fifties and early sixties who had studied with Hans Hofmann, and they taught Cézanne as if he were an analytic painter and they divvied his art up into what seemed like mathematical quotients. It was horrifying to me because while Cézanne makes everything look seamless, when you start to deconstruct the image, everything becomes strange. The forms change."

Murray peruses *Rocks in the Forest,* a Cézanne from the 1890s, perhaps of the Fontainebleau forest, depicting boulders shaded by dense trees, through which a sliver of sky and plain is visible. Just below the center of the picture, among the rocks, is an almost indecipherable mass, an ambiguous passage typical of Cézanne, which Murray says "looks like a body, like some kind of torso. It's shadowy, atmospheric, but has physicality. And it's very sensuous. I think there is a fear among some people, art historians especially, of how physical a painting is, of the physicality of paint. It can be incredibly scatological, outrageous, but also

be so delicate. Cézanne's need was to speak through the paint by manipulating and transforming it, transfiguring it into these odd things. It's not some heavy process that he forces on you. I don't believe he was actually thinking about these rocks as a torso but he allowed the chaos to be there, while on another level the image remains coherent as a landscape. He was about having a physical freedom in paint, and being very open, on an unconscious level, I think, to associations, and he hit on something that's really essential for artists: allowing your unconscious to take you places you may not even want to go. This can be hard for people to understand. It's hard for them just to relax and enjoy visual things without their heads getting in the way. Cézanne starts with his head and then he lets these other things emerge.

"As artists we're all trying to figure out who we are in the world," she continues, "and it's terribly chaotic and difficult. Genet said there are things that happen to you when you're younger that provoke either so much pain or so much curiosity that you spend the rest of your life trying to figure them out, and for some people this turns them into artists. With Cézanne, he returns again and again to certain subjects, certain people and places that are nurturing—feminine really, sensual—and he slowly works out his needs and fears by painting them."

For instance, she says, "I am fascinated by what he must have thought of Hortense, and how much you can tell from looking at this picture." She is now standing in front of *Madame Cézanne in a Red Dress,* a portrait from around 1890. It shows, seated, his wife, Hortense, as a stern figure, but slightly askew, wedged between mantel, wall and curtain.

"This suggests a mixture of fear and love. She's not really sitting in the chair, and sometimes it seems as if she weighs about five hundred pounds and other times she looks like a hollow dress with arms and a head sticking out of it. You can't really tell whether she's standing or whether she's sitting because she is so stiff, though she's tilting. The

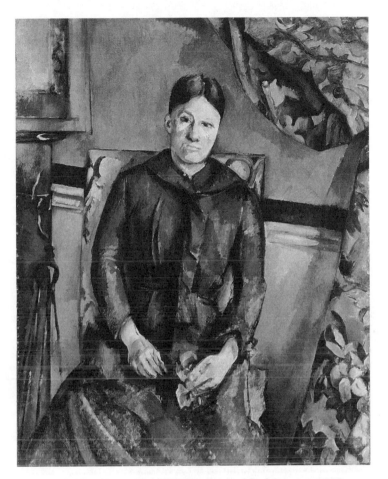

Paul Cézanne / *Madame Cézanne in a Red Dress*, c. 1890
Oil on canvas, 45⅞ x 35¼ in.
The Metropolitan Museum of Art, New York

image seems to be all about uncertainty, the deliberate way
nothing ever quite comes together. Like the hands: they're
there and not there at the same time. They're formed and
holding something, like a handkerchief or a flower, maybe,
I'm not sure, but then the longer you look the more they
decompose. From a distance you'd think those hands are
flesh-toned, but when you get up close they turn into a
multitude of different colors coming together to make this
highly abstract form."

Murray based a few of her early works on Cézanne, in-

Elizabeth Murray / *Madame Cézanne in Rocking Chair,* 1972
Oil on canvas, 35½ x 35½ in. Private collection

cluding *Madame Cézanne in Rocking Chair,* from 1972,
which involves a kind of semiabstract cartoon strip,
arranged as a grid: Madame Cézanne, a stick figure, sits be-
neath a window through which a moonbeam of speckled
yellow light falls on her. In one sequence of frames the
beam pulls her straight through the window, sci-fi style; in
another it puts her to sleep and she comically tumbles
headfirst, like Chaplin, from her chair. Murray's craziness
can bring to mind the work of other Chicago artists, like
Jim Nutt, but the painting predicts her own mature art in
various ways: its tactile surface, its narrative. One sees her
affinity for Cézanne as a painter whose work is also physi-
cal and unstable in its forms. And as in Madame Cézanne's
portrait, his subject is often domestic.

"I used to think of 'domestic' as demeaning," Murray
says. "But maybe it's what happens when you get older
and begin to relax. I've come to feel that being involved

with my family helps my work and doesn't take me away from it. It deepens the work and adds to its physicality. And I definitely relate to this portrait of Madame Cézanne on a domestic level. I mean, this is very complex stuff: clearly, Hortense is regarding her husband, not with disdain, but as if she's saying 'You old fool.' And all this emotion, this angst, this frustration is in this picture."

As with the Cézannes, Courbet's *Young Women from the Village,* a couple of galleries away, has its own spatial peculiarities, with oddly repainted cows (the pentimenti left visible) and an indefinite placement of figures. It depicts Courbet's sisters in a valley near his native Ornans. The strangeness of the scene, its quotidian women in country costumes, prompted French critics to pan the work after its exhibition at the 1852 Paris Salon.

"Courbet is really interesting to me. Definitely macho but also very deep. He is painting real life. Like these

Gustave Courbet / *Young Women from the Village* 1851–52
Oil on canvas, 76¾ x 102¾ in.
The Metropolitan Museum of Art, New York

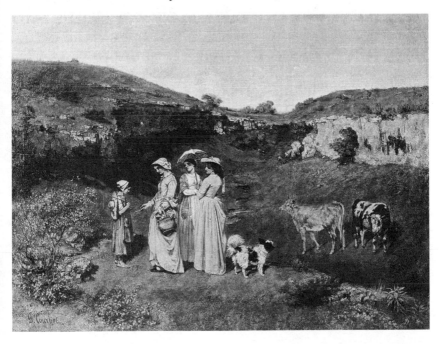

women: the girls seem kind of poky to me. Their faces are quite ordinary. But he makes you admire them because he puts this incredible light on them. Usually, his women are beautiful, very sexual. It seems to me that this man really, really enjoyed women. I have no idea if that's true but it's how it looks to me. And I like that about his paintings. Other feminists may think it's something to be criticized. That bothers me. It gender-classifies everything. It's important to see where these things, like male attitudes toward women in the nineteenth century, come from, but once you've pinpointed it, that's it. And so often these things are said to kill the work, to put a slash through it and say, 'O.K., let's never look at this again because now we know what it's about.' When I was young the question was: How does a woman who wants to be an artist in the early 1960s find her voice when her teachers and heroes are men and all the art that she admires is by men? I found the male-female thing tended to fall away the more deeply I studied their works. Courbet is a man, Picasso's a man, and they're painting naked women, and Picasso is tearing women apart. Yet I learn so much from the way he tore them apart. If I just classify the work in terms of gender, I'm denying some real love of it inside myself.

"What upsets me is the amount of art today that seems more and more conceptual, more closed, less about real life, more and more about the art world, the making of art, art strategies, for the sake of other artists. Or it's merely ideological. Courbet is a very political artist but his art doesn't seem rhetorical to me, the way so much art lately does, which you look at and it's like reading in the newspaper about some horrible thing; you say, 'This is awful,' but you're not renewed by the experience. But you look at this Courbet and you can relate to it even though his world is so distant from ours. Museums like this one can be very off-putting for people who aren't used to being in them, but there's still a common language that is accessible and unpretentious. When I bring my daughters in here and they look at a Renaissance painting, and at first they're

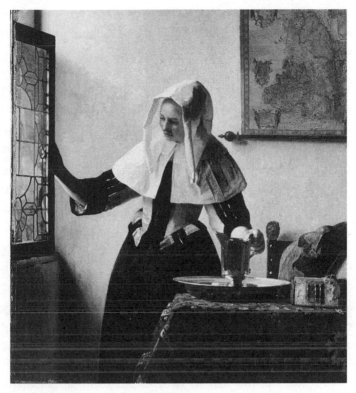

Jan Vermeer / *Young Woman with a Water Jug,* 1660s
Oil on canvas, 18 x 16 in.
The Metropolitan Museum of Art, New York

like, 'Why is this man in a cocktail dress?' But what this
Courbet or that Cézanne does is invite you into their
worlds, and when you pop out again you've got something
in your life that you didn't have before."

One of Murray's favorite pictures at the Met is Ver-
meer's *Young Woman with a Water Jug,* from the early 1660s,
a scene of ethereal silence, in which the woman holds in
one hand a shiny jug and with the other hand opens a
paned window. On the table, besides the jug, is a jewel box
with pearls and ribbons. The table is covered with a pat-
terned carpet, and on the wall hangs a map, held down by
a long blue rod. The picture is, like all Vermeer, hypnotic
and intimate, with a sense of time nearly stopped, as in a
slow-motion film, an effect that causes the ordinary to

look suddenly extraordinary: Vermeer makes an unremarkable moment when nothing much is happening gain a kind of mystical gravity. Partly it comes from the way he absents himself through the lack of visible brushstrokes, so that we seem to be looking straight through a window across time.

Murray, standing before the picture, says: "At first, I thought, How would you ever learn how to paint from looking at this? Because you can't see it happening; it's the ultimate magic of painting. But it's also about intensive labor. And the more I look at it, the more it feels to me like an act of sublime love.

"This is just a simple domestic scene but I get a very strong feeling of some meaning beyond just the facts of the oriental rug, the map, the jug. Maybe it's because of the light, which is soft but focused and very, very precise. Whatever it is, I believe that Vermeer was trying to say something about the whole world. It's something you can sense and can't quite place. And you have to look past all the magical details (which, in fact, can sometimes be annoying, you know, the way he highlights everything) and instead step back and see the entire picture, which shows this woman by a window, but as if in another world. There's maybe even a political content in the painting. I mean in his depiction of women, who have a wholeness and a humanity and a dignity. On the one hand, they are passively receiving our gaze; there's a voyeurism involved here. But they're also doing something. He seems to place women in a universe of their own and it's unlimited, even though the setting is a home and they're reading love letters or whatever. There's a kind of focus that he puts on them; they're at the center of a domestic universe."

Murray talks about Picasso's portrait of Gertrude Stein in a similar way. "I don't see it as caricature." She's in the Met's twentieth-century galleries now. "I see Picasso really grappling with how to depict this very strange, very strong, very interesting, very smart and very beautiful woman. It's an otherworldly painting: classical and remote and painted

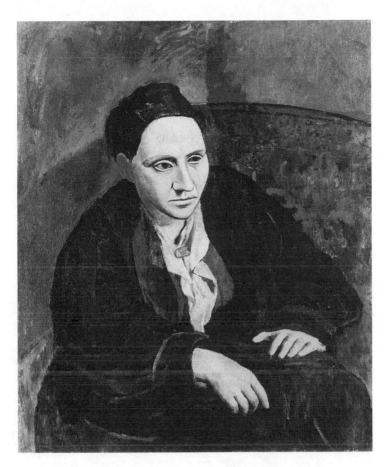

Pablo Picasso / *Gertrude Stein*, 1905–06
Oil on canvas, 39¾ x 32 in.
The Metropolitan Museum of Art, New York

in a beautiful, direct way, yet there's also that distortion of her features. She's sitting on a stool and in a room that's closing in on her, enfolding her. And at the same time, Gertrude's brutal. Her face is a mask. Yet I think he really gives her a lot of power. He obviously doesn't find Gertrude sexy. I think it's interesting to see this male painter dealing with this intellectual woman. He's fascinated. Not by her femininity, and in that sense he's not willing to deal with her as a whole person. She's in this lumpy, very asexual dress, and almost the only way you know it's a feminine face is the hair. It has this aggressive

energy. That little tonal change around the hair also makes the figure jump out.

"People always talk about the way he changed the figure, making one eye larger, and the other one smaller than it would be, and the whole African influence, as if this were an African mask. Clearly he made this creative discovery with African art. It's like the light clicked on for him. But I just can't get over the way he transformed the face and yet still made it Gertrude—it's a mask and also her face, which is what gives the image an electric power."

In the same twentieth-century gallery, Murray passes by, barely glancing at it, her own *Terrifying Terrain* (1989–90), a dense painting of reds and aquamarine, in relief, with looping strips of canvas that form something like a bow or a rolling landscape (it's illustrated on p. 122). It looks as if it's about to erupt, volcanolike. She turns her back on it to

Susan Rothenberg / *Galisteo Creek,* 1992
Oil on canvas, 112 x 148 in.
The Metropolitan Museum of Art, New York

see across the room an old friend's painting, Susan Rothenberg's *Galisteo Creek* (1992). Like Murray, Rothenberg came to prominence during the seventies and eighties as a painter linked to the so-called Neo-Expressionism that partly grew out of, but also pushed at the limits of, Minimalism. Rothenberg was in New York at the time but since 1989 she has lived in Galisteo, New Mexico, near Santa Fe. *Galisteo Creek* is a distant outlet of the Rio Grande, which runs directly behind her ranch and cuts through it—a deep, meandering gulch below a mesa where the eroded earth, layered in pink and gray stone, looks like a vast natural abstraction: the sort of abstraction that O'Keeffe made a career painting years ago. Rothenberg's art capitalizes on the vivid colors and amorphous shapes of the land. It's a conflationary kind of art, mixing various impressions over time in a way that Murray's work also does.

This painting is a big canvas covered with vigorous strokes; near the center is an ambiguous thin white form, like a tree or a figure, and swimming across its surface, like fish, are several dark, narrow shapes. The forms seem to appear and dissolve and the work is energized by its vibrant light. "What I like about Susan's work is how you always have to figure it out," Murray says. "At first it's smears of paint; then you find forms, and it's interesting to me how she gets you involved in this. You see figures, heads. You find all these different passages within the orange, like the greens, which appear, then wash away, and the pinks. She solidifies a form, then takes the solidity away. It looks free but she's very much in control, really. I especially like to talk to Susan about painting because we have a lot in common but she also thinks about things differently. For instance, when something feels wrong to me in my work, when I know viscerally that it's going to be wrong, I'll let it sit there for a while anyway because I feel it might turn into something else. But Susan's much more strict, more intellectual. She will walk away from a picture, wait until she's sure. Somehow we sort of end up in the same place.

"She inherited the legacy of the Action painters, you

know, coming out of Kline and de Kooning and Joan Mitchell." It happens that Mitchell's *La Vie en Rose,* from 1979, is nearby, a big four-panel landscapelike abstraction in purple, black, blue and white. Mitchell, American-born, became a second-generation Abstract Expressionist in the early fifties, making virtuosic pictures of subtle nervous energy, close to de Kooning's style, then moved to France in 1955 and increasingly emulated the sun-drenched palette and freedom of late Monet. Her best pictures, big and shimmering webs of coral, blue and saffron, suggested the landscape of the South of France. They have an ecstatic elegance that makes an interesting connection to Rothenberg. "You've got to respect her," Murray says, about Mitchell. "She goes all the way with it. She found herself and stuck to her guns. I'm touched, too, with the idea that here is this woman who had this amazing career. She and Grace Hartigan and Helen Frankenthaler were kind of like the dolls with the boys in the fifties. It's a superficial way of saying it, but these women had to deal with that issue, and they made very tough, strong paintings."

Like Mitchell, Philip Guston was also an Abstract Expressionist, enamored of Monet. He changed, with a kind of existential courage that bucked fashion, to become a painter of odd, cartoonish pictures that recalled his earliest, pre–Abstract Expressionist work. The images drew from a vast array of art and popular imagery, from Uccello to Crumb, and related to Guston's increasingly dark, barbed view of the world. His *Street* (1977) is typical of the late work, with its piled shoes and garbage can full of empty bottles. Hairy arms hold can lids like shields. The color is rosy and grimy at the same time, the paint viscous, like putty. Murray's work (and Rothenberg's) has always been linked to Guston's, though Murray says it took her a long time to appreciate Guston. "Maybe because it was too close to what I was doing. I think he's almost too hard for most people to deal with because his work seems so obvious. At first he was painting Abstract Expressionist pictures

Philip Guston / *The Clock,* 1956–57

Oil on canvas, 76 x 64⅛ in. The Museum of Modern Art, New York

Philip Guston / *The Street,* 1977

Oil on canvas, 69 x 110¾ in. The Metropolitan Museum of Art, New York

and then he took on this totally other character, using exactly the same soft colors and the same way of painting that he had developed before, but now with new subject matter. It turned out the whole career was preparation for singing these sad, nutty songs.

"I'm more and more drawn to stories like the ones Guston tells, and to finding ways, as he did, to paint out of abstraction, towards definable images. I hate the term 'figuration,' although the issue is about using figures. What Guston does, and it makes me mad because I wish I had gotten there first—and maybe that's why I couldn't deal with his art ten years ago—what he does is take everything, the cartoons, high art, abstraction, Abstract Expressionism, and puts it all together into funny and sad metaphors and symbols. Here you've got the garbage cans and their lids thrust out by these weird fists, as if a battle were going on. And old shrunken legs like animal legs, or spiders, and he somehow manages to take all these symbols of death and combat and make something childlike, simple and direct, and yet moving and mythical.

"He takes those greens and reds and grays and he does a lot of mixing with his whites and then he mushes them. The atmosphere is of some kind of smoky pink sky and then there are the black outlines, which are so obvious and yet so totally effective. Not that it was easy to do, because, of course, it wasn't, but it comes across as so utterly simple. Then he repeats and repeats forms in such a delightful way. He has a million ways of doing an oval." She is pointing to the lids, like Palmer method ovals, looping across the picture.

"I think a lot of the images that I've used in my work, like the shoes, didn't start with him exactly but were connected to him. As a young painter, you know, you adopt the mores of your peers, and I came to New York at a time when Conceptualism and Minimalism were dominant. And even though I couldn't think along those lines myself, I was drawn to them because I wanted to be hip too. But

it was a dead end for me, and the effect was to disguise my
interests in subject matter.

"This is the thing for me about Guston," she says, "that
in the early seventies he made this switch from abstraction,
which was very brave, because everyone said he was out of
his mind. Now I think of this switch as something quite
natural and something that begins to happen to you as you
grow and evolve and find yourself. You turn toward what
comes most naturally to you, in spite of everything. Gus-
ton couldn't help himself when he did these paintings.
And that gives me hope."

FRANCIS BACON

rancis Bacon has suggested a visit to the Victoria and Albert Museum. "If you'd like, we can see the Constables," he offers.

It is the summer of 1989. Bacon turns eighty in October, though his wide eyes, chubby cheeks, pouting mouth and tumbling mop of hair make him look boyish. He moves gingerly, but with traces of the jaunty side-to-side step that people recall from when he was young.

He has lived, for more than twenty-five years, in South Kensington, London, in a ramshackle mews house where visitors knock loudly, then cling to a rope banister while climbing the steep, narrow stairs, as on a ship. Bacon can't paint anything so large it won't fit down the steps and out the door. Someone coming to see him must maneuver past the kitchen, which includes a bathtub, into the cramped bedroom that doubles as his living room. Bacon once bought a town house by the Thames in the East End, and occasionally entertained there on a grand scale, but he claimed that the flickering light reflecting off the river and into his studio was too distracting, so he settled back here.

Naturally, he likes to be described as an artist in dialogue with masters like Michelangelo and Picasso, and, rather absurdly, denies almost any link to new art, as if to forestall the obvious comparisons. By now he must also fend off

comparisons with his own earlier self. There are times, it must be said, when he falls back on old tricks: the arrows, swinging light cords and slabs of beef are familiar devices by now, and his subjects haven't varied much over the years. Lately he has reprised *Three Studies for Figures at the Base of a Crucifixion,* the triptych that made him his name in 1945 as a master of the macabre. He still twists, mangles and X-rays the human body, making it evaporate, transmogrify and bleed. His figures huddle and struggle in windowless rooms lighted only by a dangling bulb. They vomit into sinks, or find themselves face to face with one of the Greek Furies. He pinned one figure to a bed with a hypodermic needle. And when men are engaged in sex, as they sometimes are in his paintings, they wrestle as if to the death.

It may be that he suggests looking at Constable just because it is such a perverse choice for him: Constable, the painter of fresh English pastorals, would seem a long way from Bacon, the painter of desperate, nightmarish predicaments. Maybe he likes the great limbs and rumps of Constable's animals, akin to his own muscled human figures and even to the horses he knew in his childhood, near Dublin. Maybe he finds in Constable a certain slithering, squishy eloquence, a quality of slow movement arrested— in the Victoria and Albert's *Leaping Horse,* for example— that he emulates.

He can be frank, then evasive. With an exhibitionist's enthusiasm and lots of practice he describes his fondness for alcohol and for men, his kinship with gangsters and drunks, his antipathy toward certain politicians, fashion designers and other painters. If coaxed a bit, he will tell wicked stories about being in Morocco with Paul Bowles, and also recall prowling museums with Giacometti. "He liked all the wrong pictures," Bacon says about his friend, who was, in fact, an artist of extreme insight. Friends know Bacon can be ornery and unpredictable, especially after a few drinks, but they also know him for his generosity, wit and vulnerability. He paints pictures meant to

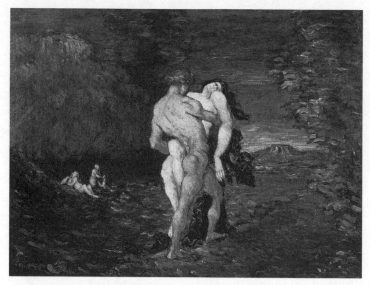

Paul Cézanne / *The Rape,* 1867
Oil on canvas, 35¼ x 45¾ in. On loan to the Fitzwilliam
Museum, University of Cambridge

alarm but in person can go out of his way to be likable and
immensely kind, a self-styled old-school gentleman.

With the passion of the self-educated, he is eager to ex-
press his views about whatever interests him, and his con-
versation is sometimes littered with dropped names:
Boulez and Sigmund Freud ("Does anyone go to analysis
anymore?" he asks with studied sincerity), Proust and
Yeats (Yeats's productivity in old age intrigues Bacon). A
recent exhibition of early Cézannes, dark, awkward and
perverse pictures, prompts enthusiastic disquisitions, until
the conversation turns to American painters, and then
Bacon becomes like a vaudevillian doing an old routine:
"He does those women, nice man, what was his name?"
was his remark about Willem de Kooning, whose raucous
Women may be too close to Bacon's work for his own
comfort. About Jackson Pollock he'd only say, untruth-
fully, "I can't see the point of those drips, and I think he
couldn't do anything else particularly well."

Subtly, Bacon manipulates a conversation so that it
never strays from topics he wants to discuss, making it

nearly impossible to get him to talk about anything else. By now he's got his patter down. Pressed about his own work, he says, "If you can talk about it, why paint it?"—an old riposte. Canned remarks let him sidestep unwanted queries.

When London's National Gallery asked him in 1985 to do the first of the "Artist's Eye" shows, in which living painters juxtapose their works with their favorites from the gallery's collection, Bacon modestly refused to include his pictures along with the fourteen he chose by Rembrandt, Raphael, Degas, Velázquez and others. He eschews most trappings of success. Though he can afford Savile Row, he has his slightly ill-fitting suits made by a neighborhood tailor to whom he remains loyal. When necessary, he reaches into his pocket, like Al Capone, for a huge roll of cash to pay off gambling debts that he still accumulates. He'll cover medical costs for a sick friend, pick up the tab at a swank restaurant or buy champagne for the crowd at the Colony Room, the rundown drinking club in Soho where he has been going, on and off, for more than forty years.

Before setting out for the Victoria and Albert, he gives a tour of his flat. In the bedroom are a simple table and chair beside the window. Four bare bulbs, hung from the ceiling, provide most of the light. A cot is tucked at the far end of the room behind several old sofas and dressers. A space heater sits in a corner. Years ago, Bacon owned paintings by the English artists W. R. Sickert and Frank Auerbach, but he gave those away. In the kitchen, next door, he has taped tattered photographs of his own works above the sink. Otherwise the walls are bare. "I can't live with pictures," he explains.

After a while he volunteers a peek at the studio, reluctantly. Typical of him, he is open and jovial one minute, reticent the next. The studio is opposite the kitchen, shaped like the bedroom but with a skylight, which he installed some years ago. It is, even more than many artists' studios, a mess. Aged paint tubes, discarded rags, brushes, papers and dust (he has used the dust in paintings of sand

dunes) have accumulated over two decades and been swept into waist-high piles around the floor. "I once bought a beautiful studio round the corner in Roland Gardens with the most perfect light, and I did it up so well, with carpets and curtains and everything, that I absolutely couldn't work in it," Bacon recalled. "I was absolutely castrated in the place. That was because I had done it up so well that I hadn't got the chaos." He jokes that the closest he ever comes to abstract painting is on the walls of his studio, which he uses as a palette. They are covered with multi-colored daubs. On an easel is a small portrait of his friend and, for the last several years, frequent subject, John Edwards, but other canvases are turned to the wall, and he declines to show them. "There's nothing on them," he says. Lingering in the doorway, he looks anxious to leave, and after a minute or two slips a leather jacket over his turtleneck sweater, eases himself down the front steps and sets off toward the Victoria and Albert.

—

In April 1945, Bacon exhibited *Three Studies for Figures at the Base of a Crucifixion* at the Lefevre Gallery in London. Bacon's trio of half-human, half-animal creatures, mutilated and eyeless, necks elongated and teeth bared, were perched on tables or pedestals in rooms with vague, fun-house proportions. They were grotesques, angrily drawn and akin to certain Picassos of the thirties, or maybe to German painting of the Weimar years. But nothing precisely like the *Three Studies* had been done by an English painter before, and Bacon was quickly praised for having captured the particular claustrophobia of postwar England, when art in Britain, like so much else, seemed in a state of exhaustion. People who went to the Lefevre Gallery may not have liked what they saw, but they didn't easily forget it.

During the next decades Bacon developed his repertory of screaming popes, butchered carcasses and blurry faces (blurry but always, uncannily, recognizable as portraits),

Francis Bacon / *Three Studies for Figures
at the Base of a Crucifixion,* c. 1944
Oil on board, each panel 37 x 29 in. Tate Gallery, London

which have made critics call him, variously, a Surrealist, an Expressionist and a sensationalist. He repeatedly says he is simply a realist, that he doesn't paint to shock. "What is called Surrealism has gone through art at all times," he says. "What is more surreal than Aeschylus?" He maintains that he is just trying to reproduce as faithfully as possible what his friend Michel Leiris calls the sheer fact of existence. Bacon is fond of saying "You can't be more horrific than life itself."

It is no wonder that private collectors have not exactly stood in line to buy his art, which is more popular in France, Italy and Germany than in Britain. Even the poet Stephen Spender, one of his old friends, told me that he wanted to hang a painting by Bacon in his house but his family wouldn't let him. Margaret Thatcher, speaking for a nation of bourgeois voters, once described Bacon as "that man who paints those dreadful pictures." In the film *Batman,* the only painting in Gotham City's Flugelheim Museum that Jack Nicholson's Joker prevented his henchmen from destroying was a Bacon.

As to American views of Bacon, David Sylvester, the English critic, Bacon's friend and author of a book of interviews with him, speculates that "Americans have tended to measure him against de Kooning and find him less good." Spender agrees: "American artists provide for Americans a foreground of activity that they can't see beyond." Another view is held by Lawrence Gowing, the English painter and historian. "American Abstract Expressionist taste was buoyed up by a solid optimism and a feeling that painting was getting better, that a way was opening to something fruitful. But Bacon's painting is rather tragic, and his whole work is an overt criticism of abstract art."

There is also a tendency among Americans, puritanical by tradition, to see art in moral terms, and as Nikos Stangos, a friend of Bacon's, says, "Francis has never expressed moral indignation about anything."

That said, few modern museums in America or elsewhere don't own or covet a Bacon, and accordingly

Bacon's work has generally gotten bigger and, perhaps, slicker, as if made for museums. Gowing describes the late pictures, even the ones violent in terms of subject matter, as "classically serene," and it's true that the second, enlarged version of *Three Studies* has what might be described as an ambiguity that comes from its softening of the original monstrous forms. It looks like a memory of the earlier triptych, vivid but less tactile. Few artists have made flesh so weirdly voluptuous. The word "shocking" is a cliché to describe Bacon's art. Actually it can be suave, to the point of a certain preciosity. He insists that his paintings be hung in gold frames behind glass to impart an evenness and sheen to the unvarnished canvases, which also makes them somehow decorous. Bacon seems to relish this sort of paradox, in art and life. He may depict two Michelangelesque nudes thrashing on a bed, but then shrouds the details behind veils of paint.

—

Born in 1909, the son of a racehorse trainer (and a collateral descendant of the eponymous Elizabethan philosopher), Bacon moved with his family between Dublin and London during his early years. He was the second of five children. He never got along with his parents. Asthma made school a problem, so he was tutored by clergymen at home, where he was otherwise left to his own devices, which involved what his father, a disciplinarian with a gambling habit, considered behavior so outrageous— Bacon had sex with the grooms at the stables, then was caught trying on his mother's underwear—that the elder Bacon banished him from the house. At sixteen, Bacon left for London, then the next year, 1926, went to Berlin. There he spent nights in transvestite bars and endless hours with the sort of rough-and-tumble characters to whom he would always gravitate.

"Berlin was a very violent place—emotionally violent, not physically—and that certainly had its effect on me," Bacon recalls. We are on the way to the Victoria and Al-

bert. "I wasn't the slightest bit interested in art until about 1930. I lived a very indolent life. I was absolutely free. I drifted for years, but you know, when you're young, there are always people who want to help." In Paris, later in 1926, he saw a show of Picasso's paintings of bathers. Over the years he has given various accounts of how much this particular exhibition affected him, but certainly he gained in France a general notion of what it was to be an artist and lead a bohemian's life. Not by chance, even now, he cultivates an image of himself as someone unconcerned with the trappings of success or with bourgeois mores.

He returned to London in 1929 and for a while designed furniture, earning a minor reputation for being innovative, though he dismisses what he did as "horrid" and "ghastly." A Cubist-inspired pattern for a rug, one of the few existing examples of his designs, suggests his interest in Picasso. He came to consider the paintings from the same years, his first, to be so awful that he painted over them and bought back the ones he had sold. But he was in a group show in 1933, the year Herbert Read reproduced his *Crucifixion* in the book *Art Now*. The next year, Bacon had a solo show, and in 1937 he was in an exhibition at Agnew's gallery.

Then he stopped showing until after the war, evidently lackadaisical about his career, if not totally indifferent to it. He had never had formal art training, and even when he began to teach himself to paint during the thirties it seems to have been, among other things, a distraction from drinking, gambling and wandering the fringes of London society. "Bacon before 1939," wrote John Russell in a monograph on the artist, was "Marginal Man personified." And he was marginal man for some years after 1939 as well: when World War II began, he was summoned by the army for a physical. He hired a dog from Harrods and took it home with him the night before the exam. Dogs, like horses, gave him asthma. He was rejected by the army, and ended up doing odd jobs for several years during the war. He was a house servant, a valet, a secretary.

Not until 1944, at thirty-five, when he began to work on *Three Studies for Figures at the Base of a Crucifixion,* did his career as a painter really start, at which time the years in Dublin, Berlin and Paris and in London during some of its grimmest days finally made their mark: the restlessness, sexual indiscretions, frustration and claustrophobia he had felt as a boy, along with the flouting of social convention and calculated lack of concern for what others thought— all these became features of his work. He realized that painting was the way to make order out of a disorderly life and translate what he called his obsessions into concrete images.

—

Having arrived at the Victoria and Albert, he marches down one of the cavernous halls, looking for an elevator to the Constables, but quickly gets lost, asks for directions, takes another wrong turn and loses his way again. The route takes him past pottery, raincoats (a Burberry's display), medieval wood carvings and jewelry, and in each case he stops to look. He can become as deeply intrigued by a chair as by a Turner—the legacy of his days as a designer—and his paintings sometimes allude to modern furniture, advertisements and the latest fashions.

Finally he stumbles upon the elevator to the Constables. "These are pictures I could live with," he says, bounding toward the great sketches for *The Hay Wain* and *The Leaping Horse.* Although he spent a part of his youth in the Irish countryside, he has painted few landscapes, but it's not what Constable paints as much as how he paints that matters to Bacon: "freely," he says, and with "tremendous spontaneity. I know that in my own work the best things just happen—images that I hadn't anticipated. We don't know what the unconscious is, but every so often something wells up in us. It sounds pompous nowadays to talk about the unconscious, so maybe it's better to say 'chance.' I believe in a deeply ordered chaos and in the rules of chance."

John Constable / *Hampstead Heath, Looking to
Harrow, Stormy Sunset,* 1822
Oil on paper, 6⅜ x 12 in. Victoria & Albert Museum, London

He noses up to the small studies by Constable, some the
size of a paperback, of clouds, water meadows and other
rural vistas, fresh, pure, briskly painted, some of them
nearly abstract. Bacon never makes preliminary drawings
but works direct on unprimed canvas, where a wayward
stroke can't easily be disguised. On at least one occasion he
has tossed a bucket of paint across the canvas as a provoca-
tion to himself—and just to see what happens. "I have to
hope that my instincts will do the right thing," he says,
"because I can't erase what I have done. And if I drew
something first, then my paintings would be illustrations of
drawings." Another favorite phrase of his, which he says in
front of Constable's clouds, is that his own pictures "are a
shorthand of sensation."

This is one reason why photographs have always been a
source for Bacon. For portraits, he dispenses with a sitter
and relies on photographs and his memory (and paints only
friends who he says won't be offended to see him maneu-
vering and rearranging their faces). Many of his ideas have
come from the newspaper and magazine photographs that
he collects, and also from the famous sequential pho-
tographs of prancing animals and wrestling men that Ead-
weard Muybridge took during the last quarter of the

Eadweard Muybridge / *Wrestling, Graeco-Roman,* 1887
Photogravure, 7 x 17⅞ in. The New York Public Library

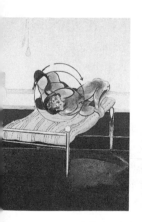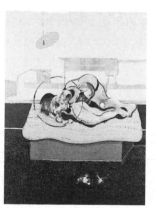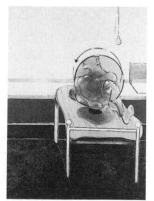

Francis Bacon / *Three Studies of Figures on Beds,* 1972
Oil and pastel on canvas, each panel 78 x 58 in. Private collection

Diego Rodríguez Velázquez, *Pope Innocent X*, 1650
Oil on canvas, 55 x 45¼ in. Galleria Doria Pamphili, Rome

nineteenth century. In the twisting movements of Muybridge's figures, Bacon sees a repertory of images at once startling and commonplace, and it is this impression of something unposed and true to life that he says he wants to get across in his own work.

Bacon has also picked up ideas from paintings by van Gogh, films by Buñuel and poems by Eliot. During the fifties, famously, he combined references to Velázquez's *Portrait of Pope Innocent X* with a still photograph of a screaming nurse from Sergei Eisenstein's *Battleship Potemkin* to invent his screaming popes, whose fame he now finds tedious. "Those references," to Velázquez and

Eisenstein, he says, "were just mental starting points, armatures on which to hang the pictures. Actually, I hate those popes because I think the Velázquez is such a superb image that it was silly of me to use it." Bacon, curiously, has said that he never actually went to see the Velázquez when he was, for a while, staying in Rome, that he has studied it only in reproductions, which is hard to imagine, though like all private articles of faith, it is perhaps as good as true if he believes it himself.

When Constable's work was first shown in Paris he became a hero to the French Romantics, who recognized a

Francis Bacon / *Number VII from Eight Studies for a Portrait,* 1953
Oil on linen, 60 x 46¼ in. The Museum of Modern Art, New York

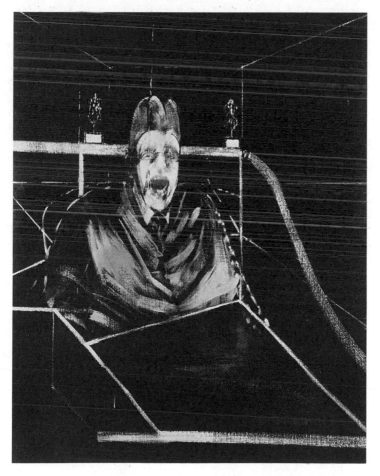

freedom and a quality of nature unbridled in some of his pictures. A few of the ones done after his wife's death, in particular, express a certain subterranean rage. Bacon likes these works for their subtle drama, which in his own art, and life, is more a kind of grand theatricality. Between 1971 and 1974 he did a series of triptychs showing George Dyer. Dyer, a depressive and a heavy drinker, who committed suicide in the lavatory of a hotel room in Paris in 1971, at thirty-seven, two days before Bacon's retrospective at the Grand Palais opened, had been the artist's lover for years. Bacon's account is that they met when Dyer broke into his house one night and Bacon simply commanded Dyer to undress and lie beside him. Their long, sensuous relationship was also beset by two other suicide attempts and a widening gap between their social circles. Bacon insists that his paintings are never about anything in particular and compares his triptychs to mug shots of a suspect's face and profiles. But the ones of Dyer are dark and transparent meditations on love and death.

Naked or almost naked, he is shown slumped on the toilet, retching into a sink, or slouching in a chair. He is half-asleep or in a stupor. Parts of his limbs and chest are invariably missing, as if evaporated. He is depicted as a fallen runner, and as a ghostly figure on a landing outside a door. In many of the scenes he is alone and in the sort of bare, windowless room that is a trademark of Bacon's work but in this case evokes the hotel where Dyer died. The flesh shifts from roseate to ashen—it is both voluptuous and deathly—and in several scenes Dyer casts a pink shadow that does not conform precisely to the shape of his body but resembles a thick pool of liquid or a spectral presence, like a version of the beastly Furies Bacon later painted in a triptych based on the Oresteia.

Perhaps the most memorable of the scenes, the centerpiece of *Triptych—August 1972,* represents Dyer as hardly more than a lumpy, oozing form, his face obliterated, his body prone across a blackened doorway. There is something of Muybridge in this twisted, fleshy figure, some-

thing, as well, of the eradicated emperor in Manet's *Execution of Maximilian,* which was, as it happens, among the other works Bacon chose to include in the "Artist's Eye" exhibition. To conceive figures at once corporeal and ghostly, sensual and morbid, beautiful and horrific, is to grasp Bacon's paradoxical aim as a figure painter. The triptychs of Dyer are what he means when he describes himself as a realist because they illustrate, in his familiar words, "the brutality of fact."

By now it is late afternoon and Bacon has had nothing to drink, so he quits the Constables for the Colony Room, where he says he hasn't been in some time. A small, oddly shaped and claustrophobic den—not unlike many of the rooms in Bacon's paintings—it is almost impossible to find from the street; one enters through an unmarked door beside a Soho restaurant. Photographs and caricatures of the owners and patrons hang haphazardly on dark green walls. Bacon likes to call the place "a concentration of camp." A dozen people are hanging out, getting drunk. They greet him warmly. It is another old performance for Bacon. He buys drinks all around, and orders for himself a bottle of champagne, then another.

"Old age is a disease, a desert, because all of one's friends die," he says. The only faith he claims to have is in the power of paint. "I am an optimist, but about nothing"—another favorite phrase—"it's just my nature to be optimistic." He stops to polish off a last drop of champagne in his glass. "We live, we die and that's it, don't you think?"

RICHARD SERRA

W hen I come here I look at one thing and then leave," says the sculptor Richard Serra, intense and determined, as always. He wants to see Jackson Pollock's big drip painting of 1950, *Autumn Rhythm,* at the Met, and then more Pollocks at the Museum of Modern Art. Serra remembers bringing his students from the School of Visual Arts to the Met in the late sixties and early seventies: "We would decide, arbitrarily, to see Room Thirty-four, or whatever. We would walk around it for five or six minutes, take a vote about which work in it we liked the best, then stand in front of the work and clap. The exercise forced the students to visit rooms they probably would never have gone to otherwise. At the same time, the clapping broke the sanctity of the museum, which I think was good, and it returned students to the joy of looking and making distinctions. There's so much in society bombarding us every day that you get used to a certain selective inattention. Here you're supposed to discriminate but the museum is actually working against this. It dissipates the amount of attention you give to any one object unless you really come with a directed idea and say, 'I want to focus on this painting and really see it.' So you have to find a way of isolating yourself to make value judgments."

Richard Serra / *Tilted Arc,* 1981
Weatherproof steel, 12 ft. x 120 ft. x 2½ in.
Installed Federal Plaza, New York; destroyed 3/15/89

Since Serra came onto the scene thirty-odd years ago, with works made of torn and bent rubber, and with lead that he splashed, rolled or propped up in big sheets one against another, he has become one of the major sculptors of his generation, certainly the most provocative one. Many Americans know him for *Tilted Arc,* the 120-foot-long, 12-foot-high slab of curved steel installed in 1981 at Federal Plaza in lower Manhattan, which caused a furious debate about public sculpture; the debate continued to rage even after the work was removed in 1989, over wide-spread objections by artists and many others. It left Serra

embittered and angry. Opponents of *Tilted Arc,* including the office workers who had to cope with it every day, attacked it as aggressive and obdurate, and regarded the art world's defense of it as a kind of armchair arrogance. Some commentators likened the aggressiveness to Serra's personality. He is famously opinionated and articulate, and in conversation may talk straight over you to make his point, but he also relishes debate. The pleasure he takes in looking at art is palpable, his feelings always unmistakable.

What he values about Pollock includes various qualities he acknowledges in himself: the sense of a solitary and singular accomplishment; the joy of making the art, which is sometimes overlooked because of the difficulty of the work; the premium on invention and decisiveness. Arriving at *Autumn Rhythm,* he immediately attacks an earlier Pollock nearby, *Pasiphaë,* of 1943, for its equivocation. It is a dense, predrip abstraction of a recumbent figure flanked, or guarded, by standing figures. "It's watered-down Picasso. The issue at the time was: How do we Americans break with European tradition and get away from post-Cubism? And this painting falls back on the usual setup for a traditional painting. Its brutishness doesn't sustain it. It's clumsily drawn. It's neither fish nor fowl: a mishmash of bad figuration coupled with an abstract surface patterning that Pollock half-digested from Picasso's *Girl Before a Mirror.*" He is referring to the 1932 Picasso in the Modern's collection, with its mirrored image of a woman set against a brilliant patterned backdrop.

"On the other hand," says Serra, now turning to *Autumn Rhythm,* "the traditional notion of patterning is gone here. Pollock has rid himself of figuration, meaning lines that enclose or contain or describe shapes. He put his canvases on the floor, came at them from all sides, throwing and pouring paint, hitting the canvas with sticks, letting gravity take over the splatters. His renunciation of the brush means you can't apply the standard criteria to this picture that you do to all those that came before it. Pollock's not playing the same game as Vermeer anymore. We

Jackson Pollock / *Pasiphaë,* 1943
Oil on canvas, 56⅛ x 96 in. The Metropolitan Museum of Art, New York

Pablo Picasso / *Girl Before a Mirror,* 1932
Oil on canvas, 64 x 51⅛ in. The Museum of Modern Art, New York

evaluate artists by how much they are able to rid themselves of convention, to change history. Well, I don't know of anyone since Pollock who has altered the form or the language of painting as much as he did. And that was, what, almost half a century ago? He had to have remarkable faith that the process would lead to fully realized statements. After all, he didn't know where he would end up when he started. With a painting like *Pasiphaë,* it's obvious that there was an original intention. But with *Autumn Rhythm,* Pollock allowed the form to emerge out of the materials and out of the process. For me, as a student, this idea of allowing the form to emerge out of the process was incredibly important."

Serra was born in San Francisco in 1939. He studied English at the University of California at Berkeley and at Santa Barbara, while working in steel mills to earn a living; then he went east to study painting at Yale. There he came into contact with New York School painters like Philip Guston and younger artists like Frank Stella, and helped to edit Josef Albers's famous book *The Interaction of Color,* which is intriguing because of his often stated, though not altogether believable, disinterest in the colors of his own

Jackson Pollock / *Autumn Rhythm,* 1950
Oil on canvas, 105 x 207 in. The Metropolitan Museum of Art, New York

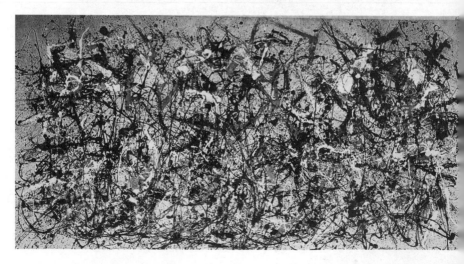

steel sculptures. He got his degree in 1964 and spent the next year in Paris. Serra would draw during the day and at night go with the composer Philip Glass, a friend, to La Coupole just to watch his hero, the sculptor Alberto Giacometti, eat dinner.

He moved to New York in 1966. "I remember when I first came here, there was a warehouse emptying out some rubber and I asked if I could cart away as much of it as I could carry. I got Phil Glass and a couple of other people to help, and we moved the rubber to my loft. I cut it and bent it and punched holes through it. I tied it together and made pieces that hung along the wall. And when I was done, I realized the works were clearly related to Pollock's *Mural* in Iowa." The painting by Pollock, belonging to the University of Iowa, was done in 1943 for Peggy Guggenheim. It is an abstraction whose sequence of twisting, interlaced shapes, almost like figures, are obvious precedents for Serra's rubber *Belts* of 1966–67. Lately, Serra has revisited the ideas raised in early rubber pieces like *Belts* and *To Lift* by, as it were, melding their fluid, draping forms to his enclosing, space-defining steel works like *Circuit* and *Terminal* of the seventies. The results include his *Torqued Ellipses,* of 1997, enveloping steel walls shaped into twisting ovals, feats of industrial technology that required the help of a shipyard and rolling mill in Maryland with a machine from World War II designed for making battleships, one of the few in existence equipped to bend sixteen-foot steel plates to his requirements. This fact is noteworthy, among other reasons, because with the *Torqued Ellipses* Serra, like Pollock, was testing new procedures to make new forms: the dripped line was the new form in Pollock's case, the twisting, enclosed steel volume in Serra's.

"Pollock made something never seen before that we now know of as a Pollock painting, an interlacing, tumbleweed creation that exists in a space unlike any other. Maybe if you enlarged a fragment of a Monet you might have something like it. But not quite." Tumbleweeds, I mention to Serra, bring to mind Cy Twombly's paintings of the

Richard Serra / *Belts*, 1966–67
Vulcanized rubber and neon tubing, 7 ft. x 24 ft. x 20 in.
Solomon R. Guggenheim Museum, New York

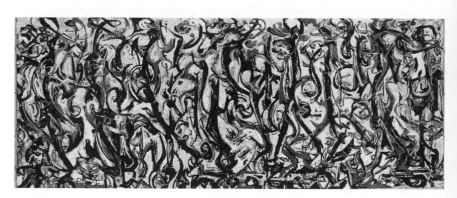

Jackson Pollock / *Mural*, 1943
Oil on canvas, 8 ft. ¼ in. x 19 ft. 10 in.
The University of Iowa Museum of Art

early 1970s that look like blackboards scrawled with Palmer method ovals, or with tumbleweeds. "But Twombly had a very definite notion of reproducing handwriting," Serra says. "If Pollock is handwriting, it's handwriting like I've never seen before. The Twomblys I find interesting are the ones in which he tackles a giant canvas with a hard pencil and crayon, in which, like Pollock, he goes for a heroic statement, but with little ideograms. I find the vulnerability of Twombly's heroicism compelling." An abstraction nearby by Bradley Walker Tomlin, Pollock's near contemporary, gives Serra another point of comparison: "It's like going from the art museum to the Kmart when you move from the Pollock to the Tomlin. The pattern in the Tomlin is so flatfooted and sterile. It's decorative. Decorativeness is a tradition in American painting, and it has produced mediocre art and also great art. Joseph Cornell used a certain decoration to pull off his fantasies. Jasper Johns's terrific *Flag* paintings are, in some ways, decorative. Decoration means pattern, geometry and repetition as the content of a work. Pollock's intention wasn't to decorate, to pattern, to use a repetitive model."

Serra talks energetically, the sentences tumbling out, and he moves restlessly up to and back from *Autumn Rhythm*, like someone trying to choose the right seat in a movie theater. He talks in spurts, in between peering and gesturing at the picture, mimicking its swirling shapes with his hands. It's not surprising that he attracts a crowd, which discreetly listens as he points to the various cadences of the work's looping lines, puzzles over which parts of the picture Pollock may have painted first and which parts last and marvels at the oddness of the palette. "Everyone at the time pointed to Pollock's weakness as a colorist. I find that extraordinary. Who ever painted in these colors? He invented his own colors." They are, in fact, a little like Serra's own, in that they derive from industrial materials (in Pollock's case, house paints) that have a raw beauty, unconventional, even unintended.

"I don't think it's wrong to talk about the organic qual-

ity of Pollock's line, with its swirls and rope-laden spatters," Serra continues. "It points to a likeness to nature without being depictive or illustrative of nature. It seems to me to be soaked, just as nature is soaked. It has a wetness and it's formed the way nature is formed, not analytically like a Cubist picture or a Mondrian, but organically."

The analogy with nature, or landscape, harks back to traditional views of the drip paintings from the 1950s, as does, in general, Serra's image of Pollock. Serra has a reputation for progressive politics, but he has always separated his political beliefs from his artistic ones. At one point he says: "What Pollock was confronting was the orthodoxy of a kind of regionalism, meaning the work of artists like his teacher Thomas Hart Benton. And in some sense, multiculturalism, while not being exactly regionalism, seems to me to suffer from the same provincial attitude that regionalism did." At another point he says: "Gender analysis knocks all the notions traditionally associated with Pollock. There may be a lot of reasons to crucify bombastic, overblown art. But Pollock is not bombastic or overblown. And when critics today use words like 'male' and 'heroic' as knee-jerk putdowns, that doesn't seem to me to have anything to do with really seeing and analyzing the work. If I sound elitist, it's O.K. by me. Some things are better than others. Picasso is better than Dubuffet; Pollock is better than Tomlin. We know that."

He notices nearby at the Met a pair of Barnett Newmans. "My own work is even more related to Newman than to Pollock, although I have more admiration for Pollock because I admire what I lack," he says. Newman, like Pollock, is important to him because while Pollock's technique of painting on the floor helped pave the way for Serra's early floor pieces, Newman's big paintings of blocks of color divided by lines, or "zips," did no less for Serra's later steel sculptures, which involve large shapes that divide and redefine the spaces they're in. Like Newman's paintings, Serra's sculptures invite a viewer to walk across them, to experience them not in a single glance but

over time, physically. "Newman gives you this physical sense of time and space and location. That's why you get nothing from photographic reproductions. They're reduced to decorations, like Mondrians."

Concord, of 1949, is a greenish Newman with a loosely painted, dusky stripe down the center that Serra considers too "theatrical." About his own sculptures he often says, not always convincingly, that he doesn't care at all about their surfaces—not just what color they are but also the quality of their finish—as if an attention to surface implied superficiality; what matters to him, he says, are the basics of space, mass, gravity and so on. The drama comes from their size, material, weight and form, so it's not surprising that he reacts to these Newmans according to more or less antidecorative principles, or that he prefers *Shimmer Bright,* of 1968, a hard-edged painting of adjacent strips of flat color, precisely because "it's about dividing and placing

Barnett Newman / *Shimmer Bright,* 1968
Oil on canvas, 72 x 84⅛ in. The Metropolitan Museum of Art, New York

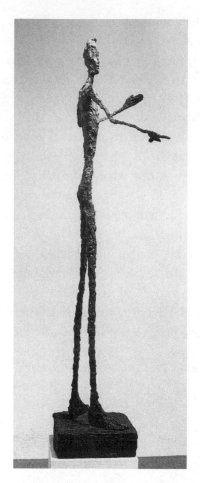

Alberto Giacometti / *Man Pointing,* 1947
Bronze, 70½ x 40¾ x 16⅜ in.
The Museum of Modern Art, New York

spaces next to one another, not about illusionism. I like
Newman's paintings when they're even larger than this.
They're great when you have to walk by them and im-
merse yourself in the divisions of their spaces," he reiter-
ates. "Then time becomes a factor: the physical time it
takes you to see it and walk across it."

Truth to materials, abhorrence of melodrama, scale as a
physical force: these are criteria by which Serra judges var-
ious artists. At the Modern, about Dubuffet, for instance,
he complains about "a kind of primitivism that rings false

because it's too calculated in terms of its schmaltz. There
are some drawings by him I like and some works with
sand. But they also involve a use of materials for materials'
sake, which adds up to decor. I know Pollock was taken
with the materiality of some Dubuffets, but Dubuffet has
always left me at the level of cartooning."

By contrast, a Giacometti he says is "as good as it gets. I
have a hard time talking about sculpture, but for me this is
where it's at because it resonates back to something very
essential and primitive in form-making. If someone told
you this sculpture was ten centuries old you'd believe it
and say it was great."

He also declares Matisse's sculpture *La Serpentine,* of
1909, "one of the very best works of the twentieth cen-
tury. Can you give me another example of figurative sculp-
ture that has followed it in terms of suggesting open
vertical volume? It's a kind of work I know I could never
do." Nonetheless, lately Serra has done *Snake,* a giant steel
sculpture for the Guggenheim Museum in Bilbao, which
can bring to mind Matisse's curvaceous form.

Most surprising, perhaps, is how he is struck by the
German painter Gerhard Richter's cycle of blurry black-
and-white images from the late 1980s, fifteen paintings
based on the deaths of members of the West German Red
Army Faction, the so-called Baader-Meinhof gang, in
Stammheim prison in 1977. Politics aside, maybe it is be-
cause they are matter-of-fact, therefore coolly untheatri-
cal, images. "I don't think there's an American painter
alive who could tackle this subject matter, and get this
much feeling into it in this dispassionate way," Serra says.
He compares one Richter image of a dead gang member
to Goya, then to late Rembrandt (see the illustration on
p. 121): "At the end, Rembrandt painted himself as meat.
It was about him confronting his own mortality, and the
paintings became smelly and foul and really great. These
paintings aren't like late Rembrandts, exactly, but they're
disturbing in a way the Rembrandts are. There's a despair
in them. And both the Richters and the late Rembrandts

Gerhard Richter / *Man Shot Down (1) from October 18, 1977*
Oil on canvas, 39½ x 55¼ in.
The Museum of Modern Art, New York

are about people recognizing their own solitude through the paintings, which is what we respond to in them."

Serra heads toward the room of Pollocks at the Modern. Earlier in the day a Met docent, talking about Pollock's drip paintings, said they could be turned any which way, that there's no up or down to them. Serra found the idea ridiculous: "I think after Pollock finished the painting he entered into an analysis of it and it was inevitable that anyone who did this would decide on some kind of Gestalt configuration—up, down, right, left—as he did. But what strikes me as amazing is how he could lay canvas on the floor and make a painting without fully seeing it until he put it up on the wall. I think for Pollock, having grown up with Benton, and having enormous admiration for Miró, Picasso, Siqueiros, turning his back on that entire easel tradition must have made him feel uncertain, and probably he wanted to hold on to some parasitic notion of history, as a kind of lifesaver: seeing a painting as having a top and bottom is a link to history. One can only project that even he

couldn't quite comprehend the extent of what he had done here, he didn't have enough perspective."

At the Modern, *Echo* (*No. 25, 1951*) is an image of black enamel on canvas in which Pollock verges on reintroducing figures after having eliminated them in earlier drip paintings. "Clement Greenberg said Pollock was finished because he returned to the figure," says Serra, referring to the critic. "But I don't buy it. In terms of sheer drawing, this picture is great. Pollock has learned to use the drip and the stick and to make a kind of drawing that is his alone, unlike what he was doing in that early work." Serra means *Pasiphaë*. "If he wants now to turn his drawing into a head or a limb, I'm not going to quibble with

Jackson Pollock / *Echo (No. 25, 1951),* 1951
Enamel on unprimed canvas, 91¾ x 86 in.
The Museum of Modern Art, New York

him. The strange thing about a Pollock painting is that as much as you think it is masking or veiling the figure, and as much as we can say that he has liberated line and made shapes that are just optical mists in front of our eyes, it's hard not to imagine figures in them. It's just something we do, not literally to see figures, but to see any line as representing a figure, because that's what a line does."

He becomes riveted by the big central picture in the room, *One (No. 31, 1950)*. He notices the rhythm of the spun-sugar lines, the way, as he steps back from it, the mass of lines begins to separate into discrete parts, with the whites becoming openings, or recessions, and the blacks seeming to push forward. Serra likes the playfulness and movement in the work. "*Autumn Rhythm* is not one of the dense Pollock drip paintings," Serra says, by way of comparison. "It's less soul-searching, more open, freer and more confident than a work like this. But *One* is a much better painting, no doubt about it, because it's more about struggle and much denser. It's not about vegetation. It's more about an Impressionist field, a kind of dizzying opticality. Something about this painting, looking at it up close, actually makes me sick." He laughs. "But I mean it in a good way. What you see here is what you seldom see in American painting: an exuberance in the act of making, in the sheer pleasure of playing with materials. No matter how aggressive you think Pollock is, no matter how much you think his work repudiates what came before it, you can't help but sense this joy in his work.

"Every artist is born into the scene at some point in time, and if these are the pictures you saw in your twenties, as I did, it's hard not to have some reverence for them. For me, looking at this painting, and I'm sure this is not true for other people, but for me America has never reached the fulfillment of this aspiration."

KIKI SMITH

The way Kiki Smith zigzags briskly through the Met, from African puppets to Byzantine weights to Central European glassware, you can't be certain where she's headed, or what she'll say. For example, when she picks out an unprepossessing eighteenth-century chair in one of the European furniture rooms it is to remark that, of all things, she finds it sexy, though pointedly she regards a sculpture by Rodin of a splay-legged nude purely as an abstraction.

"Do I care about the image itself? Sometimes. But the formal decisions that an artist makes are what turn me on the most. What's really exciting is when I can't figure out why an artist has made certain formal decisions but I know that they're interesting. That's frustrating and also kind of thrilling."

Of the generation that came to prominence in the late eighties and early nineties, Smith has gained a reputation especially for her graphic and sometimes strangely poetic depictions of bodies. She has also, less graphically, drawn deer, in vaporous lines on sheets of fine English and Japanese papers. She has cast doilies in bronze and coated them with vanishingly thin layers of silver and palladium, which flutter, like snowflakes, in the slightest breeze. Lately she has mapped the moon on a wall-sized grid of thin glass

panels and also made glass bird's nests, delicate, like Fabergé eggs.

With a cloud of long, wavy black hair and porcelain features pierced by a few decorative rings, Smith, in the obligatory all-black outfit of the art world, looks like the hippie she jokingly calls herself (she uses phrases like "super groovy"). She has a high-pitched, singsong way of speaking that's deceptively childlike. She's clever, a little coy, self-deprecating and quick to laugh.

She is also the perfect illustration of how an artist, as opposed to an art historian, talks about art, because she freely says what comes to her mind, without worrying about whether it's historically germane. This means that she occasionally makes interpretive leaps, between old art and works by living artists, for example, that can be a little baffling without a handle on her linking themes. One of these links is that art is akin to the human body, even art that doesn't have anything to do with figuration. In fact, much art in the museum is actually like a body to her, alive. A metal incense burner in the Islamic galleries, for example, is "a massive form, but with a lacy surface that opens up the mass, like a human body with skin. After all, skin is really a lacy surface, it's porous, like a big net, even though we perceive it as solid." She says that an eighteen-foot red velvet cloth, embroidered in gold with images of poppies and trees and once used to decorate a Mughal tent, is also like "a skin." Most of her own works on paper, she adds, "come from looking at Moroccan and Islamic wall tapestries, and these hangings were particularly big influences on my wall drawings, which I think of as blankets or protections for a wall."

Likewise, perusing some delicate ancient South American earrings and pendants at the Met, she imagines them trembling slightly from vibrations in the room, which causes her to say: "I'm fascinated by those survival-research laboratories that take dead animals, like cats, and reanimate them by motorizing their limbs. It's like Frankenstein or Jesus or Osiris: the reanimation of the dead." Clearly

Kiki Smith / *Deer Drawing*, 1997
Colored pencil and graphite on Griffin Mills paper, 38 x 24⅝ in.
Collection of the artist, courtesy of PaceWildenstein

Kiki Smith / *Snow Blind*, 1997
Bronze with silver and palladium leaf, 10 units, approximately
3⅜ x 8¾ x 1¾ in. to 11 x 11½ x 3¼ in. Private collection

Indian, Mughal period, Tent panel, c. 1635
Red silk velvet with gold leaf, 8 ft. 5 in. x 18 ft.
The Metropolitan Museum of Art, New York

Smith's bronzed doilies, coated with fluttering leaf, relate
to this idea of animation.

There aren't many artists today, at least in Smith's mi-
lieu, whose conversation revolves as much around spiritual
topics. "To me the most essential thing is your spiritual
life," she says, "which is why I'm fascinated by mytholo-
gies and cosmologies." She has made bronze, paper and
wax sculptures of the Virgin Mary, nude and flayed; a
rosary necklace; and tiny winged figurines she calls faeries.
Her doilies, she notices at the museum, resemble some
pre-Columbian gold jewelry that she likens to "holy cos-
mic mandalas from the everyday world." And she de-
scribes the laborious process of hammering gold as "a form
of meditation. I'm supercrazy about gold, which is from
outer space. When I worked in a foundry once, just out of
boredom, I started to hammer gold, to make rings for
friends, or whatever, and I found it very much like medi-
tating." She crusades for what might be called marginal-
ized techniques: not just metalwork but also glassware,
tapestry, ceramics, paper constructions. She terms some of
them "outmoded technologies" and says "there's a power
in art forms that are neglected."

Born in Nuremberg, Germany, in 1954, she is one of

three daughters of Jane Smith, an opera singer and actress,
and of the artist and architect Tony Smith, who died in
1980. One sister, Seton, is also an artist, living in Paris, and
the other, Bebe, died in 1988. Smith links her affinity for
the expressionistic, sometimes macabre art of northern
Europe to Nuremberg. ("I relate strongly to German art,"
she says, "to the suffering in Grünewald and to German
wood sculptures, which move me to tears. It's in me
somehow.") But she was brought up in a big Victorian
house in South Orange, New Jersey, where her family
moved in 1955. She studied baking, then went to art
school and, significantly, trained briefly to be an emer-
gency medical technician. Some of her early drawings
were copied from *Gray's Anatomy*. In the 1970s, she moved
to Manhattan and joined Colab, an artists' collective that
organized, as it were, hit-and-run shows of ephemeral and
inexpensive art in out-of-the-way places like abandoned
buildings. The idea was to be egalitarian and noncommer-
cial.

She began exhibiting on her own in the 1980s: works
such as beeswax sculptures of corpselike figures, a man and
a woman, hung as if impaled on metal armatures and ex-
creting semen and breast milk; paper sculptures of a
human's skin with the body missing; a ceramic rib cage;
and also dolls, strands of beads, paper cutout sculptures,
crystal birds, metal flowers and clusters of glass teardrops.
"A lot of my effort in the last few years has been about try-
ing to interject decorative elements into the fine arts, by
using beads or sewing or whatever. I don't want to be
owned as an artist by traditions, which dictate that, hierar-
chically, certain subjects or ideas or techniques or materi-
als are innately high art while others aren't. I sort of grew
up during the hippie movement, which was about middle-
class people looking for their roots, but it was also about
older European decorative traditions, ceramics, flower pat-
terns, as opposed to modernism. That's part of my back-
ground. And my work naturally parallels my personal life,
meaning I get to see through the work what I really care

about, what's happening to me. Not that I want anyone else to see this, that is, to see the work as personal revelation, though it's always revelatory to me."

Predictably, her favorite corners of the Met are deliberately unusual, and in the Egyptian galleries, for instance, behind the Temple of Dendur, she picks out a pair of bronze crabs that almost everyone else overlooks. The crabs were once wedges supporting the ancient obelisk called Cleopatra's Needle when it was in Alexandria, Egypt; now it's behind the museum in Central Park. The crabs are fragments, big dark lumps with missing claws and carved inscriptions from the first century B.C. in Greek and Latin.

Smith has done several works that involve severed limbs. Pointing out the missing claws, she says: "I have an obsession with cutting things off, making them ineffectual, and I indulge my gory streak occasionally, but the reality of

Egyptian, Crab from base of Cleopatra's Needle
Bronze. The Metropolitan Museum of Art, New York

mutilation and of people with maladies, that's not my situation and I don't want to use it for my own indulgent, expressionistic purposes.

"At the same time, the crabs have got what I love when I love Louise Bourgeois's work: brutal massiveness and real weight." Bourgeois's marble sculptures can be very big and are often sexually charged. "Everything to me is either sexy or not, and these crabs are the sexiest things on earth," Smith says, likening one of them, with its splayed claws, to a crotch. "Even though they're realistic, they're also more abstract than what I know how to make, which is maybe why I like them better than my own work.

"Actually, it was never my intention to become a figurative artist, and I don't want to be trapped as one now. I probably prefer abstract things, in the end, because they make you focus on what they're about formally, and my superfavorite artist is Richard Tuttle because he pays so much attention all the time to what's happening formally." Tuttle makes refined, idiosyncratic abstract constructions out of the most inconsequential materials.

Smith peruses the inscriptions on the claws, likening them to Baroque and Rococo gilding in the rooms of European palaces, then to tattoos—all instances, she says, of decoration on the surfaces of a mass. "I get tattoos compulsively all over my body, and I've also tried to make sculptures with tattoos, which comes from looking at African bronzes and Indian art, with all the surface drawings on them." Smith has created large mirrored jars inscribed with the names of body fluids in Gothic lettering, and busts with strands of paper coming out of the figures' mouths, phrases written on the paper, as if spoken by the figures.

"I hate comics," she says, "but I think combining language with images can give a work a secret magic voodoo. It's what I love about Nancy Spero's or Lesley Dill's works." Spero and Dill borrow texts from writers like Antonin Artaud and Emily Dickinson for their art. "I would love to use language more in my work but it's always a

problem because then you have to say things, which means you're committing yourself to something specific. That is limiting. In this case, not being able to read what it says actually makes it more pleasurable to me, just to see the form of the lettering, the way it's cut into the work. The cutting has a certain power, too, it leaves a residue of somebody's presence, like a snail mark in the sand. It's like with Chinese paintings: people stamped their ownership on the works over the centuries, so the paintings were no longer pure. But also each time they were stamped they got to have new lives that transcended just the time when they were painted. They were inanimate objects that got to be reincarnated."

Smith especially likes the room in the Chinese galleries with a monumental fourteenth-century mural of Buddha flanked by bodhisattvas and various other divine and mythological figures. The mural was originally for a temple in northern China, where it was a backdrop for sculptures, as it is here: several huge sixth-century Buddhas and bodhisattvas are in front of it.

"For fifteen years I came in here and thought, Gee, that's really smart to have a big painting with a sculpture in front of it and someday I want to figure out how to do that." It happens that in a recent show Smith displayed a wax sculpture of a figure, forlorn and rather touching, seated before a suite of evanescent drawings, also of the same figure. "As an artist, you go around with these lists of things that, for whatever reason, are formally interesting to you but you don't know what to do with them. They gnaw at you until you figure it out. You make lame attempts trying to do it and you go off on tangents and sometimes there's a sadness to being able to see what is interesting to you in the world but not being able to reproduce it. I'm a greedy artist and want to make everything that I think is great, but I know I can't. I'm nuts for tapestries, for example, which I think make great art, and it would be my dream to make a great tapestry, but that doesn't mean I can do it."

Smith notices how the draperies of the Chinese sculptures here attach "like flying buttresses," and relates them back to the Egyptian crabs: they're all masses with appendages. "There's something almost mystical to me about the contradiction between the powerful and the limp," she says, having made many figures that include dangling attachments. She's also intrigued by the heft of one of the sculptured Buddhas compared with two smaller bodhisattvas connected to it. "Like Gulliver and the Lilliputians," she says. "It's an example of representation, and what happens to bodies when you make them smaller or larger than normal. I don't know how to put it except that it alters your consciousness of the body through association. You imagine yourself in these bodies, which affects how you feel. There are certain poses of the Virgin Mary with her arms out to the sides, and if you actually stand that way, it opens you up and makes you vulnerable, maybe even compassionate."

Another room Smith likes at the Met is the one of Assyrian reliefs from Nimrud, its walls lined with the heraldic and massive ancient stone slabs of giant bird-headed demons and divinities in the forms of a winged lion and a winged bull with human heads. Sacred palmette trees are as delicately carved as the figures are huge, intimidating. An inscription across the slabs extols the Assyrian king's accomplishments, which involved, among other things, the massacre of various enemies. The Assyrians were brutal warriors and remarkably sensitive artists.

"Ten years ago, this was my favorite place at the Met," Smith says. "I love the mass of the stone combined with language right across the middle of everything, and I also love the flowering trees, which look braided or like textiles or blanket weavings, except in stone. I also like that there's no color, that the material shows through. I have a hard time with color, which feels extraneous to me. It adds too much information." Her work has always lacked strong color. The recent works are mostly black and white or only delicately tinted.

Mesopotamian (Assyrian), Winged Bird-Headed
Divinity, 9th century B.C..
Limestone, 94 x 66 in. The Metropolitan Museum of Art, New York

"And I especially love the morphing between humans
and animals, between birds and humans." (Smith has lately
been making sculptures of birds, like crows, as well as glass
birds' nests and prints of dead birds.) "I dream about birds.
A few years ago I started to notice all these images from
around the world of bird-humans—how birds become
stand-ins for souls, that our identity is deeply, sometimes
tragically, connected with the natural world. So I began
making bird sculptures. Maybe it's also that I've made
human bodies for fifteen years and now that turf is pretty
crowded with stuff about cultural identity, race, gender,
sexual preference. My work has dealt with some of that

and I don't disown it, but now I feel like focusing on animals, which not many artists have paid attention to in the last century.

"Anyway, I see animals as a natural progression in my work. First, I made anatomical drawings, drawings of particles and cells, then works about systems in the body, like lymphs and the digestive system, then works about skin, then whole figures and sculptures based on different cosmologies. And then, through the cosmologies, animals. It hadn't been my intention to be an artist of the human figure in particular. It just happened that that's what I did for a while but, as I said, I don't want to be trapped by that."

One of her figurative sculptures, *Lilith,* from 1994, a bronze crouching woman with glass eyes, which is hung like a painting on the wall, is in the Met's twentieth-

Kiki Smith / *Lilith,* 1994
Bronze with glass eyes, h. 31½, w. 27, d. 17½ in.
The Metropolitan Museum of Art, New York

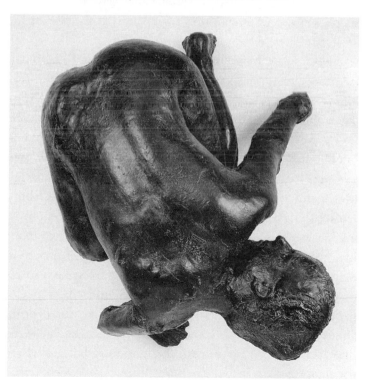

century galleries. Smith spends a couple of minutes perusing it the way a doctor checks a patient, frowning at some imperfections she perceives in its casting, wondering about its height on the wall, and finally pronouncing it healthy. "I wouldn't have thought to make a bronze sculpture hanging on a wall but I made it out of paper first, which allowed me to pin it to the wall, and that gave me the idea for a kind of weightless body." She points out that the glass eyes were directly inspired by Buddhist and Roman sculptures in the museum.

In the nineteenth-century-art galleries nearby she first peers into the room of Degas sculptures—"like a dollhouse," she observes about the cases with dozens of Degas's figures in them—and then pauses at Degas's sculpture of a fourteen-year-old dancer, clothed. "To me there's something really powerful about decorating sculptures, putting clothing or jewelry on them, like on dolls, so that they mimic humans and come alive. It's the same effect with Buddhist sculptures, where the glass eyes animate them, but then the eyes don't age the way the rest of the sculpture does, which is eerie."

About some Degas pastels, she says, "Pastel is a nutty, superfussy material, very interesting, don't you think? Trying to build up bodies with color is different from using black and white. I like drawing every pore, but with pastel you're just approximating skin tonalities. It's not about line but about light and how it bounces back off the body. Pastels are a material that not a lot of artists are using today, so that seems to me like a space to be filled. I'm also into fetishy things: gluing sheets of paper together, complicating the work, seeing the touch, the evidence of the making," she says, noticing how, with some of his pastels, Degas has attached one sheet to another to make a single one. Her deer drawings also involve uneven sheets of paper, attached to each other. She makes a related point about several Rodins. "I love him a lot when he keeps the lines from the casting process, the markings that show how the sculpture was made. The lines abstract the work, create

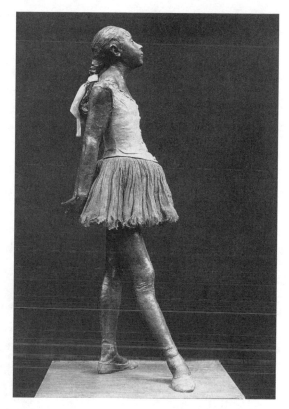

Edgar Degas / *Little Fourteen-Year-Old Dancer,*
1878–81, probably cast 1922
Bronze and muslin, h. 39 in. The Metropolitan
Museum of Art, New York

a second kind of work, in a way. They're like varicose
veins. They distort the body."

Smith's art, like *Lilith,* has dealt often with the human
body, particularly women's bodies, in poses of distress or
exhaustion—unpicturesque and even animalistic poses,
which might seem to owe something to Degas's late
bathers and to Rodin's nudes. Yet she talks about their
works in terms of materials and abstraction. It's useful to
recall that Tony Smith, her father, was an abstract sculptor.
The Met owns his *Amaryllis,* a huge steel modular abstrac-
tion from 1965, painted black. As is typical of his art,
the relationship of its shapes changes, almost as in a kalei-
doscope, when viewed from different angles, so that a

floating volume seems to flatten, an angled one becomes square. Smith says there was a model of *Amaryllis* in the dining room of her family's house in New Jersey. "I feel like I didn't even really see representational art until I went to college and took art history, so I took abstract art as the natural way of being. I spent my childhood with my sisters making little model octahedrons and tetrahedrons for our father, day after day after school," she says. "We were the local weirdos until it became cool and exotic, when I was a teenager, to be from the family of an artist. Then I became popular."

Tony Smith's use of geometric forms has caused him to be linked with the Minimalists of the 1960s, but his

Tony Smith / *Amaryllis*, 1965
Painted steel, h. 135, w. 128, d. 90 in.
The Metropolitan Museum of Art, New York

daughter points out that he belongs more to the previous generation of Abstract Expressionists, not just in terms of his age but also temperamentally. "My father's work is actually expressionistic and superemotional," she says. "People think his works are cool because they are geometric, but the idea that a curve is more expressionistic than a straight line is just ridiculous. The works are about physical presence. They're related to rock formations, crystal shapes, snowflakes."

Smith thinks her interest in making series or multiples of things, like her glass teardrops or her prints, also comes partly from her father's variations on geometric shapes. "It's about repetition versus uniqueness. My interest in printmaking is that prints mimic what we are as humans: we are all the same and yet every one is different. I also think there's a spiritual power in repetition, a devotional quality, like saying rosaries."

Recently she has made sculptures that are like tiny footstools, clusters of objects that seem to hover just above the ground, which may explain her admiration for the low-slung but otherwise nondescript chair in the last room she visits at the Met, among European furniture. "There's something sexy about lowness," she says, rather mysteriously. "I grew up in a house with very little furniture. We used boxes from the supermarket to put our clothes in. And I remember going over to my aunt Graziella's house, which had all this ornate furniture, candelabra, and also low chairs. Come to think of it, my doilies are also from Aunt Graziella, because she used to make lace." She laughs. "I guess I owe everything to my aunt Graziella."

Seriously she adds, "I've actually thought about cataloguing my sources, but you're supposed to be coy about that: people prefer to think that ideas spring straight from the artist and not that artists are paying attention to, and learning from, the world. I learn from everywhere. Of course, you have to be responsible interpreting other cultures, but you're allowed to be wrong, because good things come from cross-fertilization."

ROY LICHTENSTEIN

wouldn't believe anything I tell you," says the painter Roy Lichtenstein, walking through the Metropolitan. Slim and birdlike, the master of Pop has his gray hair, as usual, tightly pulled into a ponytail, accentuating his narrow face, big eyes and beaked nose. He's regarded as someone given to quips rather than speeches, with a puckish, self-deprecating humor and shy, soft-spoken demeanor. He responds to various works with a "no comment," which is his polite way of registering dissatisfaction. He's also intent, serious and unpredictable.

It is the spring of 1995, two years before his death from pneumonia. On this day he wants, among other things, to visit the Old Master, nineteenth- and twentieth-century galleries. The paintings in the museum that interest him are not the ones you'd necessarily expect. Some are obscure, even perverse choices. Others are counterintuitive: his own flat, crisply outlined pictures might lead you to assume he'd like, say, the cool clarity of a David or an Ingres. But he finds them colorless compared with artists like Rembrandt, Fragonard, Hals and van Gogh, whose tactile surfaces are virtually the opposite of his own. "Here I am, extolling the virtues of Fragonard and putting David down," he says at one point, a little sheepishly. "Clearly there's something wrong with me."

Roy Lichtenstein / *Yellow Brushstroke I,* 1965
Oil on canvas, 68⅛ x 55⅞ in.

For an artist whose paintings based on bubble-gum
wrappers and comic strips seemed, when they appeared in
the 1960s, to be an attack on the pure abstractionists of the
New York School, Lichtenstein can sometimes sound al
most like an Abstract Expressionist himself, focusing so
much on issues of line and color that he doesn't always no-
tice the subject of the painting he's talking about. "I hadn't
realized that this was a funeral," he says, after talking for
several minutes about color in front of Manet's *Funeral.* "I
paint my own pictures upside down or sideways. I often
don't even remember what most of them are about. I ob-
viously know in the beginning what I'm painting, and that
it will be funny or ironic. But I try to suppress that while
I'm doing them. The subjects aren't what hold my inter-
est."

To everyone else, of course, the interest of his pictures has always been inextricably linked with the sources he began to scavenge at the start of his career, like *Wee Winnie Winkle, G.I. Combat* and *Secret Hearts* ("I don't care! I'd rather sink—than call Brad for help!"). His works first drew attention when they were shown at Leo Castelli's gallery in Manhattan in 1962, where they seemed to critics like the equivalent of a giant pin aimed at the hot-air balloon of Abstract Expressionism, with its soul-searching claims and emphasis on the eloquence of a painter's touch. By contrast, Lichtenstein's art was wickedly ironic and freeze-dried, as if manufactured, because it mimicked, in carefully streamlined form, the black outlines, flat vivid colors and Benday dots of the funny pages.

"Roy got the hand out of art," the painter Larry Rivers once said, "and put the brain in." Lichtenstein was a provocateur. He was a master of satire in the 1960s, and if in his later years he was somewhat taken for granted, this was partly because his ideas had so infiltrated art that they were no longer only his: his mixing of text and image, of high and low, his whole strategy of appropriating images, paved the way for a generation of artists not yet born, or at least not yet out of elementary school, when Lichtenstein cribbed a picture of a girl holding a beach ball from an advertisement for a Poconos resort.

In a much-cited interview in 1963 he claimed that he wanted to make an art so "despicable" that no one would hang it. Probably not even he dreamed at the time that collectors would someday pay millions of dollars to put it on their walls. But, then, it was never easy to know how seriously to take Lichtenstein, and it quickly became clear, after his Castelli debut, that his interests actually extended far beyond making the culture of Mickey Mouse and Bazooka bubble gum wrappers into a new heraldic art. He actually quit using comic-book sources by the late sixties. Working in the same basic mode, he turned out paintings that mimicked Picasso, Cézanne and Mondrian, whom he treated roughly the way Andy Warhol treated Marilyn

Monroe and Elvis Presley—as brand names. He did land-scapes, interiors and nudes, even images of pyramids, whose geometry and compressed abstraction might be more commonly associated with painters like Ellsworth Kelly. He made sculptures, prints and giant murals, like the five-story *Mural with Blue Brushstrokes* at the Equitable Center in Manhattan, and in later years he exhibited draw-ings that were mostly his private exercises and preparatory studies, which have about them a feathery, almost hesitant touch very different from his assertive paintings. On what had seemed a one-liner, he composed countless unfore-seen variations. They tumbled out of his work like circus clowns from a Volkswagen, so much so that the criticism of his art eventually came to revolve around its sameness: the fact that he turned everything into basically the same cryo-genic image.

In all of his work there remained, nonetheless, a partic-ular, unmistakably American quality: a lean, laconic scrutiny of the world that separated his art from the paint-ings of Europeans of his generation who also borrowed from pop culture sources. The tone dovetailed with his wry and reticent personality, though how much the sub-jects of his art ever had to do with his own life remains a matter of debate. During the early to mid-sixties, when his first marriage was breaking up, he painted various comely women in conditions of distress, like *Drowning Girl* and *Frightened Girl. Hopeless* shows a teary blonde beneath the caption: "That's the way—it should have begun! But it's hopeless!" And *In the Car* depicts a moment of chilly si-lence between a man and woman.

Still, Lichtenstein wasn't ever one to discuss his private affairs. He was born in 1923, the son of a realtor and a housewife on the Upper West Side of Manhattan. As a boy, quiet and something of a loner, as he later described himself, he became interested in science and listened, like every other kid, to *Flash Gordon* and *Mandrake the Magician* on the radio. As an adult he spent hours poring over *Scien-tific American* and *Science News.*

He began taking art courses at sixteen, and in the summer of 1940 attended Reginald Marsh's life class at the Art Students League. "I did sort of appalling paintings," he remembers. "A kind of Reginald Marsh realism." That fall he enrolled at Ohio State University in Columbus to study art, then was drafted in 1943 and ended up in the engineer battalion of the 69th Infantry Division in Europe. At the end of the war, like a lot of American GIs interested in art, he made a pilgrimage to Picasso's apartment on the Rue des Grands Augustins in Paris, but he was too shy to ring the bell. "I walked away after a while thinking 'Why would Picasso want to see me?' "

He completed his master's degree at Ohio State and in 1951, having been denied tenure, moved from Columbus to Cleveland, for a few years doing odd jobs, including window displays at Halle's Department Store and sheet-metal designs for Republic Steel, meanwhile making frequent trips to New York City to see shows and to sit quietly at the Cedar Bar, unable to introduce himself to de Kooning, Pollock, Franz Kline and the other New York School painters who frequented it. He also began to exhibit: his first solo show in Manhattan was at the Carlebach Gallery in 1951.

Crucially, Lichtenstein took with him lessons learned from Hoyt Sherman at Ohio State, a late Fauvist painter who insisted that even representational art be regarded not as a true mirror of life but in terms of its essential abstract qualities. Through the 1950s Lichtenstein painted and made sculptures in a variety of modes, often tongue-in-cheek, sometimes influenced by the styles of Picasso or Klee or Fragonard or the Abstract Expressionists. He painted medieval subjects, images of anthropomorphic plants and themes of American folklore, including a take-off on Emanuel Leutze's *Washington Crossing the Delaware*. It wasn't really a big leap from there to his paintings of the early sixties based on comic books and advertisements. By 1957, Lichtenstein had left Cleveland and landed a job at Rutgers University in New Jersey, where a fellow teacher

Roy Lichtenstein / *Washington Crossing the Delaware I,* 1951
Oil on canvas, 26 x 32 in.

Roy Lichtenstein / *Look Mickey,* 1961
Oil on canvas, 48 x 69 in.

was Allan Kaprow, through whom he also met Claes Oldenburg and others who were to define Pop Art in the early sixties. Kaprow once told Lichtenstein, "You can't teach color from Cézanne, you can only teach it from something like this," pointing to a Bazooka gum wrapper. Contact with artists like Kaprow and Oldenburg, combined with the experience of seeing the early exhibitions of Jasper Johns and Robert Rauschenberg, paved the way for Lichtenstein's *Look Mickey*, of 1961, which he called his "first painting with no expressionism in it."

But all along, Lichtenstein continued to see art in Sherman's formal terms, as a variable system of conventions, essentially abstract. The paradox of his work has always remained that its outward embrace of images of everyday life belies an inward concern for art as arrangements of colors and shapes.

Thus his first stop in the Metropolitan is in front of a fifteenth-century Netherlandish tapestry in the Medieval Hall. The tapestry consists of fragments joined together, depicting the Sacraments, and Old Testament figures in the guise of Flemish courtiers in ermine and floral robes, standing in rooms of damask walls and marble floors. Lichtenstein is reminded of Persian miniature paintings by the tapestry's opulence, and considering his own work, you can see why he admires in particular its stylized figuration and dense overall patterning. Bordered and captioned, the scenes can also put you in mind of comics, but this interpretation is clearly a trap on Lichtenstein's part. Comics tell stories, he points out, and "I don't think storytelling has anything to do with modern painting, or with my paintings at least. When I have used cartoon images I've used them ironically, to raise the question: Why would anyone want to do this with modern painting? What interests me here is the use of local color. In the High Renaissance, chiaroscuro altered the use of color, so that instead of having, say, a solid red fill an entire robe, you'd have half the robe darker red and half lighter. And the dark and light areas wouldn't be contained within outlines.

Franco-Flemish Tapestry, 15th century
The Seven Sacraments (detail)
The Metropolitan Museum of Art, New York

They would create their own patterns within the composition. By the time you get to van Gogh, you might think he's dealing with local color again, because there's no chiaroscuro. But of course he's dealing with the intensity and amount of color. Color for its own expressive sake. The intent is entirely different."

In Lichtenstein's own work there's no chiaroscuro and the stress is on the quantity and balance of colors, not on any illusion of depth, though in his late paintings of female nudes, from the mid-nineties, he coyly alludes to chiaroscuro through patches of different-sized dots that don't conform to the outlines of the figures. His idea isn't to simulate shadows precisely, but to symbolize the conven-

Roy Lichtenstein / *Nude with Yellow Flower,* 1994
Oil and magna on canvas, 92 x 72 in.

tion of chiaroscuro, to signal it: like all Lichtenstein's paint-
ings, the nudes ultimately are about issues of perception.

"During the Renaissance, perspective held the work to-
gether and gave you the sense that the painted image is
something seen from your viewpoint. But then later, I
think, recognizing that perspective doesn't actually unify
the image but is still just a symbol of pictorial unity, and
therefore not really necessary, artists felt freer to take liber-
ties, which led to Synthetic Cubism and to pictures where
the size and shape of independent colors becomes the or-
ganizing principle, like with Mondrian.

"With my nudes I wanted to mix artistic conventions that you would think are incompatible, namely chiaroscuro and local color, and see what happened. I'd seen something similar in Léger's work. My nudes are part light and shade, and so are the backgrounds, with dots to indicate the shade. The dots are also graduated from large to small, which usually suggests modeling in people's minds, but that's not what you get with these figures. I don't really know why I chose nudes. I'd never done them before, so that was maybe something, but I also felt chiaroscuro would look good on a body. And with my nudes there's so little sense of body flesh or skin tones—they're so unrealistic—that using them underscored the separation between reality and artistic convention. I'm sure other people may see the choice of nudes differently, but the images might have been still lifes as far as I was concerned. In fact, the first work I tried along these lines was a still life.

"You know, all my subjects are always two-dimensional or at least they come from two-dimensional sources. In other words, even if I'm painting a room, it's an image of a room that I got from a furniture ad in a phone book, which is a two dimensional source. This has meaning for me in that when I came onto the scene, abstract artists like Frank Stella or Ellsworth Kelly were making paintings the point of which was that the painting itself became an object, a thing, like a sculpture, in its own right, not an illusion of something else. And what I've been trying to say all this time is similar: that even if my work looks like it depicts something, it's essentially a flat two-dimensional image, an object."

He walks around the corner from the Netherlandish tapestry to find an altarpiece by the fifteenth-century Venetian painter Carlo Crivelli. "Here you have a strange mix of naturalism and abstraction, with this flat gold Byzantine background, completely decorative, and also these shadowed figures. The artist was trying to make a beautiful object, which is why the gold leaf background is there, but also to be naturalistic. He's sort of in between what came

before him in art and the illusionism of the High Renaissance. Undoubtedly people saw it in terms of what came before in art, so maybe, in their eyes, it looked naturalistic.

"When people draw in art classes, the teacher corrects them by saying 'Just look out there and copy what you see,' as though perspective comes from just looking and not from studying Uccello and Leonardo. Everyone would draw like a child without seeing other art. But even the idea of delineating a figure is something young children don't get until they're shown it. People think one-point or two-point perspective is how the world actually looks, but of course, it isn't. It's a convention."

In the early seventies Lichtenstein painted images of mirrors, which were based on another pictorial convention: "Mirrors are flat objects that have surfaces you can't easily see since they're always reflecting what's around them. There's no simple way to draw a mirror, so cartoonists invented dashed or diagonal lines to signify 'mirror.' Now, you see those lines and you know it means 'mirror,' even though there are obviously no such lines in reality. If you put horizontal, instead of diagonal, lines across the same object, it wouldn't say 'mirror.' It's a convention that we unconsciously accept."

Lichtenstein walks upstairs to a room of Goyas, zeroing in on one no longer attributed to him, an imaginary landscape depicting a city atop an immense boulder; a trio of winged men fly outside the city walls while below a battle unfolds. "I've always loved this work, although the experts now don't think it's by Goya, which tells you why you shouldn't believe what I say." He smiles. "Everything is the right color and there's this bravura technique, with daubs of paint that look as if they're squeezed straight out of the tube and pushed around just a little so that they make people or a cannon or whatever. It's a wonderful combination of color and drawing. People sometimes separate great colorists from great draftsmen, but there really is no such thing as someone who's strong at drawing but can't color."

To prove this point, he finds a pair of Jacques-Louis

Davids, *The Death of Socrates* and the double portrait of the scientist Antoine-Laurent Lavoisier and his wife, Marie Anne Pierrette Paulze. But, in doing so, Lichtenstein becomes vexed. "Well, this ruins my argument, because you don't have spectacular color here. They resemble colored photographs. They're not insensitive, they're pleasant, but the style David wants to work in forces him away from thinking in terms of color quantities. He was about Truth, Justice and the French way, and I'm sure he knew that the results looked cold. That was his point. He was thinking about precise outlines and detail. But it's interesting to me because the Venetians or Rembrandt, say, were much looser and less interested in detail, yet their works actually look much more naturalistic, which makes sense, if you think about it, because, after all, you don't really see outlines when you look at something in space. You see blurred lines.

Style of Francisco de Goya / *A City on a Rock,* 19th century
Oil on canvas, 33 x 41 in. The Metropolitan Museum of Art, New York

Jacques-Louis David / *The Death of Socrates,* 1787
Oil on canvas, 51 x 77¼ in.
The Metropolitan Museum of Art, New York

Jean Honoré Fragonard / *The Love Letter*
Oil on canvas, 32¾ x 26⅜ in.
The Metropolitan Museum of Art, New York

"To draw outlines and color them in is about as dumb a way of painting as you can imagine, and you can look at my work and say that's how it's done. And up to a point it is. Partly that's supposed to be ironic. For example, when I did paintings based on Monets I realized everyone would think that Monet was someone I could never do because his work has no outlines and it's so Impressionistic. It's laden with incredible nuance and a sense of the different times of day and it's just completely different from my art. So, I don't know, I smiled at the idea of making a mechanical Monet. But irony alone never makes a painting. I'm always trying to get at something having to do with color, too. I'm trying to make paintings like giant musical chords, with a polyphony of colors that is nuts but works. Like Thelonious Monk or Stravinsky. It's tough to make a painting succeed in terms of color and drawing within the constraints I insist on for myself. And I think it takes appreciation of another sort of art—Fragonard, Rembrandt to pull it off."

Fragonard's *Love Letter* happens to be around the corner. It depicts a woman in a silk dress seated at a desk before a window, a bonnet on her head, flowers and a letter in her hands, a fluffy dog at her side. The image is pink, yellow and brown: "boudoirish," says Lichtenstein, who thinks it's great. "Even though the theme of this particular painting is dopey, the colors are beautiful. I know Fragonard's work seems entirely different from mine. But my art is perversely different from my thinking about art." During the 1960s, Lichtenstein points out, he incorporated brushstrokes into his works, which were widely interpreted as parodies of Abstract Expressionism, not to mention of a long tradition of expressive painting. "I couldn't resist, because I had been yearning to paint like that since my career began. My work is, after all, a kind of straitjacket. I did those pictures because it was my way of saying 'You see, painting means a tree made out of brushstrokes.' True, artists have been saying the same thing for centuries. Hals will show you he can do a beautiful brushstroke that is also

a piece of taffeta. So what I was doing wasn't new. But I saw it as referring to a tradition. I realize that, as with Monet, my style is considered to be in total opposition to Abstract Expressionism, but actually I love the Abstract Expressionists, or I like the ones I like, anyway. They put things down on the canvas and responded to what they had done, to the color positions and sizes. My style looks completely different, but the nature of putting down lines is pretty much the same; mine just don't come out looking calligraphic, like Pollock's or Kline's."

More than thirty years ago, Lichtenstein caused a ruckus when he painted his own Cézannes: sendups of *Man with Folded Arms,* from the Guggenheim, and of *Mme. Cézanne,* from the Met (the one illustrated on p. 21), in which the originals were stripped of color and the figures reduced to outlines. The works were based on diagrams in a book about Cézanne's compositions; they satirized the book's contention that Cézanne, who claimed that outlines escaped him and who composed images through patches of color, could ever have his portraits turned into black-and-white pictographs.

"Here Cézanne is painting apples and pears," Lichtenstein observes about a still life in a room of Cézannes at the Met. "But the colors aren't truly realistic and he is doing pretty much anything he wants with them. He's thinking in terms of areas of color, about their position, not about trying to get the table and fruit just right. After Impressionism, Cézanne, van Gogh and Gauguin are really the beginning of color—of color position and intensity—on its own. Cézanne stripped his art of decoration and pattern. He was about pure vision. Gauguin had a vision, too, and his colors must have looked outrageous at the time. They're tough, strong. At the same time his work was meant to be beautiful."

Lichtenstein became nationally famous, or notorious, in 1964 when *Life* magazine published an article about him, asking "Is he the worst artist in America?" His work was widely interpreted then as a critical commentary on

modern industrial society because of its allusions to contemporary culture and its pseudomechanical look. But Lichtenstein was reluctant to interpret his own art in those terms. "We like to think of industrialization as being despicable," he told an interviewer in the sixties. "I don't really know what to make of it. There's something terribly brittle about it. I suppose I would still prefer to sit under a tree with a picnic basket than under a gas pump, but signs and comic strips are interesting as subject matter. There are certain things that are usable, forceful and vital about commercial art." The Pop artists, he added, are "using those things, but we're not really advocating stupidity, international teenagerism and terrorism."

One of his American predecessors in the use of industrial and commercial imagery was Stuart Davis, whose paintings of everyday objects are often considered proto-Lichtensteins. The Davis on view in the twentieth-century rooms at the Met is a big gray mural done in 1939 for WNYC radio's Studio B. "Everyone except me knew the sources for my works six seconds after I painted them," Lichtenstein says, before the mural. "I knew about Davis but the connection wasn't strong in my mind when I did Pop Art. He did gas stations and cigarette ads decades ago. But the period wasn't right yet. They have a corny American quality, as if he's Americanizing a European idea, meaning Synthetic Cubism. I think there are very good Stuart Davises. This isn't one of them."

Elsewhere in the twentieth-century rooms, he warms more to paintings by his friend Jasper Johns, and less predictably praises a big Susan Rothenberg and Balthus's *Mountain*. "I don't understand Balthus's relationship to the history of art," he says, "but I don't think that matters. It's good painting."

About Picasso, Lichtenstein believes that while "Matisse is very great—I don't mean to put him down—Picasso's colors are even more daring, wild and strong. Not wild like the German Expressionists, who painted figures green. Picasso's colors grew inevitably out of his style. And he

seemed to understand art so fundamentally that he could generate wholly different styles, each of which had its own particular tonality."

Lichtenstein settles finally on a group of Ellsworth Kellys: a tall standing steel sculpture, nearly rectangular, and two shaped canvases, one of them all blue. "This is the ultimate in color intensity. It's entirely about the relationship between color and shape. There's no modulation of color. Modulation is usually read as atmosphere, it gives you a sense of recession. But here you don't have that, there's no illusion, which turns the picture into a thing, the opposite of a window. It's like a sculpture that just happens to be on the wall.

"I know Ellsworth says it comes from nature. But I don't know why you'd want to say this, because art relates to perception, not nature. All abstract artists try to tell you that what they do comes from nature, and I'm always trying to tell you that what I do is completely abstract. We're both saying something we want to be true. I don't think artists like myself, or Ellsworth, have the faintest idea what we're doing, but we try to put it in words that sound logical. Actually"—Lichtenstein grins—"I think I do know what I'm doing. But no other artist does."

LUCIAN FREUD

t is past midnight, and Lucian Freud is walking through London's National Gallery, his steps reverberating in the empty rooms. Having the museum to himself is a privilege that comes from being one of England's most prominent artists, added to which is his near obsession with privacy, and a schedule in which he tends to paint late into the evening. So here he is in the middle of the night, with all the lights on and the run of the place.

He has been visiting the gallery almost since he moved to England from Berlin as a boy in 1933. "I use the gallery as if it were a doctor," he says. "I come for ideas and help—to look at situations within paintings, rather than whole paintings. Often these situations have to do with arms and legs, so the medical analogy is actually right. Do you know the old story about the strip-cartoon writer who goes on holiday? He leaves his hero chained up at the bottom of the sea with an enormous shark advancing from the left and a huge octopus approaching. And the man who takes over the job can't figure out how to get the hero out of danger, and after several sleepless nights, he finally sends a telegram to the writer, asking him what to do. And the telegram comes back: 'With one tremendous bound the hero is free.' Well, when I come here I'm also looking for ways to get myself out of troubles that are self-made."

Freud sometimes speaks in a near whisper that compels you to lean forward to hear him. He has a distinctive way of sidling into a room that is half discreet, half insolent. His speech, which has a little lisp, also retains the hint of a German accent. He looks remarkably fit for his age. A slight man with short tousled hair, he has an intense wide-eyed stare that can be startling. That stare, and the long scarf that in winter he ties around his neck, are among his familiar features. So is his whippet, Pluto, a regular in recent paintings, who joins him even when he goes to lunch at the River Café. Freud parks his car while Pluto jumps out to play by the Thames. It happens that Freud is also known as a maniacal driver, careering around London with the dog hanging on for dear life by his claws in the back seat.

Freud spends most of his time in the tumbledown attic rooms of his studio, a walk-up in Holland Park, just west of Kensington Gardens. The bell is unmarked, and Freud is so scrupulous about guarding his privacy that not even his close friends have his telephone number. He also has a house nearby, elegantly but sparsely furnished, which he uses sporadically. Lately he has been painting the back garden there, working during the morning in a second-floor studio to catch the early light.

He rarely leaves London; a two-day trip to New York to see his retrospective at the Metropolitan Museum in 1993 was his first visit to the city since 1953. He has since returned a few times. He lived on and off in Paris during the early 1950s but hasn't been back there for twenty years. Yet he is hardly a recluse. He is sociable, a regular at nightclubs, a raconteur, warm and charming when he chooses to be, wry and highly amusing, blunt in his opinions, allergic to small talk though full of wicked stories. His reputation for being inaccessible stems from the fact that he wants not to be interrupted, or to waste time while he is working, which he almost always is. So he has granted almost no interviews and fiercely husbands his privacy. The chance to talk about pictures in the National Gallery is something else, because for him they are a part of his work,

William Hogarth / *The Marriage Contract*
from "Marriage à la Mode," 1742–44
Oil on canvas, 27⁷⁄₈ x 35¹³⁄₁₆ in. National Gallery, London

integral, psychologically and artistically, to his thinking.

In 1986 the National Gallery asked Freud to do one of its "Artist's Eye" shows, in which he assembled several favorite works from the collection. He picked a Rubens, a Chardin, a Constable and a Seurat, among other things. He thought about including one of the pictures from Hogarth's famous "Marriage à la Mode" series, before which he is standing now. "It's lively, marvelous, informative, poignant. But I came to feel that the subject matter was dominant. What I mean is that with the best things, Rembrandts and Cézannes, every inch of a painting counts, so that if you take away a bit of a corner, let's say, the picture doesn't work any longer. Whereas here, the Hogarth depends on the story." Freud's own paintings, of course, aren't precisely narrative, although lately they have had figures in odd configurations—under beds, in attic windows—which seem to imply stories. They invariably have to do with the plasticity of pigment simulating flesh.

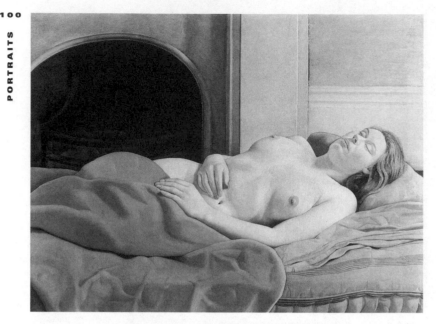

Lucian Freud / *Sleeping Nude,* 1950
Oil on canvas, 30 x 40 in. Private collection, Canada

They are about an evasive psychological inwardness, a
sense of the otherness of objects and people, scrutinized
like specimens under a hard, enveloping light. Freud likes
to talk about the truth of what he depicts, by which he
means the truth of the human transaction between him
and his models. His paintings of figures are tough, im-
pacted, unforgiving of their subjects, and in that respect
they do not lie.

Along these lines, Freud cites Chardin's *Young
Schoolmistress,* saying "the feeling is true. Generally, when
we talk about feeling we mean deep feeling. This isn't
deep, but it is true. For me, it's also an erotic painting,
maybe because it's so intimate. I prefer it to Vermeer, and
I mention Vermeer because the people in Vermeer aren't
humans. I don't mean they're subhuman, but they are ob-
jects governed by light. They're there for the picture. It's
not a lack in Vermeer, precisely, but it is one of the strange
things about him, this way of treating humans. And I think
that's why Dalí was so fascinated by him. With Chardin,

Jean-Baptiste Chardin / *The Young Schoolmistress,* c. 1735
Oil on canvas, 24¼ x 26⅛₆ in. National Gallery, London

Salvador Dalí / *Lacemaker (after Vermeer),* 1954
Oil on canvas, 9¼ x 7¾ in. The Metropolitan Museum of Art, New York

the work is too convincing to wonder how it was painted. For instance, I've looked at it very often, but I'd never really noticed this shadow before." Freud points to a shadow cast by the schoolmistress's elbow. "Now I realize Chardin must have used burnt umber. But I had never, ever, thought about this, because it's in the nature of his work that you don't question it. Even as a painter, I'm not technically aware of what he is doing, any more than you notice the vocal timbre of someone who is telling you something that is very important."

Freud has made a similar point before, about Velázquez. He has quoted Ortega y Gasset's remark that Velázquez's *Meninas* "isn't art; it is life perpetuated." Even so, in front of Velázquez's *Rokeby Venus* Freud remarks that "one of the many things fascinating about the picture is the ugliness of the woman's right arm, yet how beautiful it is. It's completely wrong, it bypasses reason, yet it works as art. I think when you are painting, there are decisions you make, and remake, and amend. And you can see that this arm was once something else, but this was how it evolved, which is

Diego Rodríguez Velázquez / *The Rokeby Venus,* c. 1650
Oil on canvas, 48 x 69½ in. National Gallery, London

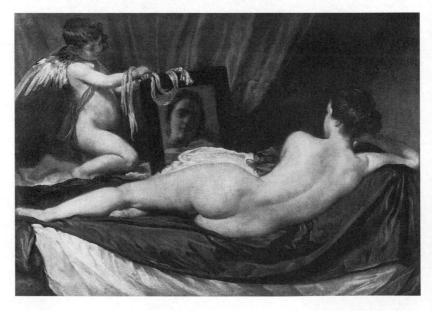

perfect. The head in the mirror is twice as big as it should
be, and she couldn't possibly see herself in it from that
angle. But all these things are completely beside the point.

"Art is by its nature wrought, however convincing it is.
It has to do with artifice, which means with an artist's abil-
ity to convey feelings that aren't necessarily ones the artist
has himself; otherwise the most remarkable artists would
also be the most virtuous and extraordinary people. I mean
to say, the character of the artist doesn't enter into the na-
ture of the art. Eliot said that art is the escape from per-
sonality, which I think is right. We know that Velázquez
embezzled money from the Spanish court and wanted
power and so on, but you can't see this in his art.

"His Venus is beautiful, as I said, though ultimately I'm
more disposed to find people in ordinary situations erotic,
like a nurse or a maid, rather than a naked woman just
lying there, because I think of people as animals. Maybe
the erotic element I find in the Chardin has to do with the
sweetness of her nature and the way it makes one feel joy-
ous. On the other hand, I think an erotic element is in
nearly all great art. I see it in Constable, certainly. It's to do
with love, not sex."

In Freud's case there is always a certain psychological
expectation to what he says that comes, justifiably or not,
from his being Sigmund's grandson. He was born in Berlin
in 1922, moved to England with his family when Hitler
came to power, and emerged as a charismatic and prodi-
gious presence in London after one of his drawings was
published in 1940 in Cyril Connolly's *Horizon* magazine.
He moved in smart circles and seedier ones with equanim-
ity. His early works came partly out of Surrealism, espe-
cially Miró and de Chirico. But his sharply focused,
sometimes spiky portraits also had to do with older Ger-
man art, Holbein and Cranach, and with paintings by Otto
Dix or Christian Schad: art from the Berlin of his child-
hood. He has always played down this German connec-
tion, perhaps, like a boy denying a likeness to his parents,
out of a certain familial rebelliousness. It is interesting that

he passes the Holbeins and Cranachs at the gallery with hardly a nod. Whatever may have attracted him to their work when he was younger, he says, has no effect on him now.

The Italians, it turns out, don't thrill him either. He barely pauses before several Titians, and stops for only an instant before Tintoretto's grave portrait of the aging Vincenzo Morosini. Freud's recent self-portraits are clear-eyed, even cruel, depictions of his own body. He admires the way Tintoretto did something similar to Morosini. But he claims to be blind to Raphael, and Bronzino leaves him cold. "Obviously there are wonderful Titians. But Italian painting gets me down. I suppose it's the Renaissance atmosphere: truth being beauty being slightly overstated. You know, Jesus is always shown to be handsome, finely made and young. His Jewishness never comes through. That's the nice thing about Rembrandt, isn't it? The halos are internal."

He warms generally to Dutch and Flemish art. About a landscape by Aelbert Cuyp, he says, "I can imagine a life where things aren't going well and people aren't doing what you want, and you say to yourself, 'I think I'll go and look at my Cuyp.' " Hals's fleshy figures have been an obvious source for Freud, who once painted a group portrait after a composition by Watteau that nonetheless had a link to Hals's voluptuous paint and to the awkward arrangement of figures in a work like the National Gallery's *Family Group in a Landscape,* which he calls "inventive and completely different. By different I mean Hals is like Giacometti: you enter a world that is singular and specific. He invented a whole new tribe of people."

Rembrandt is, of course, Freud's obsession. Before the sublime portraits of Jacob Trip and his wife, Margarethe de Geer, he says, "You feel you are being privileged because Rembrandt is giving you an ennobling insight into the nature of people. I don't mean he has made the people seem virtuous, but I mean it is ennobling to be told something

Rembrandt van Rijn / *Portrait of Margarethe de Geer,* c. 1661
Oil on canvas, 51⅞ x 38¾ in. National Gallery, London

so truthful. For instance, as people get older, the difference between the way men and women look diminishes. Rembrandt has observed this closely, so that Jacob Trip's wife actually transcends gender. As he got older and older, Rembrandt also made himself seem more like an old woman in his self-portraits. Actually, with Rembrandt, I don't necessarily feel that the portraits are like the people themselves. With Ingres, I do. Or with Géricault. But with Rembrandt, apart from the self-portraits, maybe, I don't

think that getting the personalities right was always his concern. After all, he chiefly painted businessmen, and I don't think businessmen were any more interesting then than they are now."

Freud paints only people he knows, he points out, and speaks about working "with" his models, not "from" them. In their grave and measured concentration, his portraits are meant to be respectful of the subjects, even what he calls his "naked portraits." "I'm very affected by the people I paint," he says. "Their nature even affects the way my paint goes on. For instance, I see funny things happening when I paint Bella, my daughter." Freud, twice married years ago, has children from various relationships. "I start with her head and do it over and over again, and things evolve from there in a way that can only come about because of my feelings about her. Normally I underplay facial expression when painting the figure, because I want expression to emerge through the body. I used to do only heads, but came to feel that I relied too much on the face. I want the head, as it were, to be more like another limb."

Until he died in 1994, the performance artist Leigh Bowery was Freud's most spectacular model, a huge, voluptuous man. Freud finished his last portrait of Bowery, a beautiful small painting of just his head, a year after Bowery's death. Many of the other pictures celebrate his gargantuan body.

"He was relatively unknown when I first painted him, though he was regarded as a sensation by the people who knew him. I had seen several performances and read about him, so I had a lot of him in my head before I started to paint him. In his case, with the first picture I did of him, I started with the head, then repainted it when the rest of the picture was finished. I did the head first to give me breathing space to get to know what he was like. And in the process I discovered that the body was such an absolute revelation. Generally, the reason I don't work with professional models is that when they are naked they are clothed, in a sense. They are used to being seen that way. And I

Lucian Freud / *Leigh Under the Skylight,* 1994
Oil on canvas, 117 x 47½ in. Private collection

want something that is not generally on show, something private and of a more innate kind. But Leigh Bowery's case was a special one because I felt his nakedness was his strength. I was painting that rare thing: not some dressed person who has his clothes off, but a kind of perfect instrument."

It is approaching three in the morning. Freud peruses Ingres's *Angelica Saved by Ruggiero,* with its comic-erotic

Jean-Auguste-Dominique Ingres,
Angelica Saved by Ruggiero, c. 1839
Oil on canvas, 18¾ x 15½ in. National Gallery, London

drama of a naked heroine chained to a rock. When Freud
was young, he was once called "the Ingres of existential-
ism" for his meticulous drawings of anxious figures. "In-
gres is about the best draftsman there is. Much as I like
Degas's drawings, compared with Ingres's drawings they
are like journalism to literature. But the idea that Ingres is
not a colorist, that his color was applied to his paintings
only after the drawing, is completely absurd and factually

wrong anyway. The truth is that Ingres's handling of paint is so subtle that many people don't realize the quality of it."

Then Géricault's *Horse Frightened by Lightning* causes Freud to remark that "his portraits of the insane make one of the grandest series in the history of art. What draws me to his paintings is that they nearly don't work. They're really on the edge. Everything is so dangerous—the cliffs are threatening, the horses are rearing, the women are slipping off the bed. And this is what attracts me to him, the sense of danger. The only works by him that seem at peace are the ones of dismembered limbs. At least they're calm. Géricault once told a friend that he was planning to travel, and in those days travel could be very risky. So the friend asked why, since Géricault was well-off and on the verge of a great career, did he want to take such risks. What attracted him to them? And Géricault said, 'The trials of misfortune.' Which I think says a lot about his art."

And what, if anything, does Freud think sums up his own work? Finally making his way out of the gallery, past the security desk to his car on Trafalgar Square, he replies: "My work isn't about giving art what I think it needs. You know the opening of Vasari's chapter on Michelangelo in which he says God was so dissatisfied with all the art that had been done so far that he finally sent down Michelangelo to correct the situation?

"That is not how I see myself. I remember Francis Bacon would say that he felt he was giving art what he thought it previously lacked. With me, it's what Yeats called the fascination with what's difficult. I'm only trying to do what I can't do."

SUSAN ROTHENBERG
AND BRUCE NAUMAN

We are in the Met, crowded together in the small room of extravagant fifteenth-century Italian trompe l'oeil marquetry called the Gubbio Studiolo, and Bruce Nauman says: "My father had a little shop in the basement where he liked to make furniture. As a kid, I loved making things, like model airplanes. My great-grandfather was a cabinetmaker. He worked in a Pullman factory, doing the wood paneling. There were some of his decorative pieces around the house when I was young, because my grandfather had kept them. I remember one of a frog on a lily pad. My grandfather never threw anything away, he just took stuff down to the basement and stacked it up. When he died, my father and I went to clean out the house and found two desks in the basement. Apparently, he'd filled up one with junk and instead of cleaning it out, he just started over with a new one."

You can see in Nauman's art the value he places on the inventively made object. This is clear in the odd and unhidden carpentry of some of his installations and in his waxworks, whose cast lines he leaves to show the process of their making. There is a sense in his work of labor as art, an oddly American notion of do-it-yourselfism that is clearly not about esthetic bliss but about the beauties of science and craft.

Nauman and Susan Rothenberg, who have been married since 1989, have come to the museum from their ranch in Galisteo, New Mexico, near Santa Fe. Nauman, in boots, blue jeans and a work shirt, looks like a rancher, which he is, sometimes: he raises horses and cattle when he isn't making art. Rothenberg, in a running suit, is short, with cropped hair and glasses, smiling and more immediately outgoing than Nauman.

Neither of them in person is what you might expect from their work. Nauman's art tends to be confrontational and sometimes loud and violent. It has involved videotapes of bellowing clowns and murderous couples, flashing neon signs with absurd puns and inane or obscene phrases, and installations that are claustrophobic and disorienting and have included taxidermy casts, hung as corpses, on a revolving carousel. The surprise about Nauman is that he is

Bruce Nauman / *Carousel (Stainless Steel Version),* 1988
Stainless steel, cast aluminum, polyurethane foam, wire, h. 84 in., diam. 216 in. Collection Ydessa Hendeles Art Foundation.

Susan Rothenberg / *For the Light,* 1978–79
Acrylic and flashe on canvas, 105 x 87 in.
Whitney Museum of American Art, New York

gentle, soft-spoken, amusing and perfectly straightforward, without any pretense. He pauses to gather his thoughts before talking. He speaks with a slight twang. There's something very American about him, and perhaps particularly Western: an innate kind of respect for manual labor before intellectual bona fides.

Rothenberg was born in 1945 in Buffalo, moved to Manhattan and came to prominence in the 1970s, along with New Image painting. In the eighties she was regarded as a Neo-Expressionist when the movement was prominent. At first, she painted silhouettes of horses, crude and

static outlines that were like symbols, sometimes criss-crossed by axial lines to stress the flat abstractness and arbi-trariness of the imagery. At one point at the Met, among stirrups, saddles and other ornate gear in the arms and armor galleries, she doesn't recognize a piece of armor for a horse's head, the precise shape of which she has often painted. This is because "the horse was always just a metaphor for me," she explains, likening it to Jasper Johns's bronzed Ballantine Ale cans, which were about art, not beer—that is, her horses were formal devices, she stresses, not true pictures of animals. "When I moved from New York to New Mexico, I tried riding. Now I'm more comfortable with horses, not on them. I'm a tactile person, so I like my hands in their manes, the way I like my hands in the mud and my hands in the paint."

Her paintings of horses were nonetheless a response to Minimalist geometry and its emphasis on industrial mate-rials, an attempt to open art up to the world by letting in a little nature. Gradually, the surfaces of Rothenberg's paint-ings turned into flurries of flickering strokes that suggested movement, teetering, then frenetic. She began to paint dis-embodied heads and hands, spectral figures of beggars and skulls, malevolent and pained. Color replaced black and white, and after she moved from New York to Galisteo, the colors soon echoed the rich earth tones of the landscape there. The mood shifted, too, becoming warmer.

Her focus at the Met is narrower than Nauman's. She's quicker to give the thumbs-up, or more often thumbs-down, and is specific in her descriptions of paintings. She gravitates to expressive painters like Rembrandt, Velázquez and Philip Guston. Vermeer "has got no juice," she de-cides. "The work is dehumanized somehow." She relates Vermeer's colors to a daguerreotype's, tinted. Nauman is not so sure about that.

They joke that while she is a painter, he does everything except paint. "I usually take my three-hour walk with the dogs when Bruce's videos are on in the studio." She laughs. "Actually, Bruce is more open than I am to lots of

art and is very receptive to painting, which isn't surprising if you look at his work, because he's a great colorist. The weird colors in his videotapes are deliberate. So are the colors of his waxes." Nauman has made casts of heads in sour orange, green and blue, suspended on wires. Here at the Met he's eager to see Degas's sculptures, bronze casts of the wax originals, which he admires. This admiration for sculptures of ballet dancers may seem odd, considering his work, which has put him on the crest of nearly every art wave in the last thirty years, from Post-Minimalism and Conceptualism to language games and body and installation art. "I don't know that I've spent more than an hour at a time in a museum," Nauman warned me before we met, but of course he was kidding. He's steeped in art. He is also a natural gifted draftsman, and the simmering, confounding quality of his installations and videos may have something to do with his tendency to deny himself the

Bruce Nauman / *Ten Heads Circle/Up and Down,* 1990
Cast wax, diam. 96 in., 71 in. from the floor
The Eli and Edythe L. Broad Collection, Santa Monica

physical pleasure of drawing or painting. "Bruce is probably a frustrated painter who wants all the joys of painting without having to make one," Rothenberg says. Nauman laughs.

The two of them share various interests. Both were engaged by the performance art of the 1960s and, differently, have used disconnected hand and body gestures as cryptic signs that stem in part from the performance tradition. They have been in the spotlight at separate times, and this fact, along with the differences between her work and his, has clearly allowed them space to breathe while being together in the relative isolation of Galisteo. With each other they are solicitous, respectful, deeply affectionate, inclined to cede the floor rather than take it.

For example, Rothenberg, talking about Fragonard's *Love Letter* (see p. 92), says: "It's pretty, I suppose, but the eyes are no good, the mouth is no good. There's no presence in the painting, finally, it's all just paint handling, and unconnected to the stuff that moves me."

Nauman nods. "What Susan likes to say about the efficiency of brushwork is true. This isn't efficient. We both need to have an idea before we start to work. At first when she's working and really excited, I may not have a clue about where she's going. And the same is true of her with my work. Then at a certain point I can feel the strength of her painting. I can't help her fix a problem if she's in trouble, but I can tell her if I think something is happening, and she can do that for me, too."

They also have certain favorite artists in common, like Johns and de Kooning, though having recently been to a show of de Kooning's late work, Rothenberg says, "De Kooning was always important to me because of his whole struggle to produce a painting, then becoming unsettled by it, doing something else to it, until finally it was O.K. by him. But I don't find the late paintings affecting. I respect the handling, the journey, the extreme simplifying, but the forms don't move me. The lines go nowhere, and they're interrupted by vacant spaces. I don't know what consti-

Willem de Kooning / *Untitled VII,* 1985
Oil on canvas, 70 x 80 in.
The Museum of Modern Art, New York

Bruce Nauman / *End of the World,* 1996,
with Lloyd Maines
Video projectors and laserdiscs (video still)
Private collection

tuted finishing a late painting for him: why did he stop one and start another? There's no place for my eye to land. It's a big miasma of forms and colors and shapes from his old work that don't add up as individual pictures."

Nauman agrees, but only in part. "I wouldn't necessarily want to take any of those last paintings home with me, either," he says. "But de Kooning's still important to me, because he lived a long time and continued to make work. And as you get older it's valuable to see other people continuing to try to figure out why they're doing what they're doing. De Kooning was also important when I was young and trying to learn about structure and line, and because he was what was going on—him, Barnett Newman. It took me years before I saw their paintings except in reproductions, and then it was an amazing experience. I had always thought that Newman was a hard-edge painter, until I saw the physicality of his paint, the scale, the softness of his lines. Actually seeing the art, his or de Kooning's or Lichtenstein's, gave me a sense that maybe art was something I might do too. It made it real."

Nauman and Rothenberg have now moved to the Met's galleries of musical instruments. At the University of Wisconsin in the late fifties he studied classical guitar and took music theory classes, developing an admiration for, among others, Arnold Schoenberg, whose twelve-tone system aggressively challenged the dominance of tonal music. Schoenberg became a model for Nauman, who, partly by including sound, was to rethink art in terms besides traditional painting and sculpture. "I respect Schoenberg for his intellectual curiosity," he says, staring at one of Andrés Segovia's guitars in a vitrine in the gallery. It happens that Nauman has recently videotaped the country musician Lloyd Maines playing "The End of the World" over and over, on a stringed instrument called the dobro. The sounds of Nauman's videos can be loud, grating, relentless. The critic Andrew Porter once wrote about the needle-stuck-in-the-groove annoyance he felt at Philip Glass's *Einstein on the Beach* before succumbing to its in-

cantatory effect. Something similar could be said about what Nauman's art demands. In the sixties he got to know the music of Glass, John Cage, Steve Reich, Lamont Young and others roughly grouped as Minimalists, with their insistent rhythms and expansive, repetitious forms. "I wanted to get time and sound into my work, and so they were important composers for me, especially Cage," he said. "In terms of sound and time, other things interested me too, of course, like Andy Warhol's films."

Back in the Met's arms and armor galleries, he seemed more naturally at home than Rothenberg, and he was particularly drawn to objects like the Japanese knives, simple curved blades polished to an improbable sheen. Years ago, he says, he took up knife making with his friend Richard Jackson, also an artist: "Richard hunted, took me once, and said, 'You've got to have a good hunting knife.' His uncle or father had given him the knife he'd been carrying since he was young. But to buy one like it would have cost too much, so we figured we'd make it ourselves. Then we met this guy, Bob Loveless, who revived knife making as a custom craft, and he told us that a well-made knife should feel like a tool you've been using all your life, something you could do whatever you want with. That made a big impression on me, to think about a tool that way, that there was something beautiful about its utility."

This also helps explain why he picks out certain artists at the Met, like Dürer or Degas or Eakins. "Eakins has always been especially interesting to me, not just because he's a wonderful draftsman but also because of his fascination with photography, with anatomy, with how the whole world around him worked."

I ask who Rothenberg values among painters and she takes us first to look at Velázquez's portrait of Juan de Pareja. "I'm jealous," she says, "because it's so much harder than it looks. There's nothing superfluous, just real feeling, real flesh, real volume. He's indistinct where he needs to be, like at the hairline, anywhere that would distract from the focus on those amazing eyes. Look at those little bits of

Thomas Eakins / *The Thinker: Portrait of Louis N. Kenton,* 1900
Oil on canvas, 82 x 42 in.
The Metropolitan Museum of Art, New York

white and gray and brown in them, which pick up the color of the skin, and also look at the pinkish lid. And what color is that above the eye? It's a kind of blue, isn't it?"

It turns out she has a passion for portraits, something unexpected only if you don't recognize that her works are, in part, allusive self-reflections. The vomiting and severed heads she painted starting in the late seventies were autobiographical statements in response to a divorce. Lately her paintings of poker players and, in one case, of a figure felled by a near-fatal bee sting (herself, though you wouldn't know it) derive directly from her own life.

"I'm a painter who has to know what my subject is be-

Diego Rodríguez Velázquez / *Juan de Pareja,* 1650
Oil on canvas, 32 x 27½ in. The Metropolitan Museum of Art, New York

Susan Rothenberg / *Impending Doom,* 1996–97
Oil on canvas, 69 x 94 in. Donald L. Bryant, Jr., Family Collection

Rembrandt van Rijn / *Self-Portrait,* 1660
Oil on canvas, 31⅝ x 26½ in. The Metropolitan Museum of Art, New York

fore I paint," she says. "I struggle with it all the time, and a straightforward portrait would be a kind of anchor. I envy Lucian Freud and Chuck Close, waking up every morning and knowing what they're going to do. But I also realize it would be too limiting for me. I don't want to have to make a resemblance of anybody, to have my hand and arm gestures, the way I mix paints, constrained. We wish for what we can't have. Sometimes, for instance, I wish I had a light hand, like Matisse's."

In front of one of Rembrandt's late, moody self-portraits, she says something similar: "The texture of the surface is incredible, the buildup of paint in the wrinkled skin around the chin, and I realize that I'll never get to this point myself but I hope someday to get to the point that Philip Guston did, knowing just what he wanted to paint, how to paint it, how much paint to use, how big the painting should be. Everybody has an end point where, if they

Elizabeth Murray / *Terrifying Terrain,* 1989–90
Oil on shaped canvases, h. 84½ in., w. 85 in., d. 11 in.
The Metropolitan Museum of Art, New York

do something all their life, they achieve a knowledge of themselves, like Guston. I don't respect natural talent as much as perseverance."

Guston, in particular, has influenced Rothenberg. She calls his late cartoonish painting at the Met, *The Street,* with its battalion of hairy arms grasping garbage-can lids like shields, "rambunctious, dirty, grizzly and sweet." (It's illustrated on p. 31.) She says, "Those garbage lids in the shape of halos look sweet to me. Somehow Guston found a secret pathway straight from the subconscious."

It's interesting what else Rothenberg looks at, and doesn't, in the Met's twentieth-century galleries. She quickly passes her own *Galisteo Creek,* a big, briskly painted picture of swimming shapes against a shimmering orange field (p. 28). Seeing her own work makes her uneasy, she says, turning instead to *Terrifying Terrain,* by Eliza-

beth Murray: a dense picture in relief, itself indebted to Guston. "I assume the word 'terrain' refers to a psychological, inner space," Rothenberg says. "I like what Elizabeth does with these looping folds, the way she loads up the paint, then provides nice openings with these loops, airways into and through the volumes of the painting. She takes some of the toughness away with the loops, but on purpose, I think. She wants the picture to work at cross-purposes."

It turns out that Rothenberg and Nauman spent an afternoon not long ago at a Winslow Homer show at the Met. I ask whether, before they go, they would like to see more Homers. Nauman remembers being struck by a particular watercolor of hunters killing deer by forcing them into the water to drown. "I once videotaped a neighbor of mine skinning a fox. He's a trapper and hunter and painter and jewelry maker, and skinning is part of life to him. But when the video was shown in New York, people took it as an antihunting or antitrapping statement." Art is often what you read into it, Nauman points out.

Rothenberg calls early Homer "too Audubon." She and Nauman both admire late Homers, big foaming seascapes of the rocky Maine coast. "I don't like it when every aspect of the painting is explicit," she says. "But these I like more."

"Later on, he let the paint do a lot more of the work," Nauman adds. "He still didn't entirely trust the paint, trust his hand, so he always took one step extra to explain himself."

Rothenberg agrees. "Going too far is a danger, not knowing when to stop. Bruce and I talk about it all the time. I'm never satisfied. What I say is, a picture may still make me uncomfortable, but I stop when the itch is gone. I stop when I'm not driven crazy by it anymore."

HENRI CARTIER-BRESSON

enri Cartier-Bresson is sharp, amusing, roguish. He remains an astonishingly live wire who likes to say his approach to life has been shaped by Buddhism. His wife, the photographer Martine Franck, has described him to the Dalai Lama as "a Buddhist in turbulence."

The view from their apartment, overlooking the Tuileries, takes in the Louvre to the east and the Musée d'Orsay to the south. A century ago Monet and Pissarro painted the same scene from the apartment below. These days Cartier-Bresson sometimes draws it from his balcony. "No one would care about my drawings if I weren't a famous photographer," he says. "I'm not gifted; I'm an impostor." He has taken few photographs in over twenty years, only the odd landscape or portrait or curio done for pure pleasure and on the sly. He claims he doesn't even like talking about photography anymore, and he can turn uncharacteristically peevish if asked, say, whether he saw a recent exhibition of photographs by Nadar (he didn't). "It's like when you're divorced and people keep asking you about your former wife," he says. "There's something indecent about it." In truth, photography crops up in his conversation all the time, but he fears sounding like a bro-

ken record, having spent a lifetime making his opinions known.

Drawings are something else. His undiluted, almost boyish enthusiasm for them is not only contagious but also remarkable in someone at his stage of life. These days he draws constantly, sometimes in the Louvre. This late spring day in 1995 was to have been one of those occasions, but a strike has closed the museum, so he goes to Orsay, only to discover that it is shut too. He votes to recoup over lunch at a Chinese restaurant near his apartment off the Rue de Rivoli, and to try again the next day. It's funny how indecisive he can be when faced with trivial mishaps like this, considering he is famous for a book of photographs whose English title was *The Decisive Moment* (the original French "Images à la Sauvette" might more precisely be translated as "images on the run"). But in several ways he is a contradictory person. He claims, for instance, as he does with all interviewers, not to give interviews ("This is just a friendly conversation," he repeats several times) and over lunch in-

Henri Cartier-Bresson / *Les Tuileries, Paris,* 1977
Graphite on paper. Collection of the artist

sists that a tape recorder be put away—until, that is, some bon mot pops into his head, and then, pleased with himself, he looks expectantly at the machine, his eyebrows raised, as if to say "So?"

His life story has been told many times. Born near Paris in 1908, he was the scion of a highly prosperous textile family so puritanically frugal that he thought he was poor. He became a rebellious young man, given to reading D'Annunzio, Joyce and Rimbaud. He went to Africa to hunt boar and antelope (the metaphor of shooting has naturally become a familiar one in writings about his photography), and there he contracted blackwater fever, which nearly killed him. The way he tells it, a witch doctor got him out of a coma. While still feverish he wrote a postcard to his grandfather, asking that he be buried in Normandy, at the edge of the Eawy forest, with Debussy's string quartet to be played at the funeral. An uncle wrote back: "Your grandfather finds all that too expensive. It would be preferable that you return first."

Recuperating back home, he acquired a Leica and set off with the tiny camera, taking pictures that, although related to photographs by Atget, Lartigue and Kertesz and, in their mystery, to paintings by de Chirico, were nonetheless groundbreaking. Of an uncanny formal perfection, they have become icons of photographic history. Next he turned briefly to cinema, learning the ropes from Paul Strand (whom he would always call Mâitre), then assisting Jean Renoir. When the war began, he enlisted in the army. He was captured and escaped three times from German labor camps, after which he joined the Resistance. About the camps he says, "For a young bourgeois with Surrealist ideas, breaking stones and working in a cement factory was a very good lesson." It was widely rumored that he had actually died, not merely been captured, during the war, and the Museum of Modern Art in New York even planned a posthumous Cartier-Bresson exhibition, which he attended.

In 1947 he helped to found the Magnum photo agency.

Henri Cartier-Bresson / *Behind the Gare St.-Lazare, Paris,* 1932
Gelatin-silver print, 19½ x 14⅛ in.
© Henri Cartier-Bresson/Magnum Photos, Inc.

Henri Cartier-Bresson / *Valencia,* 1933
Gelatin-silver print, 12⅞ x 19⁹⁄₁₆ in.
© Henri Cartier-Bresson/Magnum Photos, Inc.

He spent the next twenty years on assignment, bearing witness to the great upheavals in India and China. His photographs chronicled this century's singular people and events, and they are among its brilliant and most humane testimonials. Cartier-Bresson was in part Rimbaud, a nineteenth-century poet-traveler, but he was also something particular to the twentieth century, a photojournalist and eyewitness to history.

"I am fed up with the segregation between photo and drawing," he announces, settled into his Chinese meal. "I was never deeply interested in photography as such. I don't say drawing or painting is better than photography. I want to make people aware that beyond the use of a tool, there is a basic connection: what counts is your eye, your sensitivity and the strength of the shapes you make."

Describing Cartier-Bresson in 1936, Nicolas Nabokov, the composer and writer, spoke of his "blond and pink head" and "gently mocking smile." What most astonished Nabokov were Cartier-Bresson's eyes: "Like darts," he wrote, "sharp and clever, limpidly blue and infinitely agile." Today those eyes are behind thick lenses when he draws. His hair has thinned. He is tall, with patrician bearing and manners, unostentatious in his appearance. He has always had a photographer's penchant for invisibility, carried to attention-getting lengths such as shielding his face while receiving an honorary degree at Oxford. In America he traveled under the alias Hank Carter. As Cartier-Bresson he was a famous photographer, but his face was unknown, and he once recalled leaving an exhibition of his own work at the Museum of Modern Art: "It was raining. I was under an awning and there were some youngsters next to me when suddenly I leapt out, holding my Leica, and I heard one of them say, 'Look! There's a guy who thinks he's Cartier-Bresson.'"

"I call myself an artisan," he explains. "Technoscience has destroyed artisanship. Anyone with sensitivity is potentially an artist. But then you must have concentration besides sensitivity. Degas was right when he said something

like 'You must copy, copy, before you are entitled to paint a radish from nature.' He meant you have to learn from others, from the past. Art for people today starts with Duchamp. But Conceptual thinking is like walking with your head instead of your legs. You need a sense of culture to cultivate yourself. It's the difference between writing a tract and literature."

———

The Louvre remains on strike for several days. But the Musée National d'Art Moderne at the Pompidou Center is open, and Cartier-Bresson agrees to go. He takes along his sketchbook. "It's strange I never think of coming here," he says, then remembers a visit years ago with his daughter to the Musée d'Art Moderne de la Ville de Paris, another place he rarely visits these days. "We saw there was an exhibition of sculpture and wanted to get in," he recounts, "but we were told it was only for blind people. So we went blindfolded. I couldn't recognize one sculpture from another." It is, out of the blue, a slightly surreal story that puts one in mind of his roots. In the 1920s, while he was still a teenager, he used to go to the café in the Place Blanche where André Breton met twice daily with his Surrealist compatriots. Cartier-Bresson would eavesdrop. He never became a Surrealist officially, but from Surrealism he clearly developed a respect for free, iconoclastic expression, not to say a taste for revolution in politics and art. Surrealism involved an escape from reality, a denial and manipulation of the seen world, which, despite his gift for visual anomalies and psychological oddities, was never Cartier-Bresson's inclination. But Surrealism also involved a general approach to life that was antitraditional and socially revolutionary. During the 1930s he collaborated with Renoir on a propaganda film for the French Communist Party that denounced the two hundred most prominent families in France, including his own. He didn't formally join the Party, but his sympathy for the poor and downtrodden, and his dislike of class pretense, so essential

Henri Cartier-Bresson / Photograph of
Pierre Bonnard, 1944
Gelatin-silver print
© Henri Cartier-Bresson/Magnum Photos, Inc.

to his photographs and personality, led him, like many of his generation, to embrace various Communist causes.

At Pompidou, his opinions about art turn out to be refined, his tastes eclectic: he admires early Pollock, Joan Mitchell, Ernst, some Nolde, early Léger but not late Léger. What he likes is work with an edge to it, art that balances intellect with sentiment. When the balance tips, he demurs. He is left cold by most Dubuffet, for example, and actually flees a room of Duchamps. "A charming man, a dandy," says Cartier-Bresson, who took some wonderful photographs of Duchamp. "But art was just a subtle game for him. Conceptualism," he reiterates, "is a dead end."

His visit gradually takes on the air of a reunion. A Calder reminds him of a little sculpture that artist once gave him. Some Rouaults remind him that he has misplaced their correspondence. Drawings by Alberto Giacometti, to whom he was especially close, for a moment actually leave him speechless with admiration. The ner-

vous, searching lines of Cartier-Bresson's drawings owe an obvious, perhaps too obvious, debt to Giacometti, which he is perfectly happy to acknowledge. "For me, Alberto's drawings are the top, top, top. If you look at the copies he did of Cézanne, of medieval sculptures and everything else, you want to stop working because they're so inquisitive, intelligent and powerful. He was a man of tremendous culture, and you see that in his copies."

He settles into a room of Bonnards and relates one of his favorite anecdotes about the time he photographed Bonnard. It involves the importance of intuition. In 1944, he says, he stayed with Matisse at Vence, then for a week with Bonnard at Le Cannet. "We were chatting, and mostly he was quite silent," he says of Bonnard. "Suddenly, when I raised my camera, he put his scarf over his face. So I put my

Pierre Bonnard / *Self-Portrait,* 1939–45
Oil on canvas, 28¾ x 20⅛ in.
Centre Georges Pompidou, Musée National d'Art Moderne, Paris

camera down. Finally, I managed to take a picture and he asked, 'But why did you take it at that moment, why?' And I said, 'Excuse me, but why have you just put that yellow there?' "

Cartier-Bresson points out the modesty of a late Bonnard self-portrait from 1939–45, in which Bonnard stares into a mirror. "You know, Picasso didn't like Bonnard, and I can imagine why, because Picasso had no tenderness. It is only a very flat explanation to say that Bonnard is looking in a mirror in this painting. He's looking far, far beyond. To me he is the great painter of the century. Picasso was a genius, but that is something quite different. What you have in Bonnard is a combination of tremendous freedom and also discipline. You can't have freedom without discipline. There is no such thing as complete freedom, just as nothing in the world is completely good or completely bad. Everything is relative. There must be freedom, yes, but always with a sense of form and structure behind it. This is what André Lhote taught me. All I know about photography I learned from André Lhote."

In 1927 Cartier-Bresson became Lhote's student. For a while he had been pushed to take over the family business, but he more naturally gravitated toward the example of his late uncle ("my mythical father," he says), a painter killed in World War I who had studied with the artist Fernand Cormon, a student of Cabanel and Fromentin. Cartier-Bresson's father also drew, as a pastime, and Cartier-Bresson preserves at home some of his father's drawings, along with some by a great-grandfather, which he shows proudly to anyone who asks about them. "He was a wool merchant but look what a draftsman. Ohhh!" he says about his great-grandfather.

Cartier-Bresson first studied with Jacques-Émile Blanche, a friend of Proust's and Degas's, who, among other things, introduced him to Gertrude Stein. Then he went to Lhote, an early exponent of Cubism, and an admired teacher and author of pedagogical books, though a minor painter. Lhote preached a doctrine that sought to

link the French classical tradition of Poussin and David to modernism. His emphasis on geometry and the golden section left a lasting impression on Cartier-Bresson. Many critics have pondered the split between Cartier-Bresson's photographs, with their instantaneity, and his drawings, with their hesitant, even painstaking lines. The link between them includes a belief in discipline and order, traceable to Lhote.

This belief also helps to explain, for instance, his particular admiration for Matisse. In a room of Matisses at the museum, he removes a small sketchbook and pencil from his knapsack and silently settles himself before the 1917 portrait of Auguste Pellerin, the great collector. Balanced on his shooting stick, he begins to draw, starting with Pellerin's massive head, oval eyes and thick eyebrows, which he traces over and over, using an eraser to smudge the lines. The image gradually darkens so that the face, with its pinched, catlike expression, emerges out of a shadow, much as it does in the painting. While he sketches, a tourist snaps his picture and another videotapes him, unaware of who he is, but charmed by the sight of an old man sketching. He ignores them until he finishes, then says: "Goethe wrote that the best way to understand a painting was by drawing it, and he's right. How many people have been here? A dozen? More? And they don't look. They all have their cameras. But looking is meditating, and how can you meditate and look through a camera at the same time?"

Turning back to the Matisse, he holds a postcard to his face to block one half of the portrait from sight, then the other. Pellerin, he says, "seems to be questioning you from his grave, no? And you see how one side is much warmer than the other: the eye on the left is affirmative, definite; the other eye belongs to somebody who has been suffering, who doesn't pass judgment. He seems immobile at first, but there is nothing immobile about the picture. The little pink here, the swirls there, the touch of brown on the collar. And look at the black here," he says, pointing to

Henri Matisse / *Portrait of Auguste Pellerin,* 1917
Oil on canvas, 59 x 37⅞ in.
Centre Georges Pompidou, Musée National d'Art Moderne, Paris

the jacket. "See all the colors, greenish-blue, red, all down
the sleeve? Such refinement. This is real action painting.
Everything is moving, contrasting. The contradictions are
beautiful."

Now he glances at his own sketch. "Let's see where I
put the eyebrow in my drawing. Yes, in the right place.
You see, there is no logic here except the logic of paint-
ing—it's beyond reasoning. He didn't use a compass. The
head is like the shape of an egg, but not quite. And he has
a very little neck, like a chicken's almost, with this tremen-
dous egg head, so everything is in the head—everything is
intelligence, questioning, questioning—and the rest of the
body is nothing by comparison. If he has a sex it would be
miniature, no? I think this is one of Matisse's greatest

Henri Cartier-Bresson / Copy after Matisse's
Portrait of August Pellerin, 1996
Graphite on paper, 8¼ x 6 in. Collection of the artist

paintings. When I see Madame Lydia I want to speak with
her about this painting, even though it is from far, far ear-
lier than her days." He is referring to Matisse's model
Lydia Delectorskaya. He says, conspiratorially, "She's still
beautiful, you know. Madame Lydia, very beautiful." She
died in 1998.

Although he says he is finished with photography,
Cartier-Bresson makes a point of letting you know when
some image catches his eye. On the way out he stares at a
couple sitting side by side on a bench at the museum, a
child resting on the man's shoulder. "A perfect composi-
tion if you cut out the woman," Cartier-Bresson says and
makes a brisk chopping gesture toward her with his hand.
He is now standing just a few feet from the couple, who

look as you would guess, baffled by him. "Why didn't I bring my camera?" he says, then clicks an imaginary shutter and leaves.

—

"There is something appalling about photographing people," he has said. "It is certainly some sort of violation; so if sensitivity is lacking, there can be something barbaric about it." A camera, Cartier-Bresson believes, is intrusive and aggressive in a way a pencil isn't. But he also believes that "there is no esthetic peculiar to photography or drawing," meaning they are essentially akin as creative endeavors. One of his famous remarks is that photography is "a marvelous profession while it remains a modest one. But once it becomes Art with a capital *A,* it is awful." And this helps to explain why he belittles his own drawings: not because he doesn't take pride in them, because he secretly does, but because he regards them, like people, as admirable to the degree they are humble.

When the strike ends, Cartier-Bresson finally sets out to draw in the Louvre. "One must go often to museums and look at a few paintings at a time," he says. "And for a long while. It shouldn't be just about identifying this or that— oh, a landscape, oh, a portrait, oh, an Ingres—and then move on." He says, "We are nourished by studying the past, though we must also be fully involved with the moment." Nowadays he fills his sketchbooks with drawings after Old Masters. He has done a series based on works by Delacroix and Goya at the museum in Lille. Today he wants to draw Chardin's big still life of 1725–26, *The Ray.*

To get to it requires walking through many galleries of works by seventeenth-century French painters like Simon Vouet and Eustache Le Sueur and Charles Lebrun, for whom Cartier-Bresson has no patience. "We just want to show that we are rich," he says, meaning the French. "This satisfies historians, but the public suffers." He brightens when he arrives at the gritty *Peasant Family* by the Le Nain brothers. "The figures seem to come out of a very, very dis-

H.CB
80

Henri Cartier-Bresson / Drawing from Ingres, 1980
Graphite on paper, 12 x 9½ in. Collection of the artist

tant past and say 'Here we are.' They are so dignified. You
see the same in the peasants of France today. They are pro-
foundly rooted." Nearby, a Georges de la Tour of Christ as
a boy holding a candle that illuminates Joseph reminds him
of Léger and Cubism—"the sense of volumes," he says.
"It's too theatrical for me, with the candle and so on, but
interesting."

He also warms to Watteau's *Faux Pas,* an image of a
young man putting his arm around a reticent young
woman. "He didn't have the patience to wait, huh?"
Cartier-Bresson laughs. "He's like a torero." The particu-
lar combination of anecdote, wry humor and affection in

Jean Antoine Watteau / *Le Faux Pas,* 1718–19
Oil on canvas, 15¾ x 12⅜ in. The Louvre, Paris

Jean-Baptiste Chardin / *The Ray,* 1728
Oil on canvas, 45¼ x 57½ in. The Louvre, Paris.

many of Cartier-Bresson's photographs, not to mention their sensual appreciation for women, makes his attraction to this little Watteau easy to understand. "His work is so sensuous," he says. "Pornography has killed all this, of course." When he was young, he remembers, he would go with friends like André Pieyre de Mandiargues and Pierre Josse to drink mint liqueurs in a brothel on the Rue des Moulins, where Degas and Toulouse-Lautrec went to draw. "It doesn't exist anymore, and I never went upstairs for sex because I had girlfriends for that purpose, but I'd go just for the conversation and to have a drink," Cartier-Bresson says. "It was very agreeable." Later, passing an odalisque by Ingres, he pauses to drink it in: "Oh là là! C'est l'invitation à la valse, non?"

Chardin's famous *Ray* depicts a dead stingray hung to dry among pots and pans. Fish and oysters are in the foreground, a smorgasbord sniffed at by a wiry cat. Cartier-Bresson sits in front of the picture and begins sketching the cat but soon crosses out the drawing and starts again. It's especially hard for him to get the complicated spatial relationships—lots of layers within a shallow field—just right. He occasionally pulls out a postcard of the image, which he turns upside down to compare to the painting. "Like a camera obscura," he explains. "You can see it more clearly this way." He used to advise photographers to do something similar, a variation of what Dürer recommended: look at images flipped or backwards to focus more on the geometry of the pictures than on the subjects.

He spends about an hour, all told, intensely studying the Chardin. "This is a most mysterious painting. The ray seems to look up to eternity, like a Pietà. The fish and oysters and ray are dead. The cat is the only living thing. It is a picture about life and death. A spiritual painting." Himself a genius of formal geometry in his photographs, Cartier-Bresson naturally points out the work's intricate scaffolding, the way the line of a pot's edge happens to intersect with an eye of the ray, the way one leg of the cat points to the tip of the nearest oyster. "We could continue,

about the inside of the shell and the ray exhibiting her insides." He seems to be implying a sexual interpretation. "But finally there is nothing to compute in front of all this, just a deep breath of thankfulness to Chardin. It would take hours and hours to feel a painting like this. I don't say understand; I say feel."

He says he got excited recently by an article about a neurophysician who believes that emotions are the foundation of reason. "We always want to work with our brains," Cartier-Bresson says, "but we must be available and let our sensitivity direct us when we look at a painting, as if we're surfing on a wave. We must be open, open, open to what it gives us. That is the Buddhist idea."

CINDY SHERMAN

Cindy Sherman says she can't remember the last time she visited the Metropolitan Museum of Art. In the lobby, along with the tourists, she is fishing around the information desk for a map. What is there to see? she asks. She is open to suggestions. She has heard about a show of works by Nadar, the nineteenth-century French photographer, but doesn't know much about him. We might as well start there, she says, and on the way, walking through a hall of drawings and photographs, she happens upon a photograph by William Lake Price from 1857, a stagy picture of someone dressed as Don Quixote. "I never look at these sorts of photographs," she volunteers, then absentmindedly glances at the label. "Theatrical staging has found renewed relevance in the work of such contemporaries as Cindy Sherman," it says.

Of the American artists who came to prominence in the 1980s, Sherman has had a steady success, while the sky-rocketing careers of many of her contemporaries fizzled along with the market that fueled them. She began her career in 1977, having just settled in New York City after art school in Buffalo, by taking a series of artfully crude black-and-white photographs of herself that imitated B-movie stills and celebrity snapshots from the fifties and sixties. Sherman posed in the guises of housewife, ingenue, maid

William Lake Price / *Don Quixote in His Study,* c. 1857
Albumen silver print from glass negative, 12½ x 11 in.
The Metropolitan Museum of Art, New York

and starlet. In some pictures she resembled Frances Farmer, in others Sonja Henie or Anna Magnani. Occasionally, an undercurrent of sadness, even pain, ran beneath the surface of irony and camp. That undercurrent turned, rather startlingly, in the 1980s into a torrent of gore and rage when she switched to using a larger format and often lurid colors, and to concocting increasingly horrific and surreal images. (One of her favorite films, not coincidentally, is *Night of the Living Dead,* and her own directorial debut, *Office Killer,* is a sort of tongue-in-cheek slasher.) Some of her gory photographs were based on fairy tales, others on fashion spreads and pornography. As before, the theme re-

Cindy Sherman / *Film Still #7,* 1978
Black-and-white photograph, 10 x 8 in. Courtesy of
the artist and Metro Pictures

Cindy Sherman / *Untitled 250,* 1992
Color photograph, 50 x 75 in. Courtesy of the artist and Metro Pictures

mained feminine identity, but now women were often seen as brutalized victims.

Because Sherman starred in the early stills, many people came to believe that they knew what she looked like, but it's almost uncanny how little she resembles any of her own pictures, even the ones that seem fairly straightforward. She is handsome, thin, with cropped brown hair and bangs. She can remind you a little of Jean Seberg. Considering that she has become a darling of academics and has inspired reams of arcane criticism, it's nice to discover how plainspoken and easygoing she is, though like her photographs—despite their surface of theatricality—there is something slightly distant about her. Like many artists, Sherman tends to talk about her own work when she looks at the works of other people, and though she reacts to what's at the Met, art history per se doesn't interest her much. She remembers going to the Prado, she says, and being smitten by Goya's and Bosch's more graphic scenes of violence "right when I was beginning to do disgusting works of my own." She has a fairly omnivorous appetite for images and perfect instincts for adapting them to her own purposes, but clearly she isn't concerned about their past. "I can't stand the idea of art as a precious object," she has said, and also that her goal was an accessible art, "not one that you felt you had to read a book about" to understand. In fact, she claims not to read much, and used to tell interviewers that she liked to spend her free time watching television. Her work is clever but it isn't born of theory, and it is prompted no less by the props she buys at flea markets and through medical-supply catalogues than by the works of art she has seen in museums and reproduction.

"Even when I was doing those history pictures," she says of a touted series of photographs that she loosely derived from Old Master paintings, "I was living in Rome but never went to the churches and museums there. I worked out of books, with reproductions. It's an aspect of photography I appreciate, conceptually: the idea that im-

Cindy Sherman / *Untitled 211*, 1989
Color photograph, 70¼ x 57 in. Courtesy of the artist and Metro Pictures

ages can be reproduced and seen anytime, anywhere, by
anyone."

She was born in 1954 in the leafy New York suburb of
Glen Ridge, New Jersey, and grew up in the town of
Huntington on Long Island. "It wasn't until college that I
had any concept of what was going on in the art world.
My idea of being an artist as a kid was a courtroom artist
or one of those boardwalk artists who do caricatures. My
parents had a book of, like, the one hundred most beauti-
ful paintings, which included a Dalí and a Picasso among
the most recent artists. My father was an engineer and my

mother a reading teacher. I was born late and he was re-
tired when I was ten. They were very encouraging when I
chose to go to art school, though my mother suggested
that I take a few teaching courses just in case." She decided
to study photography at Buffalo State College, where she
met Robert Longo, whose work achieved its own fashion-
ability in the eighties. Together with Charles Clough, they
started an independent artists' space called Hallwalls. "I
was initially in school for painting and suddenly realized I
couldn't do it anymore, it was ridiculous, there was
nothing more to say. I was meticulously copying other art
and then I realized I could just use a camera and put my
time into an idea instead. I came to feel that there was
nothing more painting could say to me: it had explored
content and surface and color and materials, and it just
seemed like it exhausted its possibilities. What I now real-
ize is that I never had, or at least I lost, the ability to look
at painting critically; I can relate to it on a real visceral
level, but I feel I can't, like, talk about somebody's work
and say for certain that I like this year's show better than
last year's show."

Sherman has recalled being struck by Lynda Benglis's
notorious ad in the November 1974 *Artforum* magazine, in
which, nude, Benglis held a dildo to her crotch, imitating
a man with an erection, a black-humor parody of the male
artist as protean hero and of the woman as object of desire.
Sherman also saw Eleanor Antin's 1973 photographs of
herself nude during various stages of a diet—ironic but
deadpan images taken during a wave of art-world femi-
nism that, significantly, also included the photographs of
lesser-known artists like Dori Atlantis, whose parodic pic-
tures involving women dressed as Kewpie dolls or Victo-
rian whores closely anticipated Sherman's work. Sherman
says she never heard of Dori Atlantis.

She graduated in 1976, and moved to a loft on Fulton
Street in lower Manhattan, where she began to make her
stills. She finished the series around 1980 when, as she puts
it, she ran out of feminine clichés to parody. She was given

her first solo show at the nonprofit Kitchen, and her career

took off. She was only thirty-three when her retrospective
arrived at the Whitney in 1987.

The influences of seventies Performance and Concep-
tual art were clear from the start. Only later, Sherman said,
did she realize the affinities between her work and that of
older photographers like Hans Bellmer, Diane Arbus and
August Sander. Nowadays, she seems to regard photogra-
phers of the past with a kind of aloof respect. "I'm illiter-
ate in the historical, classic knowledge of photography, so
maybe the reason I'm interested is because I'm just discov-
ering it and paying attention. This is the stuff that teachers
attempted to bore into my head in school and which I re-
sisted. Of course I've seen Atget and Stieglitz for years but
just didn't pay much attention."

She seems to have no particular desires at the Met, so I
point a few things out. Among the Met's twentieth-
century photographs is a 1927 picture by the German
photographer Otto Umbehr, who called himself Umbo. It
depicts a young woman's uplighted face. "I love any image
of a woman from that era. I love looking at the way they
did their fingernail polish or their makeup," says Sherman,
who recalls often making herself up as a child. Beside the
Umbo is a photograph by Margaret Bourke-White, a kind
of abstraction from 1934, and one by Harold Edgerton,
nearly abstract: his famous image of a drop of milk filmed
at one hundred-thousandth of a second. "If this sort of
early experimental photography were done now it obvi-
ously wouldn't be so interesting because every student
since then has fooled around with emulsion and doing bad
prints and out-of-focus prints and all that. But back then
there was a sense of discovery. I guess for me the interest is
also in recognizing my roots, but the way I've always tried
to cull information from older art and put it into my work
is that I view it all anonymously, on a visceral level. Lately
I've been looking at a lot of images from Surrealism and
Dada, but I never remember which ones are the Man
Rays, say, because I'm just looking for what interests me."

Whatever the historical precedents for aspects of Sherman's art, it is, of course, quintessentially of this moment, and has inspired numerous younger artists who, like her, take many cues from pop culture. Sherman is at the forefront of a group (Sherrie Levine, Laurie Simmons, others) who have altered the status of photography and overturned some of its received notions about scale, instantaneity, truth and so on. She likes to say she isn't a photographer; she's an artist whose medium is photography—there is a difference.

She notices at the Met a 1969 work by the performance artist and sculptor Vito Acconci: a strip of photo-booth snapshots in which he mugs Cole Porter's "Anything Goes." "Less so now, but at one time Acconci was really influential on me, because he used himself in his art. Initially in art school I loved Photo Realism. I saw Acconci and my reaction at first was just feminist indignation and repulsion. I thought it was macho stuff. But when he came to Buffalo I discovered he was not about that at all. I found that his art pushed limits and made you hate it, without really knowing what it was about. Performance and Conceptual art, what Acconci was doing, turned out to be the most important for me because it was confrontational, which I liked, and because people couldn't take for granted what they were looking at."

Among older photographers, Nadar is someone you'd expect Sherman might like: a portraitist of theatrical inclinations who used a plain backdrop and props to dress up his subjects. But, almost perversely, she finds his pictures charming and saccharine compared with the less heralded ones by his hapless brother, Adrien Tournachon, some of which are included in the Met show. In 1854, Adrien, who had only lately taken up photography with Nadar's support, was commissioned by a neurologist called Duchenne de Boulogne to do a series of pictures of patients whose faces were contorted by shocks from electrodes. The idea was that Adrien's photographs would become part of the neurologist's catalogue of human expressions. "Maybe I

Vito Acconci / *Photomatic Enunciation
Piece ("Anything Goes"),* 1969
Gelatin-silver print, 9⅞ x 1½ in.
The Metropolitan Museum of Art, New York

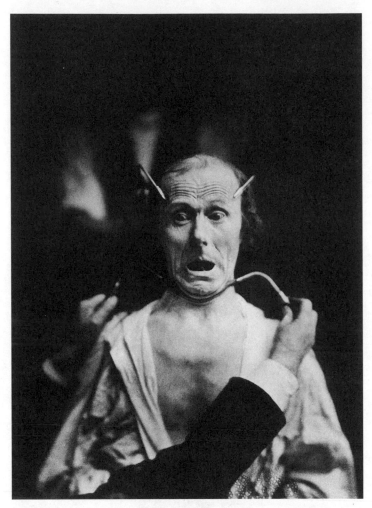

Dr. Duchenne and Adrien Tournachon / *Terror,* 1854
Gelatin-coated salted-paper print on bristol, 8⅞ x 6⅝ in.
École Nationale Supérieure des Beaux-Arts, Paris

respond to Adrien's pictures in a sick way because of the pain, the fact that these people are really experiencing it and not acting," Sherman says. "For me, using myself in my works, acting in them, it's extraordinary to see someone cataloguing real expressions and feelings. Of course, Adrien's photographs could all be titled the same: they're named *Fear, Terror, Displeasure,* but what's the difference? They look alike. That's O.K. Even if these turned out to be

fake, they would still interest me because they look sur-
real." She points out the strange pinwheel composition of
disembodied hands and electrodes surrounding a face in
one photograph and the shadowy figure in the background
of another as surreal elements. "I'm interested, like most
people, in genuine images of disturbing things. What
draws anybody to look at an actual dead person? That said,
I think the reason I do what I do, as opposed to what a re-
porter like Weegee did, going around the streets looking to
photograph real dead bodies, is that it is almost a way to
prepare myself for horrible events, the way fairy tales and
horror films do."

In the galleries of twentieth-century art, Sherman's in-
terest also turns out to be for the surreal and unconven-
tional. She breezes past the Pollocks, Ellsworth Kellys and
Barnett Newmans. She balks at a roomful of Clyfford
Stills. "My first two or three attempts at making abstract
paintings in college looked like these, smushed on with
palette knives and organic in a way. I can't respond to
them. Maybe I only respond to things that are recogniz-
able, as opposed to abstract. It's hard for me to articulate
why one Mondrian is better than another, for example. I
can relate to them on a visceral level but not critically."

Two curious works, however, catch her eye. One is the
American painter Paul Cadmus's surreal and grotesque
Lust, a small but potent image from the late 1940s, part of
a series about the seven deadly sins. Its sardonic depiction
of a hairy, thickset vixen with vaginas for armpits, her
body wrapped in a ripped condom and bathed in a hot red
light, can bring to mind Sherman's lurid sex pictures. The
other work is by the Chilean-born Surrealist Matta, his
giant 1968 mural, *Watchman, What of the Night?* It's a
nightmarish abstraction involving bizarre intestinal shapes,
acid colors and allusions to soldiers whose victims are
maimed and dead. "It looks so modern," Sherman de-
cides, and says it makes her think of works by Kenny
Scharf, the graffiti specialist, and also by Christian Schu-

Paul Cadmus / *The Seven Deadly Sins: Lust,* late 1940s
Egg tempera on Masonite, 24¼ x 11¾ in.
The Metropolitan Museum of Art, New York

mann and Carroll Dunham, two other contemporary painters: "There are those same phallic symbols and strange cartoony shapes, like they use."

I suggest we look around in nineteenth-century art next, and take her to see a group of Degas pastels of women bathing, which she thinks look natural and unsensational. "He shows the female nude from behind without obsessing about the ass, which would usually be the focal

point. They're not romanticizing. They're of women doing ordinary things."

A case containing Rodin sculptures also piques her curiosity. *Iris, Messenger of the Gods* is the famous bronze sculpture of a headless female nude, her legs splayed, her right hand grasping her right foot. "It's so outrageous," Sherman says, by which she evidently means she likes it. "Most depictions of women, pre-feminism, were exploita-

Edgar Degas / *Woman Bathing in a Shallow Tub,* 1885
Pastel on paper, 32 x 22 in.
The Metropolitan Museum of Art, New York

Auguste Rodin / *Iris, Messenger of the Gods,* c. 1890 (cast 1965)
Bronze, on a black marble base, h. (without base) 17½ in. , w. 16⅜ in., d. 9 in.
The Metropolitan Museum of Art, New York

tive, but I take that for granted. The female nude in art is
something we've got to live with because people will al-
ways use it as a symbol of beauty. It bores me to tears. But
if male artists only did male nudes, women would com-
plain, 'Oh, they think their bodies are so great.' One way
or the other, people are going to find a way to object. Nu-
dity is such an obvious attention-getting device that when
I started using fake tits and asses in my photographs, the
idea was to make fun: people would see the works from
afar and think, 'Oh, she's using nudity,' then realize I
wasn't. I wanted that jolt. Some people have even asked
me why I never used myself nude, and that's so stupid; they

think that my photographs are actually about me, that I'm somehow revealing myself in them, so why shouldn't I totally reveal myself?"

Ingres's nude odalisque at the Met, a version of the *Grande Odalisque* in the Louvre, depicts a reclining woman seen from behind, her legs crossed, head turned over a shoulder, her body improbably, theatrically, elongated. I ask what Sherman thinks of it. "The proportion amuses me," she says. "Maybe having a big, droopy rear end was a real come-on a hundred and fifty years ago, but it doesn't look sexual at all to me. I didn't know until now that the proportion was intentional on Ingres's part, but I still wonder if most people who come to the museum today just see it as a naked woman and register it as wrong. In a way it's a subversive image because it makes fun of eroticism by today's standards, even though Ingres may have meant

J.-A.-D. Ingres and workshop / *Odalisque in Grisaille*
Oil on canvas, 32¾ x 43 in. The Metropolitan Museum of Art, New York

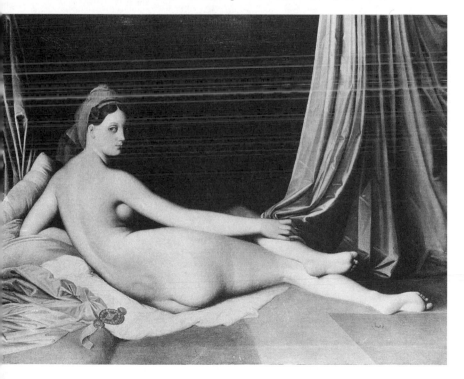

something different by it. Maybe it also reminds me a little of my own work because I've used these same elements, like drapes and a figure and a simple background. I can immediately relate to it."

And finally, what, I ask, does she make of Courbet's nudes? "I've never seen these," she says. She is serious. "They're great. What sexy pictures. Normally I wouldn't like sexy pictures, which I'd think are gratuitous, but these are wonderfully kinky. I like seeing this mass of flesh. I can't quite put my finger on precisely why. Maybe it's that Courbet's models somehow look really into it. There's a self-awareness on their part. If these were photographs I probably would be bothered by them. But why? Hmm." She pauses. "I guess it's something about the quality of the paint, and also knowing that these are somewhat idealized women, not photographs of women. The nice thing about seeing paintings in the museum is looking at them up close." She laughs. "You know, it's a totally different experience from seeing them in catalogues."

Gustave Courbet / *Woman with a Parrot,* 1865–66
Oil on canvas, 51 x 77 in. The Metropolitan Museum of Art, New York

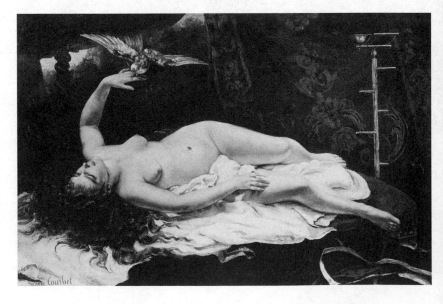

WAYNE THIEBAUD

Referring to California painting is like referring to California mathematics. The conventions of painting have always been the same, and they're the same with abstract and realist painting. I can think of nothing that can't be expressed abstractly and also realistically—grandness, fear, whatever." That said, Wayne Thiebaud is a painter from California, if not a California painter. He grew up in Long Beach and now splits his time between Sacramento and San Francisco. And he paints not abstractions but hot dogs and cream pies, barbecued chickens and gum-ball machines, along with cockamamie images of California cities. For more than thirty years these improbably lush and luminous works, peculiar Americana, deftly drawn and more than a little weird, have made him an artist somewhat apart from others.

Thiebaud is a trim man, fit (he plays tennis a few times a week), with neatly clipped white hair, dressed today for a visit to the Metropolitan, as he often is, in a V-neck sweater, slacks and tennis sneakers, with a bandanna around his neck. He's formal in his casualness, a little Gary Cooperish, with a Western inflection to his voice. He expresses opinions after a pause, sometimes only after being coaxed, as if he doesn't want to seem pushy. Then, once

going, he puts across his views in a gently ironic, quietly assured way.

By his own definition, Thiebaud's paintings are caricatures. "Caricature to me means specific formal changes in size, scale, et cetera: in relationships that combine the perceptual with the conceptual. Caricatures are opposed to simple cartoon images on the one hand, or taxidermy on the other. By taxidermy I mean the redundant visual recording of something, a dead image. The downside of realism is taxidermy. The way you escape that, it seems to me, is to collate a series of different perceptual responses into a single one, which gets back to my definition of caricature.

"If you look here, for instance, you find the Greek ideal: almond eyes, tiny mouth." Thiebaud is now staring at a bust of Empress Faustina in the Met's Greek and Roman

Wayne Thiebaud / *Five Hot Dogs,* 1961
Oil on canvas, 17¾ x 24 in. Courtesy Allan Stone Gallery

galleries. "So it's in a style that you could call caricature, though it retains certain traits specific to the person."

Boiled down, caricature roughly equals style in Thiebaud's lexicon: it's a distinctive way of evoking something visually—what he also calls "a visual species of one's own."

He sometimes talks like a teacher because for years he was one (Bruce Nauman was a student), and in front of a work of art, he'll mix professorial authority with a kind of American plainspeak: he'll go on, for instance, about perceptual strategies and "essentialized forms," then, gazing at a Degas pastel or a Frederick Church landscape, cluck his tongue, squint and shake his head in a kind of aw-shucks admiration: "Hmph, it's so good it almost makes my arm ache just thinking about how he did that," he'll say.

He loved teaching, he says, because he loves the craft of art, which he believes must be learned patiently and respectfully, otherwise it can't be learned at all. Art is Darwinian for Thiebaud: it evolves incrementally, building on itself and a knowledge of its own past. "Trying to get students to draw a white cup can take weeks," he says, "and they ask me, 'Do we really need to do this?' And I tell them it would be great if you could make a brilliant end run around all that stuff, but with painting there's no such thing—at least I haven't found it."

Born in Mesa, Arizona, in 1920, he moved with his family the next year to California. His maternal grandmother was one of the original Mormon pioneers to settle in Utah in the mid-1800s and his childhood was full of church activities for children, like drama classes and chorus and the Boy Scout troop. He also spent a lot of time on his grandfather's farm in Southern California, then on a big family ranch in Southern Utah. He milked cows, shot deer for meat, plowed wheat fields and planted potatoes, corn, alfalfa. At one time he thought he'd end up being a farmer. His incandescent and slightly antic landscapes—whose sources include a mix of Chinese, Post-Impressionist, Cubist and Bay Area art—are, in part, affectionate recollections of that time.

He recalls his mother giving him little art projects for rainy days, and his uncle Jess, an amateur cartoonist, entertaining the kids with drawings, though art wasn't in general a big part of his upbringing. Then in high school he got involved in stage productions, an experience that may have been the most important early influence on his later work: the deep shadows and hard light in his pictures are theatrical devices whereby a painted pie will be isolated and illuminated on the canvas as if it were Olivier playing Hamlet on an empty stage.

Thiebaud began to draw seriously at sixteen and soon got a job as an animator for Walt Disney. In the Army during World War II he became an illustrator for an Air Corps newspaper in Mather Field, California; then he kicked around the country for a while: in New York, hoping to sell cartoons, he made the rounds of the magazines every Wednesday, spending the rest of his time in his room at the YMCA doing new drawings to shop around the next week. Back in California, he worked briefly illustrating movie posters of John Wayne and Marlene Dietrich for Universal-International Studios. Finally, he did layouts and a comic strip for an in-house magazine of the Rexall Drug Company in Los Angeles, and it was around then, with the encouragement of an artist at Rexall, Robert Mallary, that he also began to think about a career as a painter.

So in the 1950s, when he started to paint deli counters and slot machines and shop windows and hors d'oeuvres platters, he was tailoring his cartoonist's sensibility to a new medium with different expressive and metaphoric possibilities. He rose to prominence in the early sixties on the Pop wave, until it became clear that he had almost no real affinity with artists like Andy Warhol. His rows of pies, lined up like so many headstones at a cemetery, were always as much about formal variation as about mass production or consumer culture, just as the still lifes of vases and tins by Giorgio Morandi, one of Thiebaud's heroes, were more about the relationship of shapes on a canvas than about the products the tins contained. The precise

Giorgio Morandi / *Still Life,* 1949
Oil on canvas, 14¼ x 17¼ in. The Museum of Modern Art, New York

tone of Thiebaud's still lifes, whether ironic or affectionate
or nostalgic or detached, was always hard to pinpoint. But
they certainly involved geometry and paint: the severe and
exact arrangement of forms on a flat surface, and the lumi-
nescence and thickness of pigment.

"I try to downplay subject matter because I'm afraid it
limits how people think about pictures. True, I wouldn't
have painted toys or pies if I didn't feel some emotional in-
volvement with them. As a boy, I used to work in restau-
rants, and there's something about the ritual of food, the
ritualistic care with which it's served, that has always fasci-
nated me. We can't stand the murder of a fish, so we put
down a snippet of parsley or lemon slice to soften the ef-
fect of the dead fish on the plate. We ritualize the experi-
ence. I find that interesting."

Over the years, he has acknowledged various sources:
Chardin and Hopper, the turn-of-the-century Spanish
virtuoso Joaquín Sorolla, and the Bay Area painters of the
1950s and 1960s like David Park and Richard Diebenkorn,

Rockwell Kent / *Winter, Monhegan Island,* 1907
Oil on canvas, 33⅞ x 44 in. The Metropolitan Museum of Art, New York

Wayne Thiebaud / *Curved Intersection,* 1979
Oil on linen, 28⅛ x 16 in. Courtesy Allan Stone Gallery

who like him were shaped by working at a certain remove from the center of things in New York. It's an eclectic, singular list, and at the Met it's only to be expected that he inclines to the overlooked and undervalued. He picks artists who, like him, are not easy to pigeonhole: Balthus, Rockwell Kent.

Kent's *Winter, Monhegan Island* (1907), for instance, is a landscape of Maine in creamy paint and blue light, akin to the electric-blue shadows that Thiebaud often paints. The picture is a distant turn-of-the-century ancestor of Thiebaud's whimsical views of San Francisco, in which the city's streets rise like children's slides or like raised drawbridges between impossible skyscrapers and its highways are depicted as wild spaghetti entanglements or roller-coaster rides. Kent's landscape, he says, "has an extremity I respond to. The strong color combination of blue light and dark chocolate-brown, and the drama, the delicate glow, Rothko-like, of the greenish sky, with the house on the right flattening into an abstract shape, almost like a collage element. It's got a great light, almost musical like Prokofiev, with that secondary glow of cold icy color."

Thiebaud occasionally likens art to music. When at one point I take him to see a Cézanne landscape, which Elizabeth Murray had also noticed, it makes him talk about "pacing and tempo" and "color chording." About Cézanne's portrait of his wife, (the one on p. 21), he says: "The orchestration of angles and of entrances and exits along the four sides is great. And then within the picture you have warm and cool alternations of tonalities to simulate flesh, so that there's always a kind of tonal counterpoint.

"It's absolutely strange that people say Cézanne couldn't draw, because this is wonderfully adept," he goes on about the portrait. "Look at the right hand and you see how much he knew about anatomy. But what's interesting is also what he leaves out: her ear is something you don't need and if he put an ear there it would have spoiled the space. You don't even notice it's missing at first, and it's irrelevant when you take in the whole picture. Bonnard said

one of the things that fascinated him was the immediate sensation of going into a room and seeing it all at once, before you pick out specific things that catch your eye. He wanted a kind of overall pulsating energy in his pictures. He once picked up a crumpled piece of tinfoil and said it had the sort of refracted light he was after, and he was willing to keep things loose when he painted in order to get it. He wanted a real economy of means, which resulted in those strange, wonderful color patterns.

"It's the same thing with a lesser-known artist like Marquet," Thiebaud says, having noticed an Albert Marquet seascape of creamy surface and staccato forms: little dots and dashes to signify boats. "He's a shorthand painter, everything abbreviated, kept to a minimum, only what you need. The ambiguity is as important as specificity. It becomes a beautiful dialogue, a tightrope walk, between abstraction and representation."

Thiebaud's conversation hopscotches from painter to painter. A partial list of some of the other artists, Americans and Europeans, whom he stops to look at includes Gwen John, Robert Henri, Ensor, Giovanni di Paulo, Sassetta, Hélion, Gorky ("He's much greater than Pollock"), Pearlstein, Eakins, Max Weber, Walt Kuhn, Edwin Dickinson, Soutine, Vuillard ("I love the way his images look smashed up, like they were run over on the highway") and also the self-taught Philadelphia painter Horace Pippin, whose *Victorian Parlor I,* at the Met, is a scene, like the ones Thiebaud paints, of everyday objects in nostalgic domesticity: two armchairs flanking a circular table bearing a huge bouquet. Pippin, as always, and like many so-called naïfs, meticulously painted every lace strand of the doily on the table and the antimacassars on the armchairs. Although Thiebaud is certainly no naïf, he sometimes mimics aspects of a naïf's style. Thiebaud uses thick squiggles of paint, for instance, to simulate in three dimensions mustard on a hot dog or frosting on a cake. "It's funny," he observes, "that primitive painting has its own conventions, that certain things always occur in it: the disparity of views,

the brilliant color, the intricacy, the diagrammatic style, the fact that they're mostly small pictures, like this one, except with Henri Rousseau, whose paintings are big. Also, that they're very respectful pictures, very responsible to their subjects."

Near the Pippin is a still life from 1931, by an artist named Henry Lee McFee, of a small table laden with apples, pears and oranges in a room divided by a curtain but otherwise hard to decipher. Cézanne, with his spatial eruptions, clearly inspired McFee. At Rexall, in his spare time, Thiebaud began doing expressionist works, a little like John Marin's or Lyonel Feininger's, and in 1948 one of those early pictures was included in a group show at the Los Angeles County Museum of Art. The exhibition was a break for Thiebaud. Henry Lee McFee was a juror of the show. "He taught in Southern California and influenced a whole swath of painters. I remember he was a grand old man in white linen suits. A good man. He made his students work. McFee's color sense was interesting, gauzy, like you're seeing through scrims. Unfortunately, this particular painting is one of those times we all have as artists when one is affecting the signs of art: putting in this or that element, like the curtain here, to make it look like art.

"You don't have to be a great artist to be interesting, just true to yourself. Guy Pène du Bois, for instance: he was a little-known painter but he distinguished himself because he had a particular pictorial style." Thiebaud is glancing at a Pène du Bois across the room. "Of course his style came out of various influences, traditions, so on. But it was like with van Gogh: if you want you can find van Gogh's antecedents and influences in Pissarro, Lautrec, Daumier and his big favorite, Adolphe Monticelli. But only putting all those things together do you get van Gogh, which is something else. Genuineness is key: these things must really mean something to you as an artist. My feeling about what makes van Gogh really distinctive is that he never learned to paint, though he sure could draw. I mean, the painting is always linear, as if it's drawn. It's beautiful work finally,

of course, but it's interesting that everywhere you look are these lines. It wasn't wrong, it was a notational style, and that had certain consequences. It didn't replicate light, for instance. It created its own kind of light. He'd arrive at a color for a head, let's say, that didn't look like flesh, an ashen gray—which fashionable people might call taupe—except that the red lines around the eyes and fingers that he added somehow miraculously brought it back to flesh."

Thiebaud spots another work in the twentieth-century rooms, a conté-crayon-and-charcoal depiction of heavy pitchers and an empty bowl on a table, an academic drawing, roughly in the style of Zurbarán. If you didn't know it, you'd never guess that it was by de Kooning, from the early 1920s, when he was a student in Rotterdam. For a while during the mid-1950s, Thiebaud lived in New York City, and he met de Kooning, along with Franz Kline,

Willem de Kooning / *Bowl, Pitcher and Jug,* c. 1921
Conté crayon and charcoal on paper, 18½ x 24¼ in.
The Metropolitan Museum of Art, New York

Barnett Newman and younger painters like Philip Pearl-stein, Milton Resnick and Philip Guston, who was still painting his Abstract Expressionist pictures and not yet the cartoonish ones he went on to do. Thiebaud recalls talking about caricatures and cartooning with Guston then, but was generally skeptical of the cracker-barrel chatter that passed for art criticism at artist hangouts like the Cedar Bar. Nonetheless, he was deeply impressed by the general seriousness with which art was regarded in New York. And in particular, though he wasn't painting abstractions, Thiebaud became enamored of the approach of abstract painters like Kline and de Kooning.

"This de Kooning is one of the most extraordinary I've ever seen. You see how he is using a landscape metaphor, blurring the back edge of the bowl to make it look distant, even though it actually would have been as clear to him as the front edge? It's a perceptual trick. I don't agree with Duchamp that the eye is a dumb organ. Duchamp talked about the eye of the mind. I think the eye has a mind of its own, and there are different ways we see: there's peripheral vision, the myopic up-close sensation, focused seeing." He lists more types of vision: to glance, to stare, to squint; hallucinatory vision, sharp-focus vision, a kind of closed-eye daydreaming. "The more ways you can put together in a picture, as de Kooning does here, the richer it becomes, the more like life."

It's interesting that Thiebaud takes special note of this unusual realist drawing by de Kooning because what he values about most painters is invention, not an ability to paint a resemblance. In the American Wing, for instance, at a William Harnett trompe l'oeil of a violin and sheet music, Thiebaud says: "There are inherent dangers in magicianship like this because, for one thing, if you're hoping to trick the eye, you can't suggest depth much beyond an eighth of an inch. The violin, say, doesn't work, compared to the sheet of music. But even if you could create a convincingly real illusion in paint, what would be the point? These sorts of works are little dramas, like the repertory of

William Harnett / *Still Life: Violin and Music,* c. 1888
Oil on canvas, 40 x 30 in. The Metropolitan Museum of Art, New York

a provincial theater company, but I find the stories in them, all the little tidbits of information, more interesting than the tricky parts."

By contrast, he points to the eccentric and highly original Albert Pinkham Ryder, again something of an odd man out in American art and prized as such (not unlike Thiebaud), who a century ago pushed realism toward the edge of abstraction. In truth, many of Ryder's paintings are melodramas, badly realized, but the best of them—a handful—have no precise equivalent. "Poetry is a kind of X ray of literature, and painting is a kind of X ray of visual experience: it should re-form the perceptual world, condensing it, encapsulating it. Ryder had X-ray vision and he also had a really mad sense of painting. Hardly anything is

clearly detailed in the work, yet it's everything you need. If you say Ryder's pictures are about positive and negative spaces, like Kline's work is, that clearly leaves out their romantic yearning, but they're not just about boats and clouds. What makes them remarkable, in the end, is how much he tries to have them not look like art. Certain things make a painting look like art, flashy brushstrokes, drips, signatures. But Ryder goes for his own scruffy, reductive, agonized look. He would sometimes even spit on his pictures to polish them, do anything to make them match his strange internal vision."

In the early sixties Thiebaud began to paint peculiar figures in addition to his pinball machines and sandwiches. Partly he wanted to get away from consumer images, which he felt mistakenly linked him to Pop. Partly he was turning his attention to a subject that preoccupied other artists at the time, such as Philip Pearlstein, Alfred Leslie

Albert Pinkham Ryder / *Toilers of the Sea*, 1880–85
Oil on wood, 11½ x 12 in. The Metropolitan Museum of Art, New York

and Alex Katz, who like him wanted to evolve an affect-less, unsentimental way of painting people. The figures were "not supposed to reveal anything," Thiebaud explained. "It's like seeing a stranger in some place like an air terminal for the first time. You look at him, you notice his shoes, his suit, the pin in his lapel, but you don't have any particular feelings about him." Works like *Standing Man* or *Bikini,* both 1964, showed figures straight on, at attention and blank-faced against empty backdrops; she is potbellied and thick-waisted, he looks awkward in an ill-fitting suit, but they're both psychically neutral, which for Thiebaud

Wayne Thiebaud / *Standing Man,* 1964
Oil on canvas, 60½ x 36 in. Courtesy Allan Stone Gallery

was the goal: to stress their formal qualities as shapes on a
canvas and also to convey a sense of isolation and time ar-
rested. They're akin, in that respect, to figures by Hopper
or Vermeer, whom Thiebaud emulates for their extreme
reserve.

At the Met he seeks out Vermeer's *Young Woman with a
Water Jug* (on p. 25), which he calls "a monumental image"
(though it's smallish) because of the sense of "silence ex-
tended to eternal time. It seems so straightforward. You
think that's a woman with a skirt, a map, with light com-
ing through the window, but when you look hard, you re-
alize you can't find the damn edges of anything. On close
inspection they vanish. He's giving you all these clues but
the work is still full of secrets. And I find his scale of light
exquisite: look how much light is in the map behind the
woman, for instance, compared to the blue haze beneath
it. And how he paints not pure white but a rainbow spec-
trum of pink-white, yellow-white, blue-white, purple-
white. Yet he makes it seem like a singularity."

The Vermeer, like Thiebaud's figure paintings, raises the
question: What, if anything, does a portrait actually reveal
about a person? The sort of head-on portrait against a bare
or neutral backdrop that Thiebaud paints, a kind of
mug-shot pose, goes back at least to the early Northern
Renaissance: sharp-focus images of honest burghers and
noblemen, submissive before God. Then came the sublime
flattery of a Van Dyck, in whose hands all sitters became
princes and princesses, and the grave profundity of Rem-
brandt, who gave to dull bankers and bureaucrats an illu-
sion of noble character, if not noble birth, through veiling
glazes, shadows and so on. But all portraitists are flatterers,
in the end, and all portraits are fiction, born of artful con-
ventions. Thiebaud celebrates this, calling attention to it.
He likes their artificiality, their ambiguity. Does a frown in-
dicate anger, concentration or confusion? His own figure
paintings are meant to mystify, like Vermeer's. Or like In-
gres's. "Ingres was one of the greatest mystifiers," he says,
before Ingres's portrait of Mme. Leblanc in the Met's Eu-

J.-A.-D. Ingres / *Portrait of Mme. Leblanc,* 1823
Oil on canvas, 47 x 36½ in.
The Metropolitan Museum of Art, New York

ropean paintings galleries. "You see how he alters the
body, cuts it apart and puts it back together in a way it
never really is? Look at her head and shoulders: her arm
below the elbow is twice as long as it should be, but it
doesn't matter because the picture makes its own sense. It's
almost Cubist. You can see how Picasso learned from In-
gres. The tonal control is astounding, too. There's a story,
probably it's apocryphal but I like it anyway, that Ingres
asked his students to paint a chart with a hundred tonalities
from white to black, and the students said it was impossi-
ble, that no one could see such minute differences. So

Ingres pulled out a chart that he had done with a thousand tonalities on it.

"As a viewer, you've got to participate bodily when you look at a painting. It has to do with empathy. A painting is a physical metaphor, an extension of nerves, muscles, gestures, and to grasp it you've got to feel yourself in it. Picasso supposedly said he never saw a painting he didn't like. 'Oh come on, you're not Will Rogers,' people said to him, but Picasso said: 'No, I mean it, I'll even go to a hotel someplace and see a little painting of flowers, and I think, just to get the paint from here to there without embarrassing yourself, well, my heart goes out to the artist who did it.' I guess I'm of that persuasion."

LEON GOLUB
AND NANCY SPERO

Perusing an Egyptian Book of the Dead at the Metropolitan, Nancy Spero and Leon Golub look a little funereal themselves. With her close-cropped hair and his entirely bald head, both of them dressed in black, they seem at first glance as postapocalyptic as you might expect for a couple of artists whose separate works have dealt with torture, rape and war. In fact, in conversation Spero and Golub are really more like Alphonse and Gaston ("Leon's right," "No, Nancy's right"). They are affectionate and solicitous and, as Golub puts it, "deeply implicated" in each other's life and work.

Spero is slight. She speaks quietly, almost apologetically, even when saying something tough about art. Golub, voluble and outgoing, peppers his chatter with "O.K., O.K.?" sounding a little like a character from *On the Waterfront* except that he's talking about Hittite art.

The Egyptian Book of the Dead, a papyrus dated 350–250 B.C. that, unfurled, stretches sixty-three feet along a wall, alternates inscribed incantations to the hereafter with vignettes of ram-headed guardians and crocodiles and other illustrations. Spero's art mixes text and image in ways not unlike this. Her images are almost hieroglyphic: attenuated, stylized, sometimes cryptic. "I love this format, which I adapted for my own work," she says.

Egyptian, Funerary Papyrus of the Princess Entiu-ny (detail),
The Judgment: Weighing of the Heart
The Metropolitan Museum of Art, New York

Nancy Spero / *Codex Artaud VII* (detail), 1971
Gouache and typewriting collage on paper, 20½ x 150 in.
Courtesy of the artist

"I had been working on individual sheets of paper and wanted to enlarge my range, not in terms of the classic rectangle but still physically and in terms of narrative possibilities. In the Book of the Dead you also have Egyptian gods weighing souls, deciding who is worthy, so the work is about laying down laws, in a sense. It's a power thing. And that interests me."

Power—sexual, political and otherwise—obviously interests both of them. They're old-time radicals, married since 1951, when they were young figurative artists in Chicago. "When we first got married we lived in a garage in Chicago," Golub recalls.

"A garage in an alley," Spero interjects.

"I remember Nancy downstairs working on one large painting for months, which she never finished and finally discarded. She improvised all the time, inventing new things, then painting them out, and in that way, at least, she was an Abstract Expressionist."

"I was an abstractionist waiting for the figure to emerge," Spero says, half-joking. At the time, the two of them were art-world novices. They have since become insiders, for their political and feminist works. Golub paints big, mural-sized pictures: smeared, gritty and satiric. His subjects are theatrical and larger than life: patriarchs, mercenaries, goons and giants, presented like characters in a frieze. Spero, though her installations are sometimes big too, draws and stencils delicate images; her subjects are women.

They have worked side by side in the same Greenwich Village studio since the mid-seventies. Lately, having achieved separate success, they have begun to show together in exhibitions in Paris, Hiroshima and elsewhere. They are practiced partners and their banter sometimes runs in amusing directions. In the gallery next to the papyrus is an Egyptian column capital from the fourth century B.C. depicting the goddess Hathor, which they both admire, and which circuitously leads them to a discussion of modern sculpture. "We forget today how much objects

like this column related to their settings," Golub says. "So much modern sculpture is free-floating, without a sense of location, that we forget how much context mattered." He cites Richard Serra's big steel works as examples, saying they "dominate the spaces they're in: they're blatantly physical and intrusive, qualities that fit with our times."

Spero has another view and distinguishes Serra's works, which she calls aggressive, from her own installations, which can also take over walls and rooms. "I let the architecture shine forth," she insists. "My work is sporadic, like graffiti. It's respectful of the space it's in."

But Golub disagrees. "No, it's not," he says. " 'Respect' isn't the word I would use."

Spero is taken aback. Then she says: "Well, it's subversive of the space. Leon's right about respect, but in any case

Leon Golub / *Interrogation III* (detail), 1981
Acrylic on canvas, 120 x 169 in.
The Eli and Edythe L. Broad Collection, Santa Monica

I believe my work rebels against Serra's sculpture and against very large paintings because I'm trying to break down the authority they imply. And maybe this authority also has to do with masculinity. I am against the idea of male authority."

"If I may jump in again," Golub says, because, after all, his paintings are very large. "Nancy is subverting my own work with her sporadic installations. My works have a blatant physical presence, which is different from Serra's but is also, well, crunching and aggressive. Of course, I like this aggressiveness."

"Well, you're subversive in another way," Spero offers, protectively.

"Thank you," Golub says.

For a while, years back, the two of them lived in Italy and Paris just to get away from the American art world. "I had a series of bad experiences here, culminating in 'New Images of Man,' " Golub says, about a 1959 Museum of Modern Art show in which his work appeared. "The critics were angry about my art. New York seemed impenetrable. I was devastated by some of the reactions, so we decided to leave because, frankly, we didn't have whatever it took to fight New York and the atmosphere of that time. There was, and still is, a force in New York, you see, that pushes art in certain directions—ideologically, rhetorically and rather strongly."

While they lived in Italy they saw Etruscan and Roman art, and over the years both of them have used Greek and Roman sources in their works. At the Met they admire some ancient frescoes from Boscoreale, a town buried, like Pompeii, at the foot of Mount Vesuvius, in the eruption of A.D. 79. You can see why Spero, with her discreet figures, measured colors and flat stenciled images, might especially relate to these frescoes, which she praises for their "airiness," calling them dreamscapes. "I just have a gut reaction to them," she says. "To me this is painterliness, more so than Baroque art. There is also a sense of vast space and of figures moving in the empty space that reminds me of—"

Nancy Spero / *Myth,* 1990
Handprinting/printed collage on paper, 4 panels, 86 x 84 in.
Courtesy of the artist

"Giacometti's figures," Golub volunteers, an unexpected connection, with which, just as unexpectedly, Spero concurs.

"They're as spare as Giacometti," she says.

Golub, meanwhile, has caught sight of several Roman heads nearby, like the ones on which he based various images during the fifties, and he points out their rough expressiveness and fragmentary condition—the sharp, irregular outlines of their fractured profiles. "Brutal and poignant," he calls them, and when next he and Spero turn into a room of Classical art, he gravitates to another rather brutal sculpture, a marble lion from around 400 B.C. Golub has often put animals in his art, fierce ones like street dogs. He uses photographs clipped from magazines as models when he paints; he has clipped thousands of

photographs over the years, and has lately been clipping a lot of pictures of lions. The Met's lion is particularly ferocious, ready to pounce, ears back, teeth bared, ribs tight against its lean raised sides. Golub likes it at first but then thinks the sculpture is "a little clunky. It looks held down. I mean it's wonderful, great, but a little frozen."

This is not unusual for him as he wanders the museum: a wavering appraisal that comes from an openness to new impressions, and also perhaps a friendly desire for agreement—a quality rather different from his art, which is direct, even combative. For instance, when he and Spero look at a Greek kouros, a standing male youth, from the

Greek, Statue of a Kouros, c. 600 B.C.
Island marble, 6 ft. 4 in.
The Metropolitan Museum of Art, New York

sixth century B.C., Golub initially says the sculpture is awkward. He recalls studying kouroi years ago. "I was fascinated by how, in early Greek sculpture, the male figure developed and began to suggest movement, like here. I was interested in ways to get my own stylized figures into motion." Rigid, its arms straight down its sides, one foot forward, this kouros is angular, geometric. "The head looks like it is not quite connected to the rest of the body," Golub argues.

But Spero likes it, pointing to its improbably broad shoulders and disproportionately large head. "In Leon's art," she says, "there are anatomical inconsistencies too, which partly explain its power."

Golub thinks about this for a second and changes his mind: "Actually the awkwardness does give it power. O.K., it's terrific. I was wrong. Sorry. It's beautiful. Nancy's right."

When they lived in Chicago in the 1940s and 1950s, they often went to the Field Museum of Natural History to browse in the African and primitive art galleries. "We were very moved by all that, more than with the Impressionism at the Art Institute," Golub says. "Primitive art had a tremendous influence on my early work."

"As much as I have rebelled against the traditions of art, nonetheless I want a connection," Spero adds. Both of them became scavengers of images, ransacking everything from ancient art through contemporary photographs, even porn magazines. From this, Spero derived, for instance, her image of an Egyptian vulture goddess; Golub painted sphinxes, melding the sphinxes with, of all things, cyborgs, because to him, he explains, "they are both imaginary creatures that cross physical borders, which I think speaks to our transformative and technological culture." Golub's fascination with science fiction is as deep as his connection to ancient art, and he volunteers that he'd be perfectly willing to sell his soul to the devil to return to life for a few years each century.

Passing through the Met's galleries of African and pre-

Columbian art, Spero points to a Dogon granary door from West Africa that is adorned with rows of breasts, while Golub wanders ahead to an altar from ancient Mexico, a carved boulder, which looks to him like a skull, with its deep sockets and bared teeth. In the fifties, he did drawings of skulls. He remembers in Chicago having friends, abstract painters, who regarded everything in those days in terms of abstraction. They once came to see his skull drawings. "They had an attitude about what art should be. Of course, we had an attitude too."

"Didn't we ever," says Spero.

"So, when they came to look at my work one of them said, 'Well, Leon, those are really strong blacks, strong lines, you've got there.' And I said, 'God damn it, they're skulls.' They said, 'It doesn't matter.' Well, to me it mattered. My subjects mean something, and in that case, having a very fatalistic notion about the world, I was drawing skulls because they were about death. I've never believed in an afterlife or salvation, and so a sculpture like this," he says, now about the skull-like Mexican altar, "has a rawness that I identify with."

"Raw like the beginning of nature," adds Spero.

"More like the beginning and end of nature," Golub says. "As artists, you see, Nancy and I are both content-oriented. We focus on what the images are about. I have often thought of myself as a history painter, and I think Nancy looks at things in a similar way."

This explains, for example, why in the Met's European paintings galleries Golub particularly admires the work of the archetypal history painter, Jacques-Louis David. "David has become very important to me, O.K., a major force. I'm interested in rhetorical gestures, you see, and there's a lot of rhetoric in David's work. It's a theater of passions." Golub's pictures include gesturing figures in sometimes ambiguous relationships to one another. And these gestures come partly from looking at Davids, he says. Spero describes it as a "very artificial, unreal real quality" in Golub's art that relates to David.

Mexican, Altar, feline form, 5th century B.C.
Stone, h. 20 in., l. 32¼ in., w. 24½ in.
The Metropolitan Museum of Art, New York

Leon Golub / *Skull*, 1947
Graphite on paper, 36 x 30 in. Courtesy of the artist

"When we lived in France I used to go by myself to the theater to see Racine," Golub says. "My French is really lousy, but even without understanding what I was hearing, I liked it a lot because I found myself looking not for the overall drama but at individual gestures and characters. And likewise, I can see the figures in this painting in isolation, as individual existential dramas."

Spero since the mid-seventies has virtually banished images of men from her works, concentrating on women, and among the Met's paintings she focuses on several trompe l'oeil frescoes by Tiepolo. Muted, stony gray decorative panels, they happen to be among the least eye-catching Tiepolos in the museum, but they depict women as personifications of grammar, geometry, arithmetic, and Spero is struck by the women's beauty, and also their state of undress. "Like car ads—why undressed women?" she asks. She compares them with a pair of quite different female images, a *Holy Family* by Ribera and *Charity* by Guido Reni, among the Baroque pictures, which depict women with children at their breasts in a manner that Spero considers cold and eroticized. "There's a false piety to them, with these porcelain ladies and Campbell's soup kids. I admit, I'm inculcated with what I've picked up in the last twenty-five years about women and women's status, how we are looked at. And I can't help seeing these paintings through that lens."

Golub defends her "right to say that the majority of seventeenth-century pictures don't work for her, O.K.? You don't have to like each period and be faithful to its ethos. To me the rhetoric doesn't ring true either. It's too sentimental. He paints well," Golub says about Reni. "I react to that. But—"

"It doesn't have the succinctness of David, the clarity," she says.

"Right. In David everything may look unreal but in a heightened way. Everything is made sublime."

Spero points approvingly to another work, a self-portrait by Adélaïde Labille-Guiard, a French Neoclassical painter,

Adélaïde Labille-Guiard / *Self-Portrait with Two Pupils*, 1785
Oil on canvas, 83 x 59½ in. The Metropolitan Museum of Art, New York

which, not unlike the Reni, is a porcelain image, as she puts it, but one that depicts Labille-Guiard at an easel, calm, graceful, in her silk dress and beribboned straw hat, attended by two female pupils. Labille-Guiard was one of the few female painters admitted to the French Royal Academy, and this work, from 1785, was a form of proto-feminist propaganda: an argument, by virtue of its elegance, for increasing the number of women in the academy.

"Normally I wouldn't react to a work of this period,

considering my esthetic," Spero says. "But I saw a woman painting, looking beautifully, perfectly dressed, not a spot of paint on her, with these two women assistants, and I was immediately drawn to the picture. We are all looking for a heritage, after all. It may be narrow to think this way, but artists do have a gender. They come from a milieu and it helps to recognize that."

Golub says: "Nancy has never been a zealot on this subject. She was active in the seventies protesting at the Whitney about the percentage of women artists in the Whitney annuals and biennials—"

Spero interrupts: "It is a problem doing it by the numbers. You sometimes do things out of anger. For instance, I knew when I was showing in women's galleries that those sorts of galleries can also ghettoize women artists. But I was just so angry."

"You did what you believed was necessary," Golub says.

He was once asked to do a television documentary about an artist of his choice, and picked Velázquez. "When I was young I was immersed in primitive art, New Guinea, Eskimo, African, and from that to Greek art, and from there to the photographic resources of the modern world. That was my trajectory. So Manet, Goya and so on were secondary, and it was only relatively late that Velázquez became really important to me, as important as Greek art had been. This is because I try to paint expressions that have to do not just with the figure's reaction to the moment but with the whole psyche, and I realized no one ever did this better than Velázquez."

A 1624 standing portrait at the Met of the Spanish king Philip IV is not one of Velázquez's best paintings, but as a politically inclined artist, Golub is intrigued by how Velázquez conceived it as an image of power for a clearly unprepossessing young man. "He took this awkward guy, ill at ease, and painted him in such a way that Philip could visualize himself through the paintings. This image tells you that Philip is introspective but in control. You see his incipient power."

In similar terms Golub talks about the portrait (on p. 120) of Juan de Pareja, who was a Sevillian of Moorish descent and Velázquez's servant. "I may be totally off the wall, but I think, despite his authoritative expression, that this figure has a certain vulnerability—a desire to put himself across that blacks sometimes have to have because they are excluded from power. It's a look of wariness, caution, that you don't see in Philip."

Spero simply admires the portrait. "The past is such a burden, so much to live up to. You can understand modernism wanting to reject everything that came before it."

This remark returns them both to the issue of the postwar years when their careers began. History being tidy though reality never is, the real story of American modernism after World War II doesn't conform precisely to the standard encapsulation: abstraction's victory and figuration's defeat. It's true that Golub and Spero fought against a growing consensus among the powers that were, which rallied behind the Abstract Expressionists. But the 1950s were more complicated. Tastes were broad. In 1950, *Art News,* a good bellwether of that time, named Ben Shahn, Balthus and Peter Blume, figurative painters, as having had the best one-person shows that year, not Pollock or de Kooning. Throughout the 1950s the Museum of Modern Art, the preeminent institutional arbiter of taste, bought as many works by Lucian Freud as by de Kooning, as many by the English sculptor Reg Butler as by William Baziotes, Franz Kline, Barnett Newman and Mark Tobey together, all of them American abstractionists. The fifties were when Andrew Wyeth came to prominence, when Shahn represented the United States at the Venice Biennale of 1954, when the group of Bay Area painters that included David Park and Elmer Bischoff came together and developed a sort of figurative Abstract Expressionism.

A consensus formed only by the end of the decade, which is one reason why in the early 1960s Pop seemed particularly outrageous: because it arrived at a moment when American art finally seemed sure of its direction.

The battle lines then hardened between those who ad-
hered to abstraction, specifically to Abstract Expressionism
and its progeny, like Color Field painting, and those who
didn't, and the fact that the works of many artists didn't
conform neatly to either side tended to be glossed over. De
Kooning had used Pop images as early as the 1940s, and
Rauschenberg, who in many ways grew out of Abstract
Expressionism, came to be linked imprecisely with Pop.
But the middle ground was often not recognized.

No artist illustrates the gulf between abstraction and
Pop better than Philip Guston, who, after years as a lead-
ing Abstract Expressionist, suddenly started to paint weird,
socially conscious pictures. He was immediately ostracized
by his old friends. Even Golub, whose works have a clear
kinship with later Gustons, recalls feeling only shock when
he first saw what Guston was doing. "Maybe I should have
felt a connection, but I felt so isolated then that I didn't
think in terms of connections. I still don't totally under-
stand his paintings. A work like *The Street* [see p. 31] is ob-
viously about untoward emotion, disaster, violence, and it
has an undeniable power. It's a first cousin to Beckmann's
triptychs," he says, and he links it to the wild work of the
1960s by the group of Chicago artists called the Hairy
Who, which included Jim Nutt, and to artists like H. C.
Westermann and Ed Paschke. Golub remembers giving a
talk to art graduate students in New York shortly after
Guston had abandoned abstraction, and only one student
even knew Guston's work. "What a shock that was. Two
or three years out of the art magazines and it was like you
had dropped from the earth. Everyone still knew of Pol-
lock. But not Guston."

Pollock was, of course, the reverse of late Guston: the
ultimate Abstract Expressionist, which has made him "the
ultimate irrelevance," says Golub, to him and to Spero.
Nonetheless, at my urging, they make a final stop in the
museum at his *Autumn Rhythm*. After a while, Golub says,
"I must reluctantly admit that this work has real scale and
presence."

Spero nods. "Especially after we've looked at all this older art, it's liberating. I haven't acknowledged to myself before that I probably haven't given Pollock his due."

But a few days later they are on the phone with me. They both have had second thoughts about the Pollock: "We were being kind of hypocritical," says Golub. Spero pipes in: "We just didn't want to seem like we had sour-grapes about Pollock." "We can't help it," Golub says about their mutual volte-face. "We're different artists but we react to many things in similar ways."

"We've been married too long," Spero says.

"I would second that," says Golub.

BRICE MARDEN

rice Marden is waiting for me at the round infor-
mation desk in the lobby of the Metropolitan in
black jeans, black shirt and black baseball cap.
With a nod rather than a hello, he is as subdued as his dress,
though gradually he talks more freely, in a way that's in-
tense and searching, if a little epigrammatic. It's hard to get
him to talk at length but he listens hard and takes long
pauses to think before responding. He chuckles occasion-
ally. He says "you" when he means "I," as in "You start
working with the figure and all these things begin to come
up in your art." And as he talks and looks, his body moves.
For instance, when he's concentrating on an object, his
feet crossed, his hands clasped behind his back, he rocks
and twists; and when he's demonstrating how he paints or
draws, he bobs and weaves, even dropping to his knees in
the middle of one gallery to simulate what it's like to work
on a canvas propped against a wall. I sense that art is for
him an intensely physical, sensual activity.

His partial transformation in character—a slow open-
ing-up—as it happens mirrors a change in his art. Born in
1938, he grew up in Westchester and moved to New York
City in 1963 after attending art school at Boston Univer-
sity and Yale. He quickly made a name for himself paint-
ing monochrome gray panels that were implacable, silent.

They yielded to multipanel paintings in brilliant colors,
and eventually to works in which lines turned the pictures
into intricate webs of allover activity. Drawn, erased,
rubbed and redrawn, the lines were painted so that mis-
takes and changes remain visible as pentimenti.

Other changes took place. Marden's lush and opaque
surfaces, made by adding wax to the oil paint, turned
translucent. Colors multiplied, his melony oranges and
buttery yellows bringing to mind the smooth texture and
soft luster of glazed Sung pottery. It is not an idle compar-
ison. Marden's infatuation with Chinese art is a familiar
story. Chinese calligraphy and poetry helped spark the
move in his art toward line and gesture, and it led to the
"Cold Mountain" paintings of 1988–89, works inspired by
the free-spirited eighth-century Chinese hermit and poet
of that name (Han Shan, in Chinese). At first, lines in

Brice Marden / *Cold Mountain I (Path)*, 1988–89
Oil on linen, 108 x 144 in.
© 1998 Brice Marden/Artists Rights Society (ARS) New York

Brice Marden / *For Helen,* 1967
Oil and wax on canvas, two panels, 69 x 36 in.
The Solomon R. Guggenheim Museum, New York

Marden's paintings and drawings were arranged in neat rows, like Chinese writing. But the lines got looser, and hence more evocative of landscapes and figures. The early monochrome panels had sometimes obliquely referred to figures too—for instance, the twin-paneled *For Helen,* which at sixty-nine inches tall was the exact height of his wife. But the references to figures became more elaborate and direct with the introduction of lines.

So it's not surprising that we go first to the Chinese galleries, where he peers for a while at a hand scroll of colophon inscriptions, which includes ones by Tung Chi'-ch'ang (1555–1636), the great late–Ming Dynasty painter.

Tung Ch'i–ch'ang / Hanging Scroll: Poem by
Wang Wei, Ming Dynasty
Ink on paper, 75 x 29⅜ in. The Metropolitan Museum of Art, New York

"This guy's always good," Marden says. "Each one of these is a drawing lesson. You can pay attention to all the different ways the brush goes. I think the Chinese have different names for each stroke." Marden admires how bold and seamless Tung's calligraphy looks. His own interest in calligraphy, he says, predated his interest in Chinese poetry but was enriched once he read the works of Li Po and Tu Fu and Han Shan. "It goes back to the eighties. I was going to the country and have a friend who teaches poetry and he suggested I read Pound, and this led eventually to Chinese poetry. I had been interested in calligraphy, but

this grounded it in something besides a pure, esthetic reaction. You kind of begin to understand the cross between the esthetic and what the calligraphy's saying. Also these galleries opened up," meaning the Met's galleries for Chinese painting.

As a Minimalist, Marden was concerned with grids and patterns. Looking to add freedom to his work without abandoning order, he found a model in Chinese calligraphy, with its system of drawing characters in rows, and began by drawing paired lines of mock Chinese characters, or couplets. "I'd do drawings in groups. I still have these notebooks and fill every page and then take the books apart and rearrange the pages. The idea of grouping drawings I find quite interesting.

"What happened when I was working with these couplets is that they started looking like figures. In 'Cold Mountain' I intentionally tried to eliminate those references. But then I decided: Why fight it? Why not just go with it? Now I am involved in this whole thing about control and not control. And one of the things about calligraphy is that it's highly disciplined. These guys spend years repeating and repeating the same characters, and they do it so much that they obtain a kind of freedom. Another big influence along these same lines was Pollock because with Pollock the figure kept imposing itself on his work, emerging out of the lines, instead of being applied by him, and that made the faces that appeared haunting somehow, like things welling up."

Pollock dripped paint from sticks. Marden works not only with long brushes when he paints but also with sticks when he draws. "They give me a combination of accuracy and inaccuracy," he explains, "because you can be incredibly precise but you also get mistakes and then incorporate them in the work. I get them more when I work with the sticks than with the brushes. You get your body into it more with a long brush than with a short brush, and I like that." He does a silent ballet, imitating himself painting. He says he thinks of the Chi, the Chinese life force, when

he paints. "It's a kind of energy, and every once in a while you just stop and concentrate on it—you know, where it is all coming from, this force through the body, and I've always liked the idea of this connection with the arm, the body, the heart, out through the brush."

Another scroll by Chao Tso, an early-seventeenth-century follower of Tung Ch'i-ch'ang who tempered Tung's style with a certain sweetness and lyricism, shows autumnal scenes: a village tucked into the mountains, a slender waterfall in a rocky landscape, a bridge arching over a shallow river. "How would you paint a walk in the woods?" Marden asks. "This is how. It's about respect for nature. When things are getting very static in my work, I go into nature, where there's an energy. If you're just in the studio, you repeat yourself and get clichéd. I've always found it especially difficult to draw landscape," he adds. "Painting it is one thing, you can get it sort of right. But drawing it is another. Then you see something like this, or in Western art like Brueghel's landscape drawings, or Dürer's. Wow.

"Going to museums is about trying to understand the thing that connects all artists. I remember when I worked for Rauschenberg, and also in one of my first jobs in a silk-screen place, artists would come in—Elaine de Kooning, Arman, Alex Katz—and working with them and seeing what they did was comforting because you find that you aren't far off in your own interests. The more exposure you have to real art, the more you see that there's a mysterious communalism."

He wants to show me a particular Khmer sculpture in the South and Southeast Asian galleries. Made of bronze, during the late tenth or early eleventh century, it represents a cross-legged figure, the Bodhisattva of Infinite Compassion, relaxed yet poised, serene, almost smiling. The figure is slender and linear, despite its gently swelling belly; its broad shoulders are squared so the torso twists slightly. "This one is incredible when you walk around it," Marden says. "I hate to use the phrase 'push-pull,'" he says, refer-

Cambodia or Thailand, Avalokiteshvara (The Bodhisattva of
Infinite Compassion), late 10th–early 11th century
Bronze with silver inlay, h. 22¾ in. The Metropolitan
Museum of Art, New York

ring to the term Hans Hofmann, the Abstract Expression-
ist painter and teacher, invented to describe the dynamic of
counterpoised forces in a composition that is supposed to
create simultaneously equilibrium and tension. "But that's
what this sculpture has. It's also what I'm thinking about
these days in terms of my own painting. I'll paint some-
thing, then go over it with another color in relation to
what's already there, and try to create a balance and ten-
sion with the different marks as they build up." He's look-
ing at the sculpture head-on now, so that its limbs and
body form overlapping and interlocking lines, vaguely cal-

African–Gabonese, Fang reliquary figure
Wood, metal, h. 25⅜ in.
The Metropolitan Museum of Art, New York

ligraphic, which causes him to think of Franz Kline. Kline
has been a model for him lately: his abstract gestures, from
the fifties, tend toward writing or figuration, as Marden's
recent works do. "I remember in the late fifties and early
sixties seeing Kline shows at Janis"—Sidney Janis's gallery.
"Janis had these small rooms and the Klines had an incred-
ible impact on me even then."

In the Indian rooms next, he pauses at a white marble
sculpture, a "Seated Jain Tirthankara" from the eleventh
century, whose rounded chest, sloping shoulders, circular
head and elongated limbs make the work as elegant and
stylized in its way as the Khmer bodhisattva. "Weird hands,
a strange piece," he says. "But the posture really depicts
energy in the body. You're aware of the mix of calm with
energy, in other words." Then, in the African galleries, he
stops at Fang reliquary figures made of wood blackened
with glistening palm oil. They have calm faces and some
have sticklike, tubular bodies with stumpy legs and Popeye
arms. "They are my favorite African sculptures. They be-
longed to these nomadic people who would carry the re-
mains of their ancestors with them. Someone once told
me that this Plexiglas case they're in keeps bursting open.
It sounds crazy and I don't know if it's true but I like to

think it's from the energy of the sculptures. Especially with these oils on them, they have this living quality. I like the reality and unreality of them."

Real and unreal. Energy and calm. Accuracy and inaccuracy. Abstract and representational. Marden returns often to these dichotomies. He enjoys "the complications, the mystery, that comes from opposition." In a room of Cézannes, he says Cézanne is "the greatest realist and the greatest abstractionist at the same time. In his still lifes, you've got all this movement and yet everything stops. It's so precarious, but then it just stops." He admires the way Cézanne is "always about making marks, calligraphic marks, which add up. He's also about this intense, long, slow process of working, looking, assimilating. He's very precise. I see in him a strong identification with the landscape, with the earth, which becomes this whole woman thing, you know, Mont Sainte-Victoire. I used to think that in his early portraits he just couldn't do it, he couldn't get them right, so he covered everything up with all that thick surface and black outlines. Now I believe that's not true. The blacks tie the pictures together across the surface." (One thinks of how Marden's lines knit his own paintings together.) He notices a Cézanne landscape. "Look at the energy in those trees. This is exactly what I meant about nature when we were looking at those Chinese paintings."

I'm a little surprised when he wants to look next at Clyfford Stills in the twentieth-century galleries: there is a room of these somber, forbidding, vertiginous walls of paint, like jagged mountain peaks. He picks out a small untitled blue canvas from 1943, sparsely decorated with black, yellow and red smears and squiggles. "You go around the galleries nowadays and you realize that people don't have the guts to do anything like this. To just put something down like that and leave it? Amazing. I love these pictures: they're wonderful because I see Still as a primitive. He and Agnes Martin are these mystical, visionary artists, looking out over these vast planes. I really like that." He calls Elizabeth Murray a primitive too, by which

Agnes Martin / *Untitled*, 1978
Watercolor and pencil on rice paper, 9 x 9 in. Courtesy of PaceWildenstein

Brice Marden / *Untitled*, 1964
Pencil on paper, 21¾ x 29½ in.

he seems to mean an iconoclast. Murray, he says, is "like Still and Martin and Picasso. It's almost as though they don't know anything about painting and have to figure out some way of doing it for themselves. You start out with all this stuff you're taught, and what you want to do is lose it. There shouldn't be any formula."

You'd expect Marden to like the late works of Joan Mitchell, as he does. Linear, calligraphic, they're ravishingly colored abstractions evocative of landscape. But he frowns at *La Vie en Rose,* from 1979, four panels with brushy blocks of purple, pink, black and blue. "These are the Mitchells I like the least, from the middle period. The later works, she really hit it."

Like Mitchell, Rothko is an obvious influence on Marden. His broad, atmospheric fields of color were important for Marden's early works, though Marden says, "For a few years I couldn't see Rothko at all. Now they're really coming back to me. I think they're beautiful again. I used to look at him a lot. I was so accepting of him it was like having a lover. I get these enthusiasms. I'm that way with Picasso now, and Pollock.

"I was looking at some Picasso books at one point and saw how he was exploring themes that have been explored all along, like the earth, Woman, sex, and I was reminded just how much Pollock took from Picasso, like everyone else did. But then Pollock went off on a private tangent, which is the remarkable thing. I love *Autumn Rhythm* and I love that it's here," he says, now standing before the Met's painting (the one on p. 54). "Sometimes I've thought that it looks bottom-heavy, off balance, but not now. I'm noticing how densely the lines are webbed and how hard they are to take apart as individual gestures or marks. It's also interesting to me how Pollock could take the most horrible colors you can imagine, such bad taste, then push them until they become interesting."

He compares *Autumn Rhythm* to a Bierstadt or a Cole, meaning to vistas of nineteenth-century America, but only to say they are finally dissimilar: "The Pollock is a

complete, pure expression, with a certain very American space that can make you think of landscapes, but the more you see them, and look carefully, the more you realize how truly abstract and nonlandscape they are. They're really just about themselves. You get these geniuses, like Pollock, who are working on their own plane, and no one is able to do anything with it, because it's so much about him. By comparison, de Kooning was always a European. He came out of Cubism. But Pollock's greatness was that he worked through all that stuff and came up with his own statement."

A second Pollock on view at the Met is *No. 7* (1952), in which representation and abstraction more or less fight it out. There's a footprint in a corner of the work, yellow splatters across its middle. Ribbons of black seem to form a giant head, but the head easily slips out of focus. "I love how, looked at one way, it's a monster, and then it turns into something else," Marden says. "It's so beautifully done. These circles read as nostrils and eyes, then as circles again. It's incredibly mysterious. You have this monumental, Cyclopian image but also this nervousness. It's static but energized." His hands trace the swirling lines in midair. "Maybe Pollock went into it with a vague idea about what he wanted, not necessarily with a head in mind," Marden speculates. "Then he took the lead from accidents, making adjustments based on the accidents that turned the image into something more complex. I always thought, for example, that this yellow bit was a pure accident. But it nicely complicated the image for Pollock and I think it really makes the picture work."

He could, of course, be talking about his own work when he's talking about Pollock's—the role of accident, the teetering between abstraction and representation. Looking at *No. 7,* he adds: "I find I've gotten away from being such an abstract painter to being a more figural painter. Art can make references to many things, and the way you move back and forth among those references is where the magic starts happening."

JACOB LAWRENCE

verybody says the same things about Jacob Lawrence, that he's endearing, courtly, a bearish man, gentle to the point of reticence, which he is. Typically, in front of some Jackson Pollocks at the Museum of Modern Art, he wrestles with his conscience before saying anything critical of them. "I guess there's nothing wrong with a negative statement," he tells himself. "I'm not going to face these artists" (Pollock, after all, has been dead for more than forty years) "and you have to stand by certain ideas. But still, I wouldn't dismiss anything altogether. The surface is interesting, the vitality. I can't say it's terrible, that I hate it, because it doesn't have that kind of importance to me." By Lawrence's standards, this is a denunciation.

His compassion has shaped the work that has defined him for more than half a century. Since the late 1930s, his subjects have included Toussaint L'Ouverture, the Haitian revolutionary; Harriet Tubman; John Brown; Frederick Douglass, and the history of the migration of blacks to the North from the South after World War I. Lawrence mostly paints series, or cycles, of pictures. The "Migration" series was reproduced in *Fortune* magazine in 1941, then jointly bought by the Modern and the Phillips Collection in

Jacob Lawrence / *John Brown, Series #21* (of 22), 1941
Gouache on white wove paper, 20 x 14 in. The Detroit Institute of Arts

Washington, which divided it between them. Lawrence
became famous. He was twenty-four.

His own family had migrated from the South. He was
born in 1917 in Atlantic City and lived for a while with
foster parents in Philadelphia. ("They were very Victo-
rian," he says. "I remember on Sundays sitting in the sit-
ting room, stiff, waiting for the pastor. You didn't feel like
you could go to the bathroom.") In 1930, he moved with
his mother to Harlem, then in its heyday. When he was
young he met Langston Hughes, Alain Locke, Claude
McKay. The sculptor Augusta Savage got him into the
WPA Federal Art Project, which provided him with mate-
rials, a studio and $23.86 a week, a major boost during the

Depression. Among other things he remembers going with his mother to hear Adam Clayton Powell, Sr., deliver sermons in the Abyssinian Baptist Church, and to the 135th Street Public Library to see Aaron Douglas's mural *Aspects of Negro Life,* experiences that, along with a general steeping in black history and culture, inclined him to make art about black heroes and about common black people whose lives he showed to be heroic. "I remember hearing folks in the street in Harlem tell the stories of John Brown and Harriet Tubman in such a passionate way," he says.

He was eager, gifted. He made friends with other black artists, including Gwendolyn Knight, his future wife. "A group of us used to go around to the galleries and museums, to Stieglitz's American Place gallery, then head over to Horn & Hardart's and argue about what we'd seen. As a black man you felt the same way about going into every art institution or gallery then. No one would keep you out, but it wasn't hospitable. You knew you were being watched. You learned to live with it.

"I remember John Marin's paintings were a particular discovery among people in the Harlem community at the time. Also Arthur Dove's paintings." Lawrence's first mature works, such as the Toussaint L'Ouverture series, related to Dove's art: an early American abstractionist (his pure abstractions may predate even Kandinsky's), Dove favored swelling curvilinear shapes in modulated, rich, often earthen colors, sometimes whimsical. The images alluded to nature, reduced to its essential shapes, and they stemmed partly from Fauvism, which Dove encountered in Paris in 1907, though he later said, "I can claim no background except perhaps the woods, running streams, hunting, fishing, camping, the sky." The link with Lawrence involves a common simplification of forms and saturated palette. Dove celebrated nature, Lawrence black history.

Of course, Lawrence's art also came out of Picasso and out of the work of Social Realists like Ben Shahn, whose series of paintings of Sacco and Vanzetti was on view at the Downtown Gallery in Manhattan (later Lawrence's gallery)

Ben Shahn / *The Passion of Sacco and Vanzetti,* 1931–32
Tempera on canvas, 84½ x 48 in.
Whitney Museum of American Art, New York

when Lawrence was young. At the beginning Lawrence
used egg tempera, Shahn's medium, though Lawrence says
he isn't actually sure when he first saw Shahn's work. He
cites as early influences the Katzenjammer Kids, Maggie
and Jiggs and the movies.

"I guess I was impressed by everything in my environ-
ment without even knowing it. I was interested in story-
telling. As a young artist, I wasn't getting big mural
commissions, naturally, so the way I thought to tell the
story of a person's life was through a series of panels, a lit-

tle like comics, I suppose. It was very important that the community in Harlem was supportive and left me alone to find my own way. Since I didn't have formal schooling in art, I could have been pushed in other directions. People could have said, 'That's not the way to do it,' or 'The hands are out of proportion.' I was using poster paint, a water medium, not oils. And I used egg tempera because I liked its translucence; it was easy to use. Besides, I could buy a jar with a dime. No one steered me from it. People respected the subjects I was doing, like Harriet Tubman, John Brown. And they also appreciated what they felt was a certain naïveté. They said, 'He's producing something of value, even though he doesn't really know what he's doing.' " Lawrence chuckles.

He has always been an independent painter. When battle lines in the art world were drawn between abstractionists and Social Realists, he embraced neither precisely but straddled the two. During the sixties, black artists more militant than he said his art wasn't nearly radical enough. "Maybe I was fortunate not to have thought in intellectual or ideological terms, as if I had to choose between one camp or another," he says. "I never became consumed by any particular artistic circle. I think that's my temperament."

It's also why, for instance, visiting the Modern today, he freely praises Charles Sheeler, the American Precisionist, and also Francis Bacon, Frida Kahlo, Käthe Kollwitz and Dubuffet, whose *Joe Bousquet in Bed* strikes him as unusually evocative. He thinks its clotted surface looks moldy. It resembles a gravestone, Lawrence says, "and to me the picture suggests a coffin more than a bed."

Above all, he admires Orozco's *Zapatistas*. "I've often used this work to teach the dynamics of composition and the value of social content, passionately expressed. With the Mexican muralists, you had both content and form— social content and abstract form—and, to me, he was the best of the Mexicans. It's very close to what I feel about the human condition." Lawrence likes to tell the story

about when he met Orozco. "He was working on the mural *Dive Bomber.* I think it was 1940. A friend of mine, Jay Leyda, who worked at the Modern then, arranged the meeting for me. There wasn't much of a conversation. Orozco was affable. Very quiet. Here he was, working on this mural, and I'd been taught that you do a small version of what the work is going to look like, you know, a study. But he took out a piece of cardboard, the kind you get with men's shirts from the laundry. And it had just a few vague chicken scratches on it. That was his study for the work. He told me, 'That's all I need.' It was a lesson he taught me: to be spontaneous, direct, which is even more incredible in his case because, painting frescoes, if you make a mistake, you have to dig out the plaster and start all over again. At the end of our visit, I asked if I could do anything for him. He said, yeah, he'd like to have a bag of

José Clemente Orozco / *Zapatistas,* 1931
Oil on canvas, 45 x 55 in. The Museum of Modern Art, New York

Sassetta / *The Journey of the Magi,* c. 1435
Tempera on wood, 9⅜ x 12⅛ in.
The Metropolitan Museum of Art, New York

cherries. So I went out to the street and brought a bag back to him. That's the whole story, really. It was just my little gift to somebody I admired a lot."

Lawrence has lived in Seattle since the early seventies, when he moved there to teach, but he and Knight miss New York, they say, and muse about returning now that he is retired. As a teenager during the 1930s, he'd regularly walk the sixty-odd blocks from his apartment to the Met, where he'd head first for early Italian Renaissance paintings. These days he walks uneasily, and lets Knight push him in a wheelchair if he's tired and his pride doesn't get in the way. When he leaves the Modern for the Met he goes straight for the Italian galleries and to *The Journey of the Magi* by Sassetta, the fifteenth-century Sienese painter. A famous fragment of an altarpiece, it shows a procession of figures down a steep slope beneath a row of cranes, the Star of Bethlehem hovering before them. "I can't think of a better term to describe the effect than 'magic,'" he says, and immediately you can see why he'd like this work: be-

cause of its geometry, simplicity and vivid colors, and because its story unfolds so directly, touchingly—qualities of his own art, in his first medium, tempera.

"It's simplified but very complex at the same time. We say 'simplicity' and imply something's easy to accomplish but this isn't easy. It's a highly refined composition, and I could describe why formally: the way the shapes balance one another, the way the image moves from dark to light. But there's something that I can't describe formally, which is a certain feeling, an intuitiveness, maybe. An emotional authenticity. I'm just projecting here, but I think it seems authentic to me because maybe the artist wasn't tied up too much in rhetoric, you know, talk, school talk, pedantics. When I was young I hung around painters and people in the arts, music, theater. I was just beginning to grasp what a theater person or artist meant when he talked about space or rhythm or movement. I couldn't talk the way they did. At the time I had a more intuitive sense of why I liked something, and I still think that's the most important thing to have."

A mid-fifteenth-century Italian portrait by a painter known as the Master of the Castello Nativity shows a woman, in profile, her hair in a pearl netting, topped by a jewel, a pearl necklace around her slim neck; a typical portrait of the time. Lawrence reacts to it instinctively. "I like it, but it's a stereotype. I'm thinking in ethnic terms, with this long neck and refined head. It's almost as if the painter didn't actually observe her. There are always certain characteristics pertaining to race and so on, and when you paint someone, you may think you're seeing them, but you're actually painting these traits. It's like that saying— what was it?—Minstrels were whites copying blacks who copied whites copying blacks, or something like that." Lawrence says he admires various modern portraitists—for instance Alice Neel, Francis Bacon and Lucian Freud. He rarely paints portraits himself, or rather, his portraits, almost never true likenesses, take the unconventional form

of series, like the ones of Tubman or Douglass. He inclines at the museum, somewhat surprisingly, to portraits by Romney, Gainsborough, Reynolds—light-years, in terms of style, from his own art—precisely because, he says, "I respond to what I can't do. You know those exercises in art school where the problem is to paint a white egg on a white tablecloth on white marble? When I was young, I would marvel at people who could do those sorts of paintings. I remember this painter in Harlem, he wasn't black, I'd see him through his window, and he was painting landscapes, portraits. They probably weren't very good, but they looked fantastic to me then, just seeing what he could do in terms of illusion. Magic. That's what always fascinates me. I didn't have that sort of training, so I never had a choice in terms of what kind of art I made. Of course, maybe this was fortunate. In my case, I was overwhelmed by my urban experience, arriving in New York at thirteen, in 1930, and seeing for the first time the rhythm and geometry of the fire escapes, the windows, the tenements. Sometimes I look at that work I did in the 1930s and think, That's how I want to paint now. But, of course, you can't ever go back."

From the Met's paintings galleries he goes to musical instruments, beautifully made, then to look at some French gardening tools in the decorative arts galleries. In the sixties Lawrence began to concentrate on one of his best-known subjects, his "Builders." At home, in Seattle, he keeps a collection of hand tools—planes, punches, rulers—and refers to them in his paintings, which, with their collagelike images, can almost be said to relate as much to a craft like quilting as to Cubism. He clearly prizes handicraft, the art of homespun labor, and he represents it in his art. "When I was about fifteen or sixteen, I was exposed to the workshop of these three brothers in Harlem, the Bates boys, cabinetmakers. I got to know them, and they got to know me. For me, tools became extensions of hands, and movement. Tools are like sculptures. You look at old paintings and you see in them the same

Jacob Lawrence / *Cabinetmaker,* 1957
Casein on paper, 30½ x 22½ in. Hirshhorn Museum and Sculpture Garden,
Smithsonian Institution

tools we use today. Tools are eternal. And I also enjoy the illusion when I paint them: you know, making something that is about making something."

American paintings next. During the fifties and sixties, Lawrence painted gloomy, brooding pictures that don't bring to mind Ryder exactly, though you can see how he might feel an affinity with Ryder's spare, almost abstract shapes and unconventional technique, which was a home-made craft. Ryder's *Toilers of the Sea,* from the early 1880s

(see p. 169), is a dense, yellowing picture of a sailboat in a stormy sea under a full moon. "The mystery of it is wonderful," Lawrence says. "That's no longer a moon, it's a shape that remakes itself into other shapes. And this shape here, the boat, is like a mouth. Everything's unstable, reduced, uncluttered. And because it's reduced, it becomes somehow more. The more you reduce something, the more it can become suggestive, dynamic."

That said, he also likes Thomas Hovenden's *Last Moments of John Brown,* from 1884, which in reproduction used to be found on the mantelpieces and living-room walls of many African-American families during the early decades of the century. Brown, the messianic white abolitionist from Ohio, led an uprising against a proslavery group on the banks of the Pottawatamie River in Kansas in

Thomas Hovenden / *Last Moments of John Brown,* 1884
Oil on canvas, 77⅜ x 63¼ in. The Metropolitan Museum of Art, New York

1856; then in 1859, with a group of twenty-one followers, he captured the United States arsenal at Harpers Ferry in Virginia. Robert E. Lee recaptured it and Brown was convicted of treason. The trial made him a national martyr and Virginia's governor armed fifteen hundred men to deter Brown's sympathizers from attempting to free him before he was hanged. Lawrence painted Brown in 1941 as a haggard visionary, an emaciated Old Testament prophet. In a typical panel from the series, Brown's head is bowed, he clasps a cross, his cloak is a large, flat half-moon shape, and his face is behind strands of straggly hair that resemble flames. It is an image of economy and pure color.

By contrast, Hovenden, a realist, shows Brown as noble, barrel-chested and avuncular, being led to his death, a noose already around his neck, flanked by soldiers who restrain a crowd of black men, women and children. One woman lifts her baby up for Brown to kiss. "You see blacks as real people responding to a man who is trying to better their lives," Lawrence says. "This is one of the great, great works," and he compares it with Horace Pippin's version of the same subject. A year after Lawrence painted his series, Pippin painted Brown several times: reading his Bible, at his trial, and on the tumbrel to his hanging. A lone black woman among the white onlookers in the last picture is said to be Pippin's mother, who he believed had witnessed the hanging. "There's a wonderful feeling in Pippin's work, a passion, a deep expression of the American experience," Lawrence says. "I mean, John Brown was not black but gave his life for a part of American humanity, and Pippin really conveys this sense of shared struggle. Hovenden's painting, on the other hand, is more illustrational, though he's also got great sentiment. I mean, look at those faces, that mother holding her baby, wanting the baby to come in contact with this person, and this person to come in contact with her baby. It's a picture that's great in spirit."

Lawrence recalls one day in the 1930s when, on his way home, he happened into a Harlem lecture by a certain

Professor Seyfert about the achievements of black artists in Africa. "He wanted artists to paint out of the African experience. He was very imposing. We were awed." That was also the period when Alain Locke was calling for a new black art to arise from a mix of modernist and African sources. Locke believed there was an African heritage in all black artists waiting to be released. "Perhaps we shall see eventually a decided and novel development in those subtler elements of rhythm, color and atmosphere which are the less direct but more significant way of revealing what we call race," Locke declared.

Locke touted Lawrence's Toussaint L'Ouverture series as a model of a new African-American art. Lawrence recalls seeing, in 1935, at Seyfert's urging, a show of West African sculpture at the Museum of Modern Art, then

Horace Pippin / *John Brown Going to His Hanging,* 1942
Oil on canvas, 24⅛ x 30¼ in.
The Pennsylvania Academy of Fine Arts, Philadelphia

going home and whittling some crude wood sculptures. "I didn't have regular carving tools, so I whittled more than I carved," he says. "The show made a great impression on me." He believes, nonetheless, that Locke's theories directly affected other black artists more than they did him at the time, and for years his interest in African art did not seem to him to have a special importance for his work. Then in 1962 an exhibition in Nigeria of the "Migration" series became an occasion for Lawrence to go to Africa. The trip affected him so much that he and his wife sold their house in Bedford-Stuyvesant, Brooklyn, where they'd moved from Manhattan some years earlier, and settled briefly in Nigeria. They stayed from April to November, 1964. He painted his "Nigerian" series. Knight began to make works influenced by the Janus-faced headdresses she saw there.

"It was an entirely black culture, which very few of us experience, and it was a feeling I never felt before," Lawrence says. He has arrived at the Met's African galleries to peruse a Dogon sculpture of a seated man and woman. He and Knight own some Dogon sculptures, and also some Benin and Yoruba figures. "We never intended to stay in Africa, but I guess our interest went back to our days in Harlem and the Africa movement, Marcus Garvey on the street corner, the whole thing. We met artists, playwrights there. I became aware of West African sculpture and its particular relation to Cubism. Not that in my case I could ever do anything in direct imitation of African art, or that I wanted to. Locke wanted a whole new art form to come out of African influences, and I think there are maybe some sculptors now who might come closer to achieving that goal than I ever did: Mel Edwards, Richard Hunt. I think it's more difficult for painters. Besides, some things come out of a spirit, out of, what can I call it?" He pauses, then points to his gut. "Some force down here. And you can never fake that."

HANS HAACKE

ans Haacke first achieved a measure of fame in 1971 when he did not have a show at the Guggenheim Museum. One had been planned, but then the museum's director, Thomas Messer, discovered that Haacke wanted the show to include documentation of the real-estate holdings of New York City slumlords, and Messer thought the Guggenheim wasn't the place for "active engagement toward social and political ends," as he put it. He canceled the exhibition. Its curator, Edward Fry, was dismissed.

Seen today in the Metropolitan, Haacke doesn't look particularly fearsome. Wary, maybe. He's amiable, but a little cautious. He has one stipulation: no photographs of him. "I don't want to push myself as a person into the foreground," he says. "The foreground should be my work. And also the image can be a fetish, a fetishization of the artist, which I don't want." For the record, the German-born Haacke is balding, graying, bearded and of medium height and build, and he is dressed casually in the rebel's uniform: black leather jacket and jeans.

As you might expect, he doesn't go through the museum as other people tend to do. He'll stop just to admire one thing or another but he's as interested in the labels, the

August Sander / *Unemployed Man, Cologne,* 1928
Gelatin-silver print, 9 ⅟₁₆ x 6 ¹¹⁄₁₆ in.
The Metropolitan Museum of Art, New York

architecture, the lists of donors and exhibition sponsors—
the infrastructure and apparatus of the museum—as he is
in the art. When he says, before starting out, that he has
just a couple of ideas in mind, you know he's underplay-
ing his hand. He has already chosen the works he plans to
talk about, not to mention his words, very carefully. About
art, he's a tyrant. But a likable tyrant.

He stops first in a gallery of photographs with a 1928
August Sander, *Unemployed Man, Cologne.* The man, hat in
hand, looks demure and touching, as if shrinking into
himself (a penitent's pose, almost) and he turns his eyes
from the camera toward an empty Cologne street. It hap-
pens that Haacke, born in 1936, lived in Cologne as a child

at the beginning of the war, then moved to Bonn. He left for art school in Kassel, a bombed-out city (a tank-building center for the Nazis) that after the war ended up just on the western side of the new border with East Germany. There, in the ruins of the city center in 1955, was begun the exhibition called Documenta that has become a major international showcase for new art. Among other things, the show was invented to demonstrate to the world the quality of the new West Germany, which embraced modern art that the Nazis had condemned. Its openness was also a rebuke to the more repressive East next door: art, in other words, was meant to serve implicit political ends. "Since Kassel was a border town, it was economically disadvantaged. Partly, Documenta was an attempt to revitalize the region. When the second Documenta came around in 1959, I was a student and was hired to help with the installation, as a guard and then as a guide. That was an incredible education. I took six or seven rolls of film during the show, and lately these pictures have been unearthed in Germany and they are said by critics to reveal something about the sociology of my later work—that I was already curious about the ancillary aspects of an art exhibition. Maybe so."

Haacke settled in New York City in 1965 (he speaks colloquial English with a German accent). At a time of Minimalism, Performance, Process and Environmental art, his early works involved biological references: one, *Ant Coop,* consisted simply of an ant farm. Haacke's aim, he explains, was to explore socialization among the ants. In a sense, it wasn't all that big a leap from there to the more elaborate political works he began to do by the late sixties that explored the dynamics of human relations, in particular the relations between corporations and individuals, governments and citizens, museums and museumgoers. Haacke's métier became a territory more familiar to investigative reporters than to artists: a project planned for a museum in Cologne involved tracing the background of one of the donors to the museum of a Manet, Hermann Josef

Abs, who turned out to have been a high official at Deutsche Bank in the days of Hitler. That museum, like the Guggenheim, declined to show Haacke's work.

Over the years, Haacke has become more or less the dean of political artists, and various followers have tried to imitate his blend of reportage, bite and humor. He winces at some of the so-called political art of the early nineties. "I am often impatient with all the well-intentioned stuff that doesn't turn me on visually," he says, and volunteers that while he sympathized with the idea behind a Whitney Biennial that accentuated political art, the wall labels, which were preachy and humorless, gave him "stomachaches—not the principle behind them but their execution," he hastens to add.

Haacke himself is heir to figures like Bertolt Brecht, George Grosz, Hannah Höch and John Heartfield: German artists of acerbic wit. He has constructed sculptures and installations and done photographic pieces and paintings aimed at unmasking what he regards as dubious goings-on at companies like the Swiss arms manufacturer Oerlikon-Buhrle, at American Cyanamid, at Mobil Oil and at the advertising firm of Saatchi & Saatchi, and also involving politicians like Margaret Thatcher, Ronald Reagan and George Bush.

It's not just because he lived in Cologne that Haacke is interested in August Sander's photographs. He once based a painting, of the German chocolate manufacturer Peter Ludwig, on a Sander picture of a pastry maker. His affinity for Sander has to do with the fact that Sander saw his art as having a social, not just an esthetic, purpose: in his case to document, through photographs, people from all parts of German society, dividing them into peasants, businessmen, the insane and so on. His accomplishment was to suggest the coherence of such categories while maintaining the individuality of each of his subjects. An initial selection of the pictures Sander took for this vast, encyclopedic enterprise, which he called "Citizens of the Twentieth Century," was published in 1929, but the Nazis suppressed the

book and no further parts of the project were published until after Sander's death in 1964.

"Cataloguing has dangerous overtones," Haacke says. "But the Nazis tried to present specimens. There were the ideal types that they wanted to promote, and we all know the consequence of that. And then they had rogues' galleries. Sander was cataloguing as a sociologist might do. He tried to be impartial, though in a picture like this," he says about the photo of the unemployed man, "he was clearly sympathetic. I believe his work, in terms of categories and a standoffish way of photographing them, must have inspired the Bechers and through them the current generation." Haacke means Bernd and Hilla Becher, the German couple whose pictures, which they began to take in the 1950s, of vernacular and industrial architecture—plain, head-on, like mug shots, and strangely anthropomorphic—have influenced younger Conceptual artists, German and otherwise.

"Sander was about making sense of society, of its range, and as a conglomerate of various people," Haacke adds. "The Nazis obviously did not like the idea of society as a broad range of different people. And they did not like the fact that a good number of people he photographed were Jewish dignitaries. He belonged to a tradition of photography as scientific documentation, which happens to be art. Because certainly photographs like this were not the type of postcard pictures you would send back to your friends from vacation."

The Met's galleries for nineteenth-century European paintings and sculpture are decorated in a pseudo–Beaux-Arts style: columns, dados, lintels, in a variety of designer greens, yellows and grays. From the entrance to them, at the end of a long columniated vista, Haacke shakes his head. "Disneyland," he says. "The claim that this re-creates the environment in which these paintings were first shown is not credible. The Paris salons didn't look like this. Paintings in the salons, as we know from photographs, were stacked from floor to ceiling." The salons were the

giant annual state-sponsored exhibitions in Paris. It was in part by breaking with the salon traditions that the avant-gardists, like Courbet, defined themselves. "This is fake architecture," Haacke says. "We can visit here on Sundays but it's like slumming in the past. The effect is to divide us from another period."

When the Met was built, in the late nineteenth century, its grand building was described in democratic terms, like the White House or the Capitol in Washington, or for that matter like the vast new department stores of the time: it was a palace for the people. America, searching for an architectural style befitting a new democratic society, looked to ancient Athens and Rome, at the same time that the nineteenth-century Beaux-Arts style also added a certain paradoxical implication of opulence, if not elitism, to the architecture of populist palaces like the Met. And these buildings retain this dual reputation, as off-putting to, and celebratory of, the masses. "I admit," says Haacke, "it is difficult to list alternative examples of a true democratic architecture. It's tricky. I cannot totally disagree with the attempt here in these galleries to put nineteenth-century works in a context related to their time. But it would be better if one could arrive at a presentation for the works that convicts, so to speak, the salon paintings, the official paintings, on their own terms. It's not easy and I don't have a scheme."

One of those salon pictures is the academician Cabanel's *Birth of Venus,* of a glassy female nude reclining on the crest of a wave, an allusion to Botticelli's *Venus.* "The picture was part of the bedrock of the Met's early collection, which immediately tells you something of the outlook of the founders of the museum," Haacke says. "The salon was their model, in every sense of the word 'salon.'" The wall label beside the picture names its donor as John Wolfe, a cousin and art adviser of Catharine Lorillard Wolfe, one of the Met's first major patrons. Haacke looks at the label and says, "They shouldn't be written with the assumption that the reader knows art history. Here you have 'oil on

canvas.' Well, we see that anyway. O.K., the title obviously needs to be there. But the label should put us in the context of Cabanel's period. For example, a naked woman appears in this painting. I would talk about this somehow in the label: what it meant in Cabanel's time, what implications it has, how this subject is still our subject today. When works of art are presented like rare butterflies on the walls, they're decontextualized. We admire their beauty, and I have nothing against that, per se. But there is more to art than that. Museums are managers of consciousness. They give us an interpretation of history, of how to view the world and locate ourselves in it. They are, if you want to put it in positive terms, great educational institutions. If you want to put it in negative terms, they are propaganda machines. They're both. This is something usually not acknowledged and there's probably a good reason why: because if this were in one's consciousness, then one would be a bit more immune to brainwashing—assuming brainwashing is the intent. Although I wouldn't go so far as to say that it is. That would be a little paranoid."

Alexandre Cabanel / *The Birth of Venus,* 1863
Oil on canvas, 41¾ x 71⅞ in. The Metropolitan Museum of Art, New York

It should go without saying that Haacke is not, nor would he wish to be, regarded as a connoisseur in the Berensonian sense, which is to say as an esthete, and he takes a certain pleasure in pictures that, like him, are unconventional, even disagreeable. "Origins of Impressionism," an exhibition of painting in France in the 1860s, has opened at the Met, and he finds within it Cézanne's *Madeleine,* a big, grossly painted image of the Magdalene weeping, in the overheated manner of the artist's early work (his *Rape* on p. 36 is another example). Like this picture, Haacke notes, the coat of arms of Cologne shows human tears, which are meant to represent the eleven thousand virgins martyred in the city centuries ago. "It's a personal connection for me to this God-awful painting, which I also think is one of the most interesting in the show. Not only is the imagery something we see later with Expressionism, but also the application of paint is so outrageous for its time, with really dirty colors. Paint is applied, to put it in fancy terms, to be a signifier for distress. Compared to the late, mature Cézannes (they are great paintings, no question), this one has more energy behind it. It is painted with passion."

For a similar reason, Haacke also likes Cézanne's *Banquet,* an early takeoff on Tintoretto ("He makes Manet look like an academic almost, with these figures made out of Play-Doh"), and Renoir's *Young Boy with a Cat.* It depicts a naked adolescent from the rear, standing, his legs crossed, his head turned over his shoulder toward the viewer. The cat, which the boy bends slightly to cuddle, sits on a tall piece of furniture covered in patterned white silk.

"Look at the way the cloth is pleated, soft, and how it contrasts with the figure next to it. The folds, of course, are full of sexual connotations. I don't know of another painting off the top of my head of a young boy seen naked from the back. Obviously there's affection on the part of Renoir toward the boy. It's a homoerotic image. The boy is looking out at us in a very strange way—as if there's

Pierre Renoir / *Young Boy with a Cat,* 1868
Oil on canvas, 48¾ x 26⅜ in. Musée d'Orsay, Paris

some unspoken drama going on." The Renoir is in a part
of the show devoted to nudes. The centerpiece of it is
Courbet's *Woman with a Parrot* (on p. 156). Haacke sees a
connection not only between its reclining nude and Ca-
banel's *Birth of Venus,* an obvious link, but also, less obvi-
ously, to Marcel Duchamp, because the Courbet reminds
him of Duchamp's *Étant Donnés,* in the Philadelphia Mu-
seum of Art. *Étant Donnés* is his famous installation involv-
ing a peephole in a door through which is glimpsed a

landscape with a naked woman on the ground, as if dead. She holds a lamp. "The hair, the posture, the raised arm that in this case holds the bird and in the Duchamp, a gas lamp. The fuzzy background: a waterfall in Duchamp, here a vague landscape. And of course, they're both erotic images. I don't know whether Duchamp was aware of this painting, but he was someone who pulled all sorts of things together in ways that were open to interpretation. The Duchamp is also like *Origin of the World* because of the peephole, the invitation to see something you're ordinarily not meant to see." *Origin of the World,* painted by Courbet for the private delectation of a collector around the time he painted *Woman with a Parrot,* shows a close-up of a woman's genitals. Haacke additionally recalls a series of Duchamp prints on the theme of lovers, which includes an image of a falcon peering up at the genitals of a female nude, who derives from Courbet. "It's important when we

Marcel Duchamp / *Étant Donnés,* 1946–66
Mixed media assemblage, 95½ x 70 x 49 in. Philadelphia Museum of Art

Édouard Manet / *The Battle of the Kearsarge and the Alabama*, 1864
Oil on canvas, 52¾ x 50 in. Philadelphia Museum of Art

see something on exhibition that we think not only in terms of where it comes from, but also where it leads to," he says.

Around the corner, in a room of marine pictures, Manet's *Battle of the Kearsarge and the Alabama* depicts a scene from the Civil War that occurred in French waters: The Confederate steam-driven *Alabama* lost to the Union sloop *Kearsarge* outside Cherbourg harbor on June 15, 1864. The painting shows the *Alabama* sinking under a cloud of smoke into a dark green sea, the *Kearsarge* in the distance on the horizon and, in the foreground, a small French sailboat full of spectators. As the label says, the picture is "not simply a marine but also a reportage of a significant contemporary event." Haacke points out how

"carefully constructed it is, with this long diagonal from the sailboat in the lower left to the *Kearsarge* in the upper right, and the way the tips of the sails of the small boat line up with the *Alabama*. But it's also a curious composition, because in the foreground there's this huge expanse of mostly nothing, just water, of relatively uniform color and little detail. While at the back you have the opposite: very minute details, with all the ships and flags.

"A standard line, promoted by people like Clement Greenberg," Haacke says, referring to the late American critic, who was one of the chief champions of Abstract Expressionism, "is that politics contaminates art, and Manet is often cited as an example of art for art's sake." Haacke in this remark overlooks the last quarter-century of Manet scholarship, not to mention Greenberg's own early writings, but his point, he says, is that "Manet is acting like a reporter and commentator. Aside from the fact that it's a beautiful painting, the reason I'm excited about it is because it's a precedent for making current political events a subject matter of art. The label mentions this but still treats the event like an anecdote. It had big implications. This was a matter of international significance, painted not so long after its occurrence, and we know now that Manet was a republican, and I believe his gut feelings were sympathetic with the North, so he would have seen this as a victory for the good. Coming near the Franco-Prussian War it also maybe had meaning in France in terms of fighting a republican cause: the French Revolution, the American Revolution. I'm glad that a painter who has these convictions also happened to be a good painter."

Courbet, like Manet a painter of astringent social commentary, was imprisoned after the siege of Paris, accused (wrongly, perhaps) of inciting fellow Communards to tear down the Vendôme column. He spent his last years in exile in Switzerland, having been judged responsible for the enormous cost of re-erecting the column. Much of his time was spent painting unremarkable landscapes to please the market. His *Oak Tree in Flagey, Called the Oak of*

Vercingetorix in the exhibition is an example of an earlier Courbet landscape, deeply symbolic. In Courbet's day, the people of Burgundy and of the artist's native Franche-Comté region were in heated dispute over the true location of Alesia, the ancient capital of Gallic resistance to Julius Caesar. Particularly in the 1860s, when Napoleon III ruled France, Alesia became a symbol of anti-imperialism. The giant oak, Courbet believed, represented the Alesian site in Franche-Comté where Vercingetorix, the Gallic general, battled the Romans. The oak was a kind of surrogate portrait of the general by Courbet. It was also, maybe, a reference to the trees planted during the French Revolution as emblems of liberty.

"The tree is very strong," Haacke says. "The whole thing's painted with a palette knife, so there is a thick texture to the pigment. Courbet was a materialist. You sense this tree is made out of paint, not bark. No trompe l'oeil," he says, which causes him to think of Brecht: "Brecht wanted his actors to present themselves to the audience as actors, in contrast to pretending that they are the people they portray." Haacke makes a further connection between the Courbet and *The Sea of Ice,* by Caspar David Friedrich, the German Romantic. Friedrich is more of a political artist than people think, Haacke contends. *Sea of Ice* is his image of a shipwreck in frozen waters. Wood fragments protrude from the ice; shards of the ship's broken mast, which Haacke says are also like tree trunks, their branches cut off, symbolize trees of liberty akin to Courbet's oak. "Trees for Friedrich represented Germany," he says, "and that image expressed his disappointment at the failure of the democratic movement there. You know those paintings by him of men looking at the moon? I believe that the guys are wearing clothes that the revolutionaries wore in nineteenth-century Germany, the ones who wanted to topple the princes. The moon signified the future to which they were looking hopefully. And after the wars of liberation against Napoleon, German patriotism didn't

Caspar David Friedrich / *Das Eismeer (The Sea of Ice)*, c. 1823–25
Oil on canvas, 38 x 50 in. Kunsthalle, Hamburg

Hans Haacke / *Germania,* 1993
German pavilion at Venice Biennale, 1993

have the nasty overtones that it later had with the Nazis, though Friedrich's patriotism did make him a perfect figure for them to exploit." Friedrich was in Hitler's cultural pantheon, and it took decades for his reputation to recover. It happens that as an artist representing Germany at the 1993 Venice Biennale, Haacke smashed the marble floor of the German pavilion, which had been designed under Hitler, and after doing so he realized the similarity of the floor's piled marble slabs to the image of broken ice in the Friedrich. His installation thus became, in part, an homage to Friedrich and implicitly an allusion to Friedrich's fragile reputation. "I'm a Romantic in many ways, like Friedrich," Haacke says, "though many people may not believe that."

He notices at the exit of "Origins of Impressionism" a sign that identifies its sponsor as Philip Morris, which had lately tried to persuade New York cultural institutions to which it has given money to campaign in its behalf against antismoking legislation. It asked them to contact the New York City Council to stress how important the company is to the arts in the city. In 1990, Haacke recalls, he created a giant cigarette package, modeled after Philip Morris's Marlboro brand, with "Helmsboro" where the word "Marlboro" would be. A picture of Senator Jesse Helms of North Carolina was placed within the Philip Morris insignia. And the words "Philip Morris funds Jesse Helms" were printed on each of the cigarettes, a reference to contributions by the company to the senator's reelection campaign at a time when Helms was vigorously campaigning against the National Endowment for the Arts. Haacke's SoHo gallery, John Weber, got a letter from a Philip Morris lawyer who had seen an announcement for the show. The lawyer objected to the use of the Marlboro design, and Haacke thought he had reason to believe that the gallery would be sued if the show went on as planned. It wasn't sued, and the lawyer insists he was only trying to stop the gallery from using the design on the invitation card. "We ignored it," says Haacke. "But in most cases,

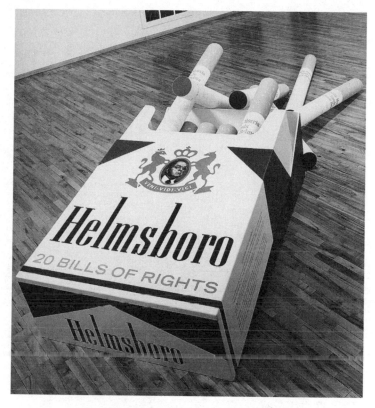

Hans Haacke / *Helmsboro Country*, 1990
Wood, cardboard, paper, silkscreen, photo, 30½ x 80 x 47 in.

the gallery would have said to the artist, 'We love you, but we don't have the money to fight this.' "

He makes a final stop, at the Degas bronze of a four-teen-year-old ballerina wearing a muslin tutu and a silk ribbon around her hair (see p. 77). "The bronze figure pretends to be a real human while the tutu and ribbon are, in fact, real. I don't know how to express it perfectly, but the relationship between reality and representation becomes complicated. It's the precursor to the collages of Picasso and to the Dadaist readymade. The real world and the fictive world mingle. There is a tendency to sequester, to ghettoize, art, to separate it from the world that we actually inhabit," he says. "But here Degas is breaking down the barriers."

CHUCK CLOSE

I n the African galleries at the Metropolitan Museum of Art, Chuck Close is looking at a couple of Congo power figures, wood fetish objects believed to have healing powers and impaled with nails and spikes. "For me, it is the transcendence of an object that counts, and I don't mean a religious or mystical transcendence but a physical transcendence.

"Why make art? Because I think there's a child's voice in every artist saying: 'I am here. I am somebody. I made this. Won't you look?' The first painting ever was by some artist at Lascaux or Altamira or wherever, who put his hand on the wall and then blew soot through a straw around his hand. What is it about people that since the dawn of time we've wanted to mark our presence so that other people will see it? I mean, people always wonder how paintings get made. How do they magically transcend their physicality? How do you take a stick with hairs on it, rub it in colored dirt, wipe it on a piece of cloth wrapped around some wood and make space where it doesn't exist? I am no closer to understanding it today than when I began."

Close is known for the mostly giant portraits, at first black and white and now dizzyingly colorful, that he has been painting since the late 1960s. They relate, in different

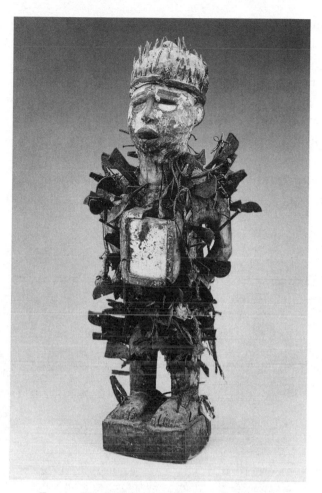

Congo (Yombe), Power Figure, 19th century
Wood, iron, glass, pottery, shells, cloth, fiber, pigments, seeds, glass beads,
h. 28½ in. The Metropolitan Museum of Art, New York

ways, to the works of other artists of the sixties, besides
Katz and Leslie, painters like Richter and Malcolm Mor-
ley. Based on photographs, they are monumental close-ups
of heads of family members and friends (the composer
Philip Glass, the sculptor Richard Serra) that have been
created under a succession of self-imposed limitations. He
has made portraits out of thousands of his own finger-
prints, out of pads of handmade paper pulp, and out of
countless dots arranged in grids of different sizes. He has
made a portrait using only a diluted spoonful of black

paint. And in recent years, he has taken to large grids, each square of which he crams with multicolored ovals and hot-dog shapes, making the portraits look swimmy, as if re-fracted through water or pebbled glass.

These paintings and his photographs have helped make him a figure of his generation perhaps akin to what Roy Lichtenstein was to the previous generation—that is, of an unmistakable style, graphic and accessible. However, Close is tougher to categorize than Lichtenstein in the end. He was linked at the beginning of his career with the Photo

Chuck Close / *Phil,* 1969
Synthetic polymer on canvas, 108 x 84 in. Whitney Museum of
American Art, New York

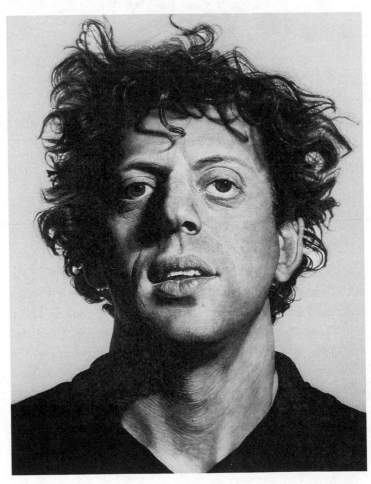

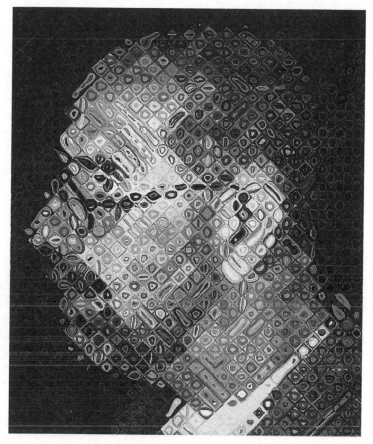

Chuck Close / *Self-Portrait II*, 1995
Oil on canvas, 72 x 60 in.

Realists, but it soon became clear that his allegiances were more to the Minimalists and the Process artists of the sixties and seventies because he said he considered subject matter almost incidental compared with the manner in which he worked and the methods he established for himself.

He says that his heroes were Willem de Kooning and Ad Reinhardt, great fifties abstractionists of divergent attributes, the one extravagant, the other contained (Reinhardt made black-on-black paintings, among other things). "One of the great thrills for me was going to de Kooning's studio in the 1980s and watching him talk, with his hands moving

through the air like Leopold Stokowski conducting, tracing what were de Kooning shapes in the air," Close recalls. "I had been a de Kooning acolyte in school, painting de Koonings, so I told him that it was nice finally to meet someone who had made even more de Koonings than I had. He's still hugely important to me, along with Reinhardt, which may surprise people, because our works are so different, but this is because his art involved a commitment to self-imposed restrictions as a way to change and grow. I'm sure he'd have hated what I do, but he made the choice not to do something into a positive decision."

To complicate matters further, Close has lately reversed himself about his lack of interest in subject matter, coming "out of the closet as a portraitist," as he puts it, to pay homage to a long line of predecessors, from the anonymous Egyptians who painted faces on mummies to Holbein, Hals, Velázquez, van Gogh and Lucian Freud. One of the purposes of this visit to the Metropolitan is to see their works.

About some of the other artists he passes along the way he is dismissive. Renoir is "Italian restaurant painting and unless you're having pizza you wouldn't want to look at it." He doesn't care much for Titian or Tintoretto either.

Balding (he shaves his head), spectacled and bearish, Close is a voluble, amusing man, not without a sanguine and sometimes touchy view of an art world in which he is generally liked and admired. He seems to know everyone in New York's hothouse art community. He now moves about in a wheelchair. A spinal artery suddenly collapsed in 1988, leaving him what is called an incomplete quadriplegic, with all the muscles from his shoulders down affected to some degree. At forty-eight, he had to relearn to paint, with brushes strapped to his hands. "When I was in the hospital, zonked on steroids, I remember having nightmares of flying through huge Germanic halls, rushing in one-point perspective, in black and white, through what were essentially Anselm Kiefer paintings," he says. "I real-

ized the drugs duplicate a psychotic state, and that, weirdly, Kiefer has his finger on the pulse of this condition."

Close tries to view his setback as another potentially creative limitation. "I don't mind being seen as an artist who is handicapped. I'm just not a handicapped artist," he says. As a student at Yale in the early sixties, he was regarded as someone who, if anything, had to struggle with his own facility to avoid becoming merely a virtuoso. With his disability, he found himself struggling to paint at all. "I had a really profound experience in the Met recently," he says. "I had to give a lecture I didn't want to give, and to reward myself I came to the museum to see a Corot show. I've never been a fan of Corot and people were twelve deep and I thought, What am I doing fighting to see these crummy paintings when down the hall are some of the greatest paintings in the world? So I went to look at the Petrus Christuses and Holbeins and realized that everything I loved in the history of painting, and portrait painting in particular, is small and tight and the product of fine motor control, which I had lost. I was depressed for days, but then I ended up with a cathartic experience because I found myself in my studio feeling so happy just to be working again that I was literally whistling while I painted and at the same time tears were streaming down my cheeks."

Anselm Kiefer / *Bohemia Lies by the Sea*, 1996
Oil emulsion, shellac, charcoal and powdered paint on burlap, 75¼ x 221 in.
The Metropolitan Museum of Art, New York

Close was born in 1940 in Monroe, Washington, near Seattle, and went to the University of Washington. He recalls as a child marveling at the illusionism of the drawings on the covers of the *Saturday Evening Post*. "I think I made so many black-and-white works because I grew up thinking of art as the black-and-white images I saw in reproductions in magazines like *Art News*." He began to draw and paint when he was young. He remembers the first time he saw a Pollock. "I was thirteen and I'd been studying art since I was eight, and it outraged me. I remember it had tar and gravel and aluminum paint. I couldn't believe it. But within days I was dribbling paint over all my representational paintings, covering them up."

Generally, Close says, there wasn't much great Western art to see in Seattle, though there was the art of the Northwest Coast Indians, and in the Met's Pacific art galleries he wonders aloud how growing up in Seattle and seeing so many Native American masks may have affected him as an artist. "I remember making papier-mâché masks when I was eight or ten, and I also made hand puppets out of sawdust and glue. Those were probably the first heads I ever did. I also recall being knocked out by the dioramas in the natural history museum. Everyone else looked at the stuffed animals and I was looking at the way the fake grass on the ground merged with the painted grass on the walls. I was really into the notion of verisimilitude early on.

"My learning disabilities also affected what I did as an artist. I could never remember faces, and I'm sure I was driven toward portraits because of the need to scan, study and commit to memory the faces of people who matter to me. The other thing, which is also a learning-disability issue, is that I've always been incredibly indecisive and overwhelmed by problems, and I've learned that breaking them down helps, which is exactly how I paint a portrait: I break it down into bite-sized pieces, into lots of little manageable decisions." He's referring to his grids, painted square by square. "It's how I believe my work relates to women's work: because traditionally men could go off and

work all day on a project, but women would pick up things and then have to put them down—they would knit, then have to stop to make dinner, or whatever, so they needed to do projects that could be broken into incremental units, like knitting, weaving, quilting, crocheting, petit point. I was trained in school to finish a painting all at once, like an Abstract Expressionist, but I remember hooking a rug as a freshman. It took forever."

After Washington, Close found himself at Yale with Serra, Nancy Graves, Janet Fish, Rackstraw Downes and Brice Marden. Some of Marden's early prints, Minimalist grids in black and white, happen to be on view while Close is at the Met, and passing them, he recalls that "around the time Brice did these prints, I visited him in lower Manhattan. He said he had made a red painting; then when I got to his studio I saw a gray painting, that sludgy gray he made. But he had made it from mixing these high-intensity reds and blues, which canceled each other out, so that hidden in that gray and broadcasting in a subtle way, like a radar beacon, was this rich, rich, full-intensity, full-saturation color, but neutralized and contained. It couldn't have been less like battleship gray slapped onto the canvas." Close lately has made black-and-white works that, in a similar way, are the result of mixing dozens of colors.

Marden at school, Close says, was a "great draftsman, but not at figure drawing. The work he is doing now is almost figurative, but he got to it partly through Chinese calligraphy, so it's not straight figuration. Brice's gift has always been his sensitivity to the way marks go down on the surface, because you know when you're just making marks without imagery it's very easy for those marks to become decoration, by which I mean a sleight of hand that makes people go ooh and aah but is a celebration of virtuosity without content. One of the interesting things about the difference between abstraction and representation is that a really bad abstract painting will easily become meaningless background for cocktail chitchat; it just becomes wallpaper. But you can't stop looking at a bad figurative paint-

ing. It's like a sore thumb. The reason involves the different ways the two things fail: bad abstraction fails because it's meaningless decoration, but it's never as grating as bad figure drawing."

Close calls himself a "dyed-in-the-wool formalist," who clearly sees portraits not in terms of the character of the people they depict but as elaborations of line, surface and color. It's hard to get him even to speculate about what faces suggest about character. At the Met, in front of Petrus Christus's serene and pristine portrait of a Carthusian monk, he says: "It's not that I'm not interested in his character or who the monk was. I do find it amazing that ordinary people posed for figures of saints, so that you have a baker or a friend of the artist as Saint Peter. But I enjoy looking at a portrait like this, first of all, for the fuzziness of the edge of the beard, and all the hard edges and big shapes. When I do a portrait, I'm trying to present it flat-footedly, without editorial comment, although information about character is there anyway, if people want to look for it. I like to say that if a person laughs, the laugh lines show; if the person frowns, the brow is furrowed. Faces are road maps of a life."

Likewise, looking at Rogier van der Weyden's portrait of Francesco d'Este, he focuses on an "incredible cluster of shapes in the lower left-hand corner, like an octopus, of fingers. Look at that complicated curve coming down the left side of his face. The speed of the curve keeps changing, the way it wraps about and defines the form. And there's the barest hint of a slightly lighter passage of paint, which makes the skin wrap tightly around his teeth. They say studying anatomy is important, but I think once you know something is supposed to happen anatomically, you convince yourself that it is there. This is why so much academic painting is bad: because academic painters couldn't resist putting in all the muscles they had studied. Anatomical drawing is a convention like any other, and there's no guarantee that if you use a convention, the results will move someone. My favorite analogy is a brick building:

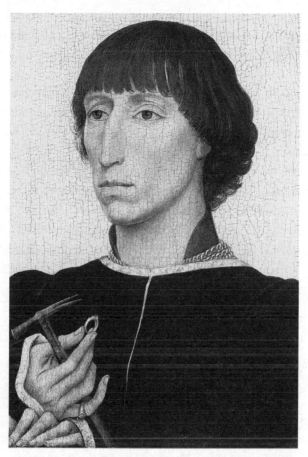

Rogier van der Weyden / *Francesco d'Este,* c. 1460
Oil on wood, 11¾ x 8 in. The Metropolitan Museum of Art, New York

stacked up one way the bricks make a cathedral, another
way they become a gas station."

Of course, Close's own paintings are made of identical
or nearly identical dots or marks, not unlike bricks, in
themselves neutral and unspecific, which, depending on
how he puts them together, become descriptive of differ-
ent faces. This explains why, before some Seurats, for ex-
ample, he says: "What moves me about Seurat's art is the
incremental, nuanced, part-to-whole way his paintings are
built out of elegant little dots, though I feel even more of
a kinship with Roman mosaics because the mosaics are
made out of big, clunky chunks, and I especially like the

idea that something can be made out of something else so different and unlikely. In Roman mosaics, an eyeball is made from the exact same chunk of stone as the background, and this brings up the concept of alloverness and Jackson Pollock. It's what I aim for in my own work, an alloverness that's different from what most portraitists do by putting all of their attention into the eyes, nose and mouth."

The issue of equal attention, alloverness, when it comes to the picture surface, an Abstract Expressionist concept, relates, among other things, to Close's dislike of Rembrandt. In the Met's European paintings galleries, with *Aristotle with a Bust of Homer,* he says, "Rembrandt's paintings, to me, say, 'I can make fur, or brass buttons, or satin,' but the result isn't more than just his ability to simulate

Rembrandt van Rijn / *Aristotle with a Bust of Homer,* 1653
Oil on canvas, 56½ x 53¾ in. The Metropolitan Museum of Art, New York

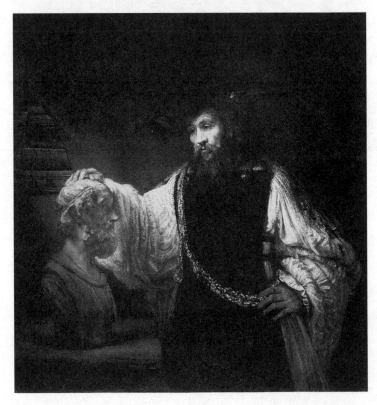

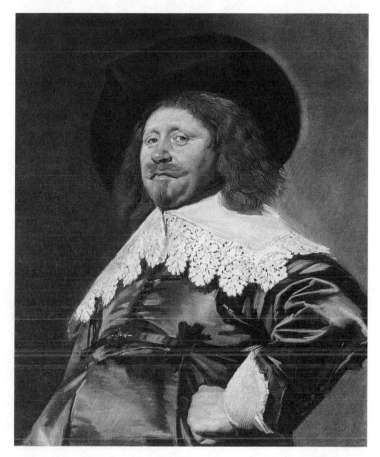

Frans Hals / *Portrait of Claes Duyst van Voorhout,* 1630s
Oil on canvas, 31¾ x 26 in. The Metropolitan Museum of Art, New York

these things. I love his drawings and prints. He's a great,
great draftsman and printmaker. But in his paintings, I find
that all the highlights keep popping off, like flashbulbs, and
then he mixes up stews of brown, soppy oils to obscure the
incoherence." Close prefers Frans Hals, Rembrandt's
compatriot, because Hals's pictures look to him more co-
herent, and he chooses, by way of comparison with the
Rembrandt, Hals's portrait from the 1630s of a pneumatic
Dutch brewer, Claes Duyst van Voorhout.

"When I was a student in 1961, the rap on me was that
I could be the John Singer Sargent of my generation,
which was meant in a derogatory way—that I was flashy—

and which I fought against by imposing limits on myself as a portraitist. But what I still loved about flashy painters like Sargent and Hals was their shorthand, their ability to make a stroke stand for a finger and yet be just a stroke. In Hals, you can see the speed of the mark; you can always tell the nature of the brush, how flexible it was, the width, how much paint he picked up, that he painted wet into wet. The greasiness of Hals's paint is always wonderful, the way it celebrates the oiliness, the slipperiness of paint. And I love watching his brush dance and slide across the surface. I also love the black-and-whiteness of his art, so that when he slips a little color in, it's like *pow*, an explosion. Then he cuts out the figure's form by painting the background around it, the way Cézanne did. The whole surface of the work is equalized because the background gets a positive presence. It's like a jigsaw puzzle of interlocking pieces. And I find it thrilling, physically, the way one's eye is pushed from space to space in the picture."

Perhaps Close's favorite of all paintings in the Met is Velázquez's Juan de Pareja (see p. 120). "Rembrandt would have doggedly drawn every single button of Juan de Pareja's jacket, then highlighted every one of them. What Velázquez does is paint something by not painting it. You see the way he makes the hand palpably real without anything precisely described except its outside edge? The same with the mouth, one of the great orifices in art, out of focus yet you still know just how soft the lips would be to kiss. It's like a movie: if you don't like the film, then the fact that a person is holding a fork in the right hand in one shot and the left hand in the next is annoying, but if the film is a great film, then you forgive the flaws."

Since Close makes paintings from photographs, it's not surprising, perhaps, that the terms of film and photography tend to crop up when he describes paintings. About Vermeer's *Young Woman with a Water Jug* (on p. 25), which he seeks out, he remarks on "its blurry, soft-focus and general quality, with shapes lurking in the dark." Vermeer, he says, "is painting the situation of an edge of a table covered by a

tapestry, not its simulation. He's the first painter from pho-
tography, in his case from camera obscura, in that no one
had painted out of focus before. Eyeball realists claim to
paint what they see and are against people like me who
work from photographs, but they rely on the conventions
of perspective, which means they often don't look at what
they're actually seeing. Vermeer, by contrast, painted what
a camera shows—in other words, what is true. An artist
today who does something similar is Rackstraw Downes, a
genuine eyeball realist who throws out all the conventions
and deals with what really happens at the blurry edges of
our fields of vision, where things curve away and there are
no straight lines. This goes back to Vermeer."

Close also talks about photography before Ingres's
black-and-white odalisque (p. 155), which, he jokes,
"looks like an inflated Macy's Thanksgiving Day balloon,
full of air with no bones, and of course it makes you think
first of a black-and-white photograph. One of the reasons
I used to chafe at the term 'realist' is that I'm just as com-
mitted to artificiality as to realism. 'Art' is in the word 'ar-
tificial,' and I can only imagine that the first photographs,
which were black and white, must have struck people as
highly artificial. The only visual precursors were black-
and-white drawings or grisaille paintings like this one. My
daughter once asked me if I was alive when the world was
black and white, which is a pretty amazing thing to say,
when you think about it, because everything she saw that
was old on TV was black and white.

"Photography changed everything. It put portrait paint-
ing out of business on a certain level. At the same time,
painting, sensing competition from photography, gravi-
tated toward things that photography wasn't very good at.
Photographs were black and white, so paintings became
more about color. Photographs were static and detail-
filled. So in paintings you got broken-up, Impressionist
brushstrokes, then Futurist movement. I remember being
asked by some children once, 'Do you work from pho-
tographs or can you really draw?' as if looking at a photo-

graph means you're not really looking, as if you're cheating, whereas there are so many representational artists working from live models who make the exact same image over and over, without any specificity. It's hard to remember now, but I was considered the Antichrist in the sixties by representational painters because my paintings looked like photographs, and were made from photographs, and because I suppressed virtuoso flourishes that were signs of a painter's touch. My work looked cool and detached, which made it like Minimalist art, except that I happened to be dealing with images of people. The notion at the time, which came from Abstract Expressionism, was that abstract art was an arena in which you had to spill your guts out on the canvas. But as a fourth-generation junior Abstract Expressionist, what angst did I have? I was just duplicating the look of angst, which didn't seem like an alternative. Meanwhile, figurative art at the time was the domain of artists with heavy humanist baggage, like Leon Golub, whom I respect very much, but that wasn't my thing either. So I found a way of working from photographs in which verisimilitude was just an automatic byproduct of the process.

"The reason works like this Ingres give me such immense pleasure is that I feel a shared experience in the making of it," Close says. "I've always wondered how a magician watches another magician perform: does he see the illusion or the device that makes the illusion? For me, the thrill as a painter is not only seeing what another painter has made but how he or she has made it. And I think one reason painting continues to have urgency, when so many so-called experts like to say it is dead, is that there is something about the smearing of colored dirt on a flat surface and denying the flatness through the illusion of depth which retains its original magic from the days of the cave painters and which can never be denied."

ACKNOWLEDGMENTS

My first and deepest debt is to the artists, many of whom spent a lot of time after the interviews making sure everything came out right. I thank them. It was a pleasure, an honor and an education for me.

At *The New York Times,* Myra Forsberg encouraged me to do this project, supported it and, with Wendy Sclight, Don Caswell, Nancy Kenney, John Storm, Ron Wertheimer, Wade Burkhart and Will Joyner, skillfully edited most of the interviews in their initial incarnation in the Weekend section. Connie Rosenblum, Bill McDonald and Annette Grant shepherded a few of the other interviews into the pages of Arts & Leisure. I have a Columbo-like reputation for returning endlessly to fiddle with my copy, and so I am especially grateful to all of these people for their indulgence and also for their friendship. Ray Paganelli, Zvi Lowenthal, Sara Krulwich and Fred Conrad (whose photograph of Cindy Sherman is on the book jacket) made sure the articles were extravagantly illustrated in the *Times.* Gwen Smith helped me keep track of myself. Joe Lelyveld, Bill Keller, John Darnton, Marty Gottlieb, Bob Berkvist, Dan Lewis, Al Siegal and Gene Roberts have been the best bosses a critic can have. All writers should have editors like these.

What I owe to John Russell for his help and encouragement is incalculable. Likewise, to my good friends and colleagues Roberta Smith, Holland Cotter and Marilyn Minden. I'm proud to know them.

Rosamond Bernier read the manuscript. John Richardson put me in touch with Lucian Freud. Maria-Gaetana Matisse interceded with Balthus. Peter Galassi introduced me to Cartier-Bresson, and Helen Wright made sure that Cartier-Bresson's chapter in the book was properly illustrated. They were all remarkably generous.

So were Philippe de Montebello, Harold Holzer, Elyse Topalian and Sabine Rewald at the Metropolitan Museum of Art and Glenn D. Lowry and John Elderfield at the Museum of Modern Art.

At Random House, my enormous debts are to Virginia Avery, Enrica Gadler, Jim Lambert, Sally Marvin, Jo Anne Metsch, Robbin Schiff and above all to Ann Godoff, my friend, whose Job-like patience is equaled

248

ACKNOWLEDGMENTS

by her grace as an editor. I'm lucky to have these people as my publishers, and to have Suzanne Gluck of I.C.M. as my agent: it's amazing that having known each other since high school, we now take each other seriously, sort of.

Amy Zorn, with the gracious help of innumerable artist representatives and assistants scrambling to track down photographs and crucial information, quickly pulled together the illustrations for the book, which turned out to be an insanely complicated project, and, as always, she generally helped to bring order to the chaos of my work.

Maria Simson brings joy to my life, and not incidentally is the perfect editor. This book simply wouldn't have happened without her.

—MICHAEL KIMMELMAN
New York City, June 1998

PICTURE CREDITS

p. 5: Nicolas Poussin, *Rinaldo and Armida*. Photograph: Erich Lessing/ Art Resource, New York

p. 5: Balthus, *Thérèse Dreaming*. © 1998 Artists Rights Society (ARS), New York/ADAGP, Paris

p. 10: Balthus, Copy after Piero della Francesca's *The Invention and Recognition of the True Cross*. © 1998 Artist Rights Society (ARS), New York/ADAGP, Paris

p. 11: Piero della Francesca, *Portrait of Sigismondo Malatesta*. Giraudon/Art Resource, New York

p. 12: Dora Maar, Untitled. The Museum of Modern Art, New York, Robert and Joyce Menschel Fund. Transparency © 1998 The Museum of Modern Art, New York

p. 13: Balthus, *Joan Miró and His Daughter Dolores*. The Museum of Modern Art, New York, Abby Aldrich Rockefeller Fund. © 1998 Artists Rights Society (ARS), New York/ADAGP, Paris. Photograph © 1998 The Museum of Modern Art, New York

p. 14: Georges de La Tour, *The Cheat*. Kimbell Art Museum, Fort Worth, Texas. Photograph © Erich Lessing/Art Resource, New York

p. 15: Balthus, *The Game of Cards*. © 1988 Artists Rights Society (ARS), New York/ADAGP, Paris

p. 18: Elizabeth Murray, *Stirring Still*. Photograph: Ellen Page Wilson, courtesy of PaceWildenstein

p. 21: Paul Cézanne, *Madame Cézanne in a Red Dress*. The Metropolitan Museum of Art, New York, Mr. and Mrs. Henry Ittleson, Jr., Purchase Fund, 1962 (62.45)

p. 22: Elizabeth Murray, *Madame Cézanne in Rocking Chair*. Photograph courtesy of PaceWildenstein

p. 23: Gustave Courbet, *Young Women from the Village*. The Metropolitan Museum of Art, New York, Gift of Harry Payne Bingham, 1940 (40.175)

p. 25: Jan Vermeer, *Young Woman with a Water Jug*. The Metropolitan Museum of Art, New York, Gift of Henry G. Marquand, 1889 (89.15.21)

p. 27: Pablo Picasso, *Gertrude Stein.* © 1988 Estate of Pablo Picasso/Artists Rights Society (ARS), New York. The Metropolitan Museum of Art, New York, Bequest of Gertrude Stein, 1946 (47.106)

p. 28: Susan Rothenberg, *Galisteo Creek.* The Metropolitan Museum of Art, New York, Purchase, Lila Acheson Wallace Gift, 1992 (1992.343)

p. 31: Philip Guston, *The Street.* The Metropolitan Museum of Art, New York, Purchase, Lila Acheson Wallace and Mr. and Mrs. Andrew Saul Gifts, Gift of George A. Hearn, by exchange, and Arthur Hoppock Hearn Fund, 1983 (1983.457)

p. 31: Philip Guston, *The Clock.* The Museum of Modern Art, New York, Gift of Mrs. Bliss Parkinson. Photograph © 1998 The Museum of Modern Art, New York

p. 36: Paul Cézanne, *The Rape.* By permission of the Provost and Fellows of King's College, Cambridge. Photograph © Fitzwilliam Museum, University of Cambridge

p. 39: Francis Bacon, *Three Studies for Figures at the Base of a Crucifixion.* Copyright © Marlborough Fine Art, London. Photograph: Tate Gallery, London/Art Resource, New York

p. 44: John Constable, *Hampstead Heath.* Victoria & Albert Museum, London/Art Resource, New York

p. 45: Eadweard Muybridge, *Wrestling, Graeco-Roman.* Photography Collection, Miriam and Ira D. Wallach Division of Art, Prints and Photographs, The New York Public Library, Astor, Lenox, and Tilden Foundations

p. 45: Francis Bacon, *Three Studies of Figures on Beds.* Copyright © Francis Bacon Estate. Photograph: Marlborough Fine Art, London

p. 46: Diego Rodríguez Velázquez, *Pope Innocent X.* Photograph: Alinari/ Art Resource, New York

p. 47: Francis Bacon, *Number VII from Eight Studies for a Portrait.* The Museum of Modern Art, New York, Gift of Mr. and Mrs. William A. M. Burden. Photograph © 1998 The Museum of Modern Art, New York

p. 51: Richard Serra, *Tilted Arc.* Photograph: Anne Chauvet

p. 53: Jackson Pollock, *Pasiphaë.* The Metropolitan Museum of Art, Purchase, Rogers, Fletcher and Harris Brisbane Dick Funds, and Joseph Pulitzer Bequest, 1982. (1982.20). © 1998 Pollock-Krasner Foundation/Artists Rights Society (ARS), New York

p. 53: Pablo Picasso, *Girl Before a Mirror.* © 1988 Estate of Pablo Picasso/ Artists Rights Society (ARS), New York. The Museum of Modern Art, New York, Gift of Mrs. Simon Guggenheim. Photograph © 1998 The Museum of Modern Art, New York

p. 54: Jackson Pollock, *Autumn Rhythm.* The Metropolitan Museum of Art, New York, George A. Hearn Fund, 1957 (57.92). © 1998 Pollock-Krasner Foundation/Artists Rights Society (ARS), New York

p. 56: Richard Serra, *Belts.* Solomon R. Guggenheim Museum (Panza Collection), New York. Photograph: Peter Moore

p. 56: Jackson Pollock, *Mural.* The University of Iowa Museum of Art, Gift of Peggy Guggenheim, 1959.6. © 1998 Pollock-Krasner Foundation/Artists Rights Society (ARS), New York

p. 59: Barnett Newman, *Shimmer Bright.* © 1988 Barnett Newman Foundation/Artists Rights Society (ARS), New York. The Metro-

politan Museum of Art, New York, Gift of Annalee Newman, 1991 (1991.183)

p. 60: Alberto Giacometti, *Man Pointing*. © 1998 Artists Rights Society (ARS), New York, ADAGP, Paris. The Museum of Modern Art, New York, Gift of Mrs. John D. Rockefeller 3rd. Photograph © 1998 The Museum of Modern Art, New York

p. 62: Gerhard Richter, *Man Shot Down (1)* from *October 18, 1977*. The Museum of Modern Art, New York, Purchase. Photograph © 1998 The Museum of Modern Art, New York

p. 63: Jackson Pollock, *Echo (No. 25, 1951)*. The Museum of Modern Art, New York. Acquired through the Lillie P. Bliss Bequest and the Mr. and Mrs. David Rockefeller Fund. Photograph © 1988 The Museum of Modern Art, New York. © 1998 Pollock-Krasner Foundation/Artists Rights Society (ARS), New York

p. 67: Kiki Smith, *Deer Drawing*. Photograph: Ellen Page Wilson, courtesy of PaceWildenstsein

p. 67: Kiki Smith, *Snow Blind*. Photograph: Ellen Page Wilson, courtesy of PaceWildenstein

p. 68: Tent panel. The Metropolitan Museum of Art, New York, Purchase, Bequest of Helen W. D. Mileham, by exchange, Wendy Findlay Gift, and funds from various donors, 1981 (1981.321)

p. 70: Crab from base of Cleopatra's Needle. The Metropolitan Museum of Art, New York, Gift of Commander Henry H. Gorringe, 1881 (81.2.2)

p. 74: Winged Bird-Headed Divinity. The Metropolitan Museum of Art, New York, Gift of John D. Rockefeller, Jr., 1932 (32.143.7)

p.75: Kiki Smith, *Lilith*. The Metropolitan Museum of Art, New York, Purchase, Roy R. and Marie S. Neuberger Gift, 1996 (1996.27)

p. 77: Edgar Degas, *Little Fourteen-Year-Old Dancer*. The Metropolitan Museum of Art, New York, Bequest of Mrs. H. O. Havemeyer, 1922 (29.100.370)

p. 78: Tony Smith, *Amaryllis*. The Metropolitan Museum of Art, New York, anonymous gift, 1986 (1986.432)

p. 81: Roy Lichtenstein, *Yellow Brushstroke I*. © Estate of Roy Lichtenstein. Photograph: Robert McKeever

p. 85: Roy Lichtenstein, *Washington Crossing the Delaware I*. © Estate of Roy Lichtenstein. Photograph: Robert McKeever

p. 85: Roy Lichtenstein, *Look Mickey*. © Estate of Roy Lichtenstein. Photograph: Robert McKeever

p. 87: *The Seven Sacraments*. The Metropolitan Museum of Art, New York, Gift of J. Pierpont Morgan, 1907 (07.57.3-5)

p. 88: Roy Lichtenstein, *Nude with Yellow Flower*. © Estate of Roy Lichtenstein. Photograph: Robert McKeever

p. 91: Style of Francisco de Goya, *A City on a Rock*. The Metropolitan Museum of Art, New York, The H. O. Havemeyer Collection, Bequest of Mrs. H. O. Havemeyer (29.100.12)

p. 92: Jacques-Louis David, *The Death of Socrates*. The Metropolitan Museum of Art, New York, Catharine Lorillard Wolfe Collection, Wolfe Fund, 1931 (31.45)

p. 92: Jean Honoré Fragonard, *The Love Letter*. The Metropolitan Museum of Art, New York, The Jules Bache Collection, 1949 (49.7.49)

p. 125: Henri Cartier-Bresson, *Les Tuileries, Paris.* © Henri Cartier-Bresson

p. 127: Henri Cartier-Bresson, *Behind the Gare St.-Lazare, Paris.* © Henri Cartier-Bresson/Magnum Photos, Inc.

p. 127: Henri Cartier-Bresson, *Valencia.* © Henri Cartier-Bresson/Magnum Photos, Inc.

p. 130: Henri Cartier-Bresson, Photograph of Pierre Bonnard. © Henri Cartier-Bresson/Magnum Photos, Inc.

p. 131: Pierre Bonnard, *Self-Portrait.* © 1988 Artists Rights Society (ARS), New York/ADAGP, Paris. Photograph: Jacques Faujour, © Centre Georges Pompidou, Musée National d'Art Moderne, Paris

p. 134: Henri Matisse, *Portrait of Auguste Pellerin.* © 1998 Succession H. Matisse, Paris/Artists Rights Society (ARS), New York. Photograph: Philippe Migeat, © Centre Georges Pompidou, Musée National d'Art Moderne, Paris

p. 135: Henri Cartier-Bresson, Copy after Matisse's *Portrait of August Pellerin.* © Henri Cartier-Bresson

p. 137: Henri Cartier-Bresson, Drawing from Ingres. © Henri Cartier-Bresson

p. 138: Jean Antoine Watteau, *Le Faux Pas.* Photograph: Giraudon/Art Resource, New York

p. 138. Jean-Baptiste Chardin, *The Ray.* Photograph: Giraudon/Art Resource, New York

p. 142: William Lake Price, *Don Quixote in His Study.* The Metropolitan Museum of Art, New York, Gift of A. Hyatt Mayor, 1969 (69.635.1)

p. 143: Cindy Sherman, *Film Still #7.* Courtesy of the artist and Metro Pictures

p. 143: Cindy Sherman, *Untitled 250.* Courtesy of the artist and Metro Pictures

p. 145: Cindy Sherman, *Untitled 211.* Courtesy of the artist and Metro Pictures

p. 149: Vito Acconci, *Photomatic Enunciation Piece ("Anything Goes").* The Metropolitan Museum of Art, New York, Purchase, The Horace W. Goldsmith Foundation Gift, 1994 (1994.186.2)

p. 150: Dr. Duchenne and Adrien Tournachon, *Terror.* École Nationale Supérieure des Beaux-Arts, Paris

p. 152: Paul Cadmus, *The Seven Deadly Sins: Lust.* The Metropolitan Museum of Art, New York, Gift of Lincoln Kirstein, 1993 (1993.87.1)

p. 153: Edgar Degas, *Woman Bathing in a Shallow Tub.* The Metropolitan Museum of Art, H. O. Havemeyer Collection, Bequest of Mrs. H. O. Havemeyer, 1929 (29.100.41)

p. 154: Auguste Rodin, *Iris, Messenger of the Gods.* The Metropolitan Museum of Art, New York, Gift of the B. G. Cantor Art Foundation, 1984 (1984.364.7)

p. 155: J.-A.-D. Ingres and workshop, *Odalisque in Grisaille.* The Metropolitan Museum of Art, New York, Catharine Lorillard Wolfe Collection, Wolfe Fund, 1938 (38.65)

p. 156: Gustave Courbet, *Woman with a Parrot.* The Metropolitan Museum of Art, New York, H. O. Havemeyer Collection, Bequest of Mrs. H. O. Havemeyer, 1929 (29.100.57)

p. 158: Wayne Thiebaud, *Five Hot Dogs.* Courtesy: Allan Stone Gallery, New York

p. 161: Giorgio Morandi, *Still Life*. © Estate of Giorgio Morandi/Licensed by VAGA, New York, New York. The Museum of Modern Art, New York, James Thrall Soby Bequest. Photograph © 1998 The Museum of Modern Art, New York

p. 162: Rockwell Kent, *Winter, Monhegan Island*. The Metropolitan Museum of Art, New York, George A. Hearn Fund, 1917 (17.48.2)

p. 162: Wayne Thiebaud, *Curved Intersection*. Courtesy: Allan Stone Gallery, New York

p. 166: Willem de Kooning, *Bowl, Pitcher and Jug*. © 1998 Willem de Kooning Revocable Trust/Artists Rights Society (ARS), New York. The Metropolitan Museum of Art, New York, Van Day Truex Fund, 1983 (1983.436)

p. 168: William Harnett, *Still Life: Violin and Music*. The Metropolitan Museum of Art, New York, Catharine Lorillard Wolfe Fund, 1963. The Catharine Lorillard Wolfe Collection (63.85)

p. 169: Albert Pinkham Ryder, *Toilers of the Sea*. The Metropolitan Museum of Art, New York, George A. Hearn Fund, 1915 (15.32)

p. 170: Wayne Thiebaud, *Standing Man*. Courtesy: Allan Stone Gallery, New York

p. 172: J.-A.-D. Ingres, *Portrait of Mme. Leblanc*. The Metropolitan Museum of Art, New York, Catharine Lorillard Wolfe Collection, Wolfe Fund, 1918 (19.77.2)

p. 175: Egyptian, Funerary Papyrus of the Princess Entiu-ny (detail): The Judgment: Weighing of the Heart. The Metropolitan Museum of Art, New York, Museum Excavations, 1928–29, and Rogers Fund, 1930 (30.3.31)

p. 175: Nancy Spero, *Codex Artaud VII* (detail). Courtesy of the artist

p. 177: Leon Golub, *Interrogation III* (detail). Courtesy of the artist. Photograph: Zindman/Fremont

p. 179: Nancy Spero, *Myth*. Courtesy of the artist. Photograph: David Reynolds

p. 180: Greek, Statue of a Kouros. The Metropolitan Museum of Art, New York, Fletcher Fund, 1932 (32.11.1)

p. 183: Mexican, Altar, feline form. The Metropolitan Museum of Art, New York, The Michael C. Rockefeller Memorial Collection, Gift of Nelson A. Rockefeller, 1963 (1978.412.22)

p. 183: Leon Golub, *Skull*. Courtesy of the artist

p. 185: Adélaïde Labille-Guiard, *Self-Portrait with Two Pupils*. The Metropolitan Museum of Art, New York, Gift of Julia A. Berwind, 1953 (53.225.5)

p. 191: Brice Marden, *Cold Mountain I (Path)*. © 1998 Brice Marden/ Artists Rights Society (ARS), New York. Photograph: Bill Jacobson.

p. 192: Brice Marden, *For Helen*. © 1998 Brice Marden/Artists Rights Society (ARS), New York. The Solomon Guggenheim Museum, New York.

p. 193: Tung Ch'i-ch'ang, Hanging Scroll. The Metropolitan Museum of Art, New York, Bequest of John M. Crawford, Jr., 1988 (1989.363.100)

p. 196: Cambodia or Thailand, Avalokiteshvara. The Metropolitan Museum of Art, New York, Purchase, The Annenberg Foundation Gift, 1992 (1992.336)

p. 197: African–Gabonese, Fang reliquary figure. The Metropolitan Museum of Art, New York, The Michael C. Rockefeller Memorial Collection, Gift of Nelson A. Rockefeller, 1965 (1978.412. 441)

p. 199: Agnes Martin, *Untitled*. Photograph: Bill Jacobson, courtesy of PaceWildentsein

p. 199: Brice Marden, *Untitled*. © 1998 Brice Marden/Artists Rights Society (ARS), New York. Photograph: Zindman/Fremont

p. 203: Jacob Lawrence, *John Brown, Series #21* (of 22). The Detroit Institute of Arts, Gift of Mr. and Mrs. Milton Lowenthal. Photograph © 1998 The Detroit Institute of Arts

p. 205: Ben Shahn, *The Passion of Sacco and Vanzetti*. © Estate of Ben Shahn/ Licensed by VAGA, New York, New York. Collection of Whitney Museum of American Art, New York, Gift of Edith and Milton Lowenthal in memory of Juliana Force

p. 207: José Clemente Orozco, *Zapatistas*. © Estate of José Clemente Orozco/Licensed by VAGA, New York, New York. The Museum of Modern Art, New York. Photograph © 1998 The Museum of Modern Art, New York

p. 208: Sassetta, *The Journey of the Magi*. The Metropolitan Museum of Art, New York, Bequest of Maitland F. Griggs, 1943, Maitland F. Griggs Collection (43.98.1)

p. 211: Jacob Lawrence, *Cabinetmaker*. Hirshhorn Museum and Sculpture Garden, Smithsonian Institution, Gift of Joseph H. Hirshhorn, 1966

p. 212: Thomas Hovenden, *Last Moments of John Brown*. The Metropolitan Museum of Art, New York, Gift of Mr. and Mrs. Carl Stoeckel, 1897 (97.5)

p. 214: Horace Pippin, *John Brown Going to His Hanging*. The Pennsylvania Academy of Fine Arts, Philadelphia, John Lambert Fund

p. 217: August Sander, *Unemployed Man*. © 1998 August Sander Archiv/ SK-Stiftung Kultur, Cologne/ArtS, New York/VG Bild-Kunst. The Metropolitan Museum of Art, New York, Purchase, The Horace W. Goldsmith Foundation Gift and Samuel J. Wagstaff, Jr., Bequest, 1991 (1991.1232)

p. 222: Alexandre Cabanel, *The Birth of Venus*. The Metropolitan Museum of Art, New York, Gift of John Wolfe, 1893 (94.24.1)

p. 224: Pierre Renoir, *Young Boy with a Cat*. Photograph: Erich Lessing/Art Resource, New York

p. 225: Marcel Duchamp, *Étant Donnés*. © 1998 Artists Rights Society (ARS), New York/ADAGP, Paris/Estate of Marcel Duchamp. Philadelphia Museum of Art, Gift of the Cassandra Foundation

p. 226: Édouard Manet, *The Battle of the Kearsarge and the Alabama*. The John G. Johnson Collection, Philadelphia Museum of Art

p. 229: Caspar David Friedrich, *Das Eismeer (The Sea of Ice)*. Photograph © Elke Walford, Hamburg

p. 229: Hans Haacke, *Germania*. © Hans Haacke/VG Bild-Kunst. Photograph of interior: Roman Mensing

p. 231: Hans Haacke, *Helmsboro Country*. © Hans Haacke/VG Bild-Kunst. Photograph: Fred Scruton. Photo of Senator Jesse Helms: John Nordell/JB Pictures

p. 233: Congo (Yombe), Power Figure. The Metropolitan Museum of Art, New York, The Murial Kallis Steinberg Newman Collection, Gift of Murial Kallis Newman in honor of Douglas Newton, 1990 (1990.334)

p. 234: Chuck Close, *Phil*. Collection of Whitney Museum of American Art, New York, Purchase, with funds from Mrs. Robert M. Benjamin

p. 235: Chuck Close, *Self-Portrait II*. Photograph by Ellen Page Wilson, courtesy of PaceWildenstein

p. 237: Anselm Kiefer, *Bohemia Lies by the Sea*. The Metropolitan Museum of Art, New York, Purchase, Lila Acheson Wallace Gift and Joseph H. Hazen Foundation Purchase Fund, 1997 (1997.4.a,b)

p. 241: Rogier van der Weyden, *Francesco d'Este*. The Metropolitan Museum of Art, New York, The Friedsam Collection, Bequest of Michael Friedsam, 1931 (32.100.43)

p. 242: Rembrandt van Rijn, *Aristotle with a Bust of Homer*. The Metropolitan Museum of Art, New York, Purchase, special contributions and funds given or bequeathed by friends of the Museum, 1961 (61.198)

p. 243: Frans Hals, *Portrait of Claes Duyst van Voorhout*. The Metropolitan Museum of Art, New York, The Jules Bache Collection, 1949 (49.7.33)

INDEX

Page numbers in *italics* refer to illustrations.

ABOUT THE AUTHOR

MICHAEL KIMMELMAN is chief art critic of
The New York Times.